# *The Best of*

# BUSINESS CARD
# DESIGN

FIRST PUBLISHED IN THE UNITED STATES OF AMERICA BY:
ROCKPORT PUBLISHERS, INC.
146 GRANITE STREET
ROCKPORT, MASSACHUSETTS 01966
TELEPHONE: (508) 546-9590
FAX: (508) 546-7141
TELEX: 5106019284 ROCKORT PUB

DISTRIBUTED TO THE BOOK TRADE AND ART TRADE
IN THE U.S. AND CANADA BY:
NORTH LIGHT, AN IMPRINT OF
F & W PUBLICATIONS
1507 DANA AVENUE
CINCINNATI, OHIO 45207
TELEPHONE: (513) 531-2222

OTHER DISTRIBUTION BY:
ROCKPORT PUBLISHERS, INC.
ROCKPORT, MASSACHUSETTS 01966

ISBN 1-56496-416-7

10 9 8 7 6 5 4 3 2

DESIGNER: CAROL BUCHANAN
EDITOR: ROSALIE GRATTAROTI
PRODUCTION MANAGER: BARBARA STATES
PRODUCTION ASSISTANT: PAT O'MALEY
PHOTOGRAPHY: PAT STAUB PHOTOGRAPHY

PRINTED IN HONG KONG

*The Best of*

# BUSINESS CARD
# DESIGN

ROCKPORT PUBLISHERS

ROCKPORT, MASSACHUSETTS

DISTRIBUTED BY NORTH LIGHT BOOKS, CINCINNATI, OHIO

What is rectangular, square, round and triangular? Black and white, two, three, and four colors, full of superfluous text, embossed, foil stamped, thermographed, letterpressed, silkscreened and void of superfluous text? Witty, dry, corporate, non-corporate and made of paper, wood, metal and plastic and can be found in Rolodexes, ringed binders, and even wallets and purses? The answer can be found on the following 160 pages of this book.

A business card can be many things, but it does only one thing. It represents the company or person who presents it. It is often the only visual reminder one takes away after a first-time introduction. It is most often the only thing one keeps throughout the entire business relationship...and after. A few of the people in my studio think that business cards answer to a "higher calling." Cori uses hers for a bookmark. Coleen leaves messages on the back of her cards to place on friends' windshields. And me? Well, I hand them out in an effort to explain what we do for a living and to legitimize my existence as a graphic designer.

A few months ago, I was looking through a drawer in our studio archives and realized that I have designed more business cards in my nineteen years as a designer than any other single category of print communication; somewhere in the neighborhood of 245 cards. While flipping through hundreds of cards in alphabetical order I was reminded of a major awards ceremony I attended a few years ago. It was produced by the San Francisco Art Directors Club (known today as the San Francisco Creative Alliance) and the San Francisco Advertising Club. A creative director for one of the hottest agencies in the US was sitting in front of me with a bunch of his cronies from the ad biz. Michael Mabry had just been announced as the winner of the Best of Show award for his identity design for Il Fornaio restaurants and bakeries (see page 43 in this

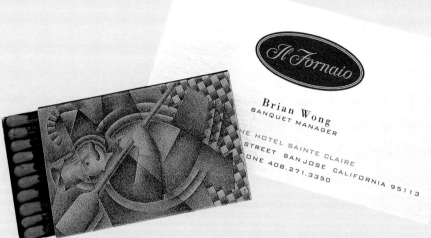

book). Upon his victory march to the podium to receive the award, the ad guy shouted "I didn't know they gave awards for business cards!" Was he implying that advertising has a loftier intellectual value than the visual identity of a business? Or was he merely taking advantage of an opportunity to show off his copyrighting wit? I don't like to assume anything, but I'd like to think he was just being clever.

It did get me thinking, though. What did all of these business cards in our files represent? Was it just a bunch of printed ephemera that seemed to fill in the time for me between those loftier projects over the years? I'd like to think that each and every one positioned the company or service in an ethical, appropriate and memorable way and...that, once in a while, they added a bit of levity to an otherwise ordinary exchange of important information. The creative examples reproduced in this book typify successful applications of the business card as effective communication.

Rick Tharp
Designer
THARP DID IT
San Francisco/Portland

**❶**

**DESIGN FIRM**
SUN RAY SIGN
GROUP, INC.
**DESIGNER**
CHRISTOPHER WIERS
**CLIENT**
SUN RAY SIGN
GROUP, INC.

**❷**

**ART DIRECTOR**
SARAH FORBES
**DESIGNER**
SARAH FORBES
**CLIENT**
RECREATIONS

**❸**

**DESIGN FIRM**
EILTS ANDERSON
TRACY
**ART DIRECTOR**
PATRICE EILTS
**DESIGNER**
PATRICE EILTS
**ILLUSTRATOR**
PATRICE EILTS
**CLIENT**
PB & J RESTAURANT
PARADISE GRILL

**❹**

**DESIGN FIRM**
LINE DRIVEN
**ART DIRECTOR**
CANDACE LOURDES
**DESIGNER**
CANDACE LOURDES
**ILLUSTRATOR**
CANDACE LOURDES
**CLIENT**
LINE DRIVEN
COMPUTER
ILLUSTRATION

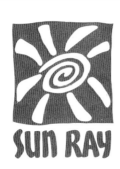

Sun Ray
Sign Group, Inc.
376 Roost Ave.
Holland, MI 49424
616.392.2824

**❶**

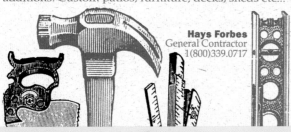

ReCreations
Commercial & residential renovations, remodelling &
additions. Custom patios, furniture, decks, sheds etc...

Hays Forbes
General Contractor
1(800)339.0717

**❷**

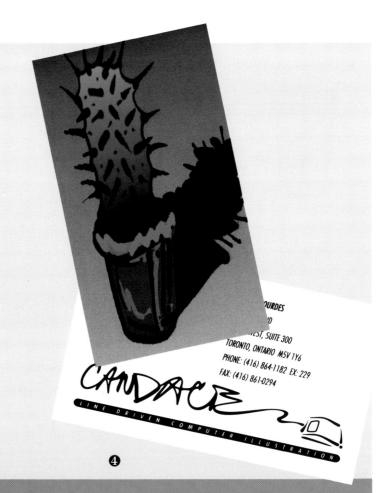

...OURDES
...D
...ST, SUITE 300
TORONTO, ONTARIO M5V 1Y6
PHONE: (416) 864-1182 EX: 229
FAX: (416) 861-0294

CANDACE
LINE DRIVEN COMPUTER ILLUSTRATION

**❹**

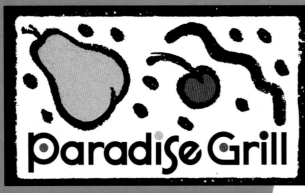

Paradise Grill

**❸**

This Card is good for One
Free Appetizer (Excluding Nachos)
With Purchase of $5.00 or More

PARADISE GRILL

5225 N.W. 64th St.
North Kansas City
Missouri 64151
816•587•9888

**❶**
**DESIGN FIRM**
CHRISTINE
HABERSTOCK
ILLUSTRATION
**ART DIRECTOR**
CHRISTINE
HABERSTOCK
**DESIGNER/**
**ILLUSTRATOR**
CHRISTINE
HABERSTOCK
**CLIENT**
SHEBEEN
MANAGEMENT

**❷**
**DESIGN FIRM**
DEAN JOHNSON
DESIGN
**ART DIRECTOR**
JERRY VELASCO
**DESIGNER**
JERRY VELASCO
**ILLUSTRATOR**
JERRY VELASCO
**CLIENT**
THE BUNGALOW INC.

**❸**
**DESIGN FIRM**
PONT STREET INC.
**ART DIRECTOR**
CHRIS PINKHAM
**DESIGNER**
CHRIS PINKHAM
**ILLUSTRATOR**
CHRIS PINKHAM
**CLIENT**
DEBORAH HOFFMAN

**❹**
**DESIGN FIRM**
GABLE DESIGN
GROUP
**ART DIRECTOR**
TONY GABLE
**DESIGNER**
TONY GABLE
**ILLUSTRATOR**
KARIN YAMAGIWA
**CLIENT**
JEFFREY ROSS
MUSIC

**❺**
**DESIGN FIRM**
O'LEARY
ILLUSTRATION
**ART DIRECTOR**
PATTY O'LEARY
**DESIGNER**
PATTY O'LEARY
**ILLUSTRATOR**
PATTY O'LEARY
**CLIENT**
O'LEARY
ILLUSTRATION

**❻**
**DESIGN FIRM**
GRAPHICUS
CORPORATION
**ART DIRECTOR**
MICAH PICCIRILLI
**DESIGNER**
MICAH PICCIRILLI
**ILLUSTRATOR**
MICAH PICCIRILLI
**CLIENT**
MICHAEL VEINBERGS

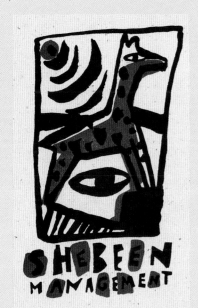

❶

❷

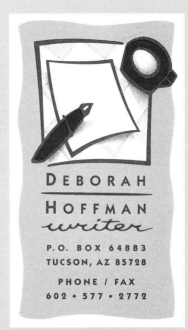

❸

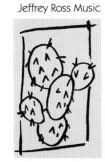

❹

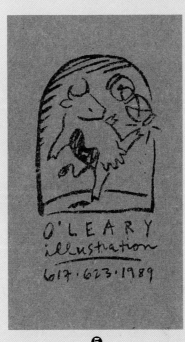

❺

❻

**❶**
**DESIGN FIRM**
ORTEGA DESIGN
**ART DIRECTOR**
JOANN ORTEGA
**DESIGNER**
JOANN ORTEGA
**ILLUSTRATOR**
JOANN ORTEGA
**CLIENT**
CAPT'N KIDS

**❷**
**DESIGN FIRM**
ORTEGA DESIGN
**ART DIRECTOR**
JOANN ORTEGA
**DESIGNER**
JOANN ORTEGA
**CLIENT**
TIM DARRIN

**❸**
**DESIGN FIRM**
MARJORIE POST
**ART DIRECTOR**
MARJORIE POST
**DESIGNER**
MARJORIE POST
**ILLUSTRATOR**
ELIZABETH WALKER
**CLIENT**
MARJORIE POST

**❹**
**DESIGN FIRM**
RICHARDSON OR RICHARDSON
**ART DIRECTOR**
FORREST RICHARDSON
**DESIGNER**
BETH ROYALTY
**ILLUSTRATOR**
BETH ROYALTY
**CLIENT**
PHOENIX FIRE DEPARTMENT - FIRE PAL

**❺**
**DESIGNER**
ANDY LACKOW
**ILLUSTRATOR**
ANDY LACKOW
**CLIENT**
ANDY LACKOW

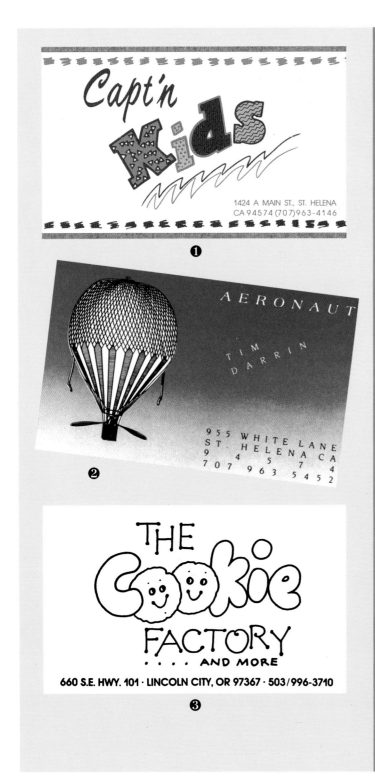

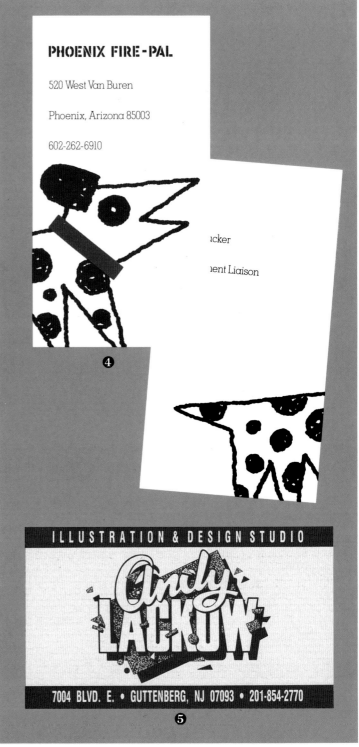

**❶**

**DESIGN FIRM**
SIEBERT DESIGN
ASSOCIATES
**ART DIRECTOR**
LORI SIEBERT
**DESIGNER**
LORI
SIEBERT, LISA
BALLARD
**ILLUSTRATOR**
LISA BALLARD
**CLIENT**
FINIS

**❷**

**DESIGN FIRM**
POWER DESIGN
**DESIGNER**
PAT POWER
**CLIENT**
POWER DESIGN

**❸**

**DESIGN FIRM**
JOTTOWORLD
**ART DIRECTOR**
J'OTTO SEIBOLD
**DESIGNER**
J'OTTO SEIBOLD
**ILLUSTRATOR**
J'OTTO SEIBOLD
**CLIENT**
J'OTTO SEIBOLD

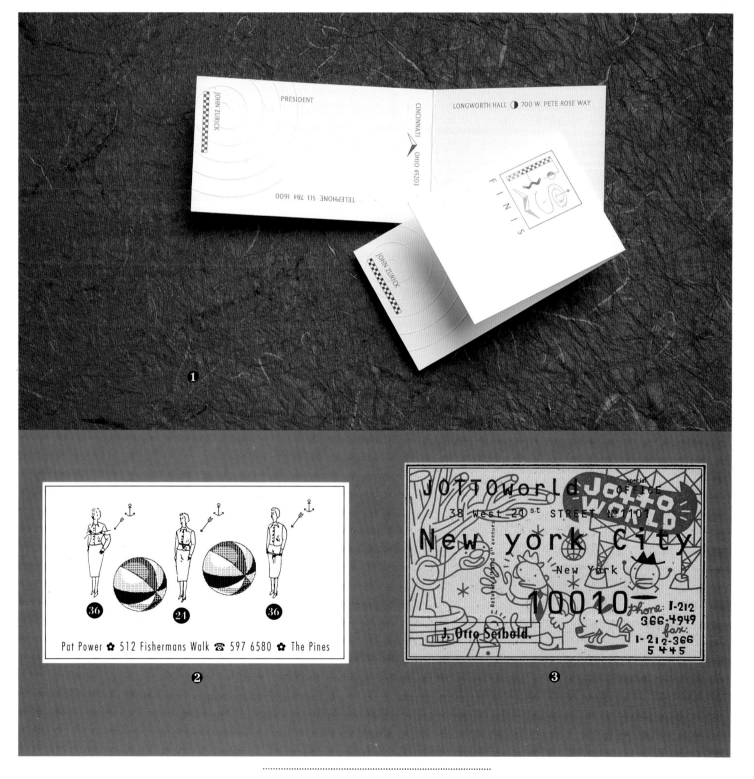

❶
**DESIGN FIRM**
POWER DESIGN
**DESIGNER**
PAT POWER
**CLIENT**
NANCY BLAINE

❷
**DESIGN FIRM**
MARK PALMER DESIGN
**ART DIRECTOR**
MARK PALMER
**DESIGNER**
MARK PALMER, PAT KELLOGG
**ILLUSTRATOR**
MARK PALMER, PAT KELLOGG
**CLIENT**
SCRIBBLER'S INK

❸
**DESIGN FIRM**
RICK EIBER DESIGN
**ART DIRECTOR**
RICK EIBER
**DESIGNER**
RICK EIBER
**ILLUSTRATOR**
NORMAN HATHAWAY
**CLIENT**
TRADE-MARX SIGN &
DISPLAY CORP.

❹
**DESIGN FIRM**
ASCENT
COMMUNICATIONS
**ART DIRECTOR**
ALLEN HAEGER
**DESIGNER**
ALLEN HAEGER
**CLIENT**
AMERICAN DESIGN

❺
**DESIGN FIRM**
KYM ABRAMS
DESIGN
**ART DIRECTOR**
KYM ABRAMS
**DESIGNER**
KYM ABRAMS
**CLIENT**
JULIA RYAN, JULIA
RYAN RETOUCHING

❶
**DESIGN FIRM**
CAROLINE MISNER
**ART DIRECTOR**
CAROLINE MISNER
**DESIGNER**
CAROLINE MISNER
**ILLUSTRATOR**
CAROLINE MISNER
**CLIENT**
KAREN GREENFIELD
COPYWRITER

❷
**ART DIRECTOR**
LINDA DEVITO
SOLTIS
**DESIGNER**
LINDA DEVITO
SOLTIS
**ILLUSTRATOR**
LINDA DEVITO
SOLTIS
**CLIENT**
NEIL'S PLANTASIA

❸
**DESIGN FIRM**
DEAN JOHNSON
DESIGN
**ART DIRECTOR**
SCOTT JOHNSON
**DESIGNER**
SCOTT JOHNSON
**ILLUSTRATOR**
SCOTT JOHNSON
**CLIENT**
INTERGENERATIONAL
ENTERPRISES, INC.

❹
**DESIGN FIRM**
MERVIL PAYLOR
DESIGN
**DESIGNER**
MERVIL M. PAYLOR
**CLIENT**
KATHERINE LAMB

❺
**DESIGN FIRM**
CAROL LASKY
STUDIO
**ART DIRECTOR**
CAROL LASKY
**DESIGNER**
LAURA HERRMANN
**CLIENT**
SUPERFORMANCE
INCORPORATED

❻
**DESIGN FIRM**
GALLINGHOUSE
GREGORY &
ASSOCIATES
**DESIGNER**
IAN MUNDEE,
SHELLY BACHARACH
**CLIENT**
CRESCENT
LANDSCAPE

**❶**

**DESIGN FIRM**
HORNALL ANDERSON DESIGN WORKS, INC.
**ART DIRECTOR**
JACK ANDERSON
**DESIGNER**
JACK ANDERSON, DAVID BATES, JULIA
LAPINE, MARY HERMES
**ILLUSTRATOR**
YUTAKA SASAKI
**CLIENT**
TRAVEL SERVICES OF AMERICA

**❷**

**DESIGN FIRM**
RICHARDSON OR RICHARDSON
**ART DIRECTOR**
FORREST RICHARDSON
**DESIGNER**
NEILL FOX
**ILLUSTRATOR**
NEILL FOX
**CLIENT**
WILDERNESS PRODUCTS, INC.

**❸**

**DESIGN FIRM**
BARRY POWER
GRAPHIC DESIGN
**ART DIRECTOR**
BARRY POWER
**DESIGNER**
BARRY POWER
**CLIENT**
BARRY POWER

**❹**

**DESIGN FIRM**
AD DIMENSION II,
INC.
**DESIGNER**
BARBARA LARSON,
KAREN MAXWELL,
ROBERT BYNDER
**CLIENT**
AD DIMENSION II,
INC.

**❶**

**❷**

**❸**

**❹**

**❶**

**DESIGN FIRM**
CHAMP/COTTER
**DESIGNER**
HEATHER CHAMP
**CLIENT**
PETER MOORE
& ASSOCIATES

**❷**

**DESIGN FIRM**
ROCHELLE SELTZER
DESIGN
**ART DIRECTOR**
ROCHELLE SELTZER
**DESIGNER**
MINNIE CHO
**CLIENT**
VANESA PLIURA
PHOTOGRAPHY

**❸**

**DESIGN FIRM**
RJB STUDIO, INC.
**ART DIRECTOR**
ROBERT J. BUSSEY
**DESIGNER**
ROBERT J. BUSSEY
**CLIENT**
THOMAS LOWE
PHOTOGRAPHY

**❹**

**DESIGN FIRM**
MERVIL PAYLOR
DESIGN
**DESIGNER**
MERVIL M. PAYLOR
**CLIENT**
MERVIL PAYLOR
DESIGN

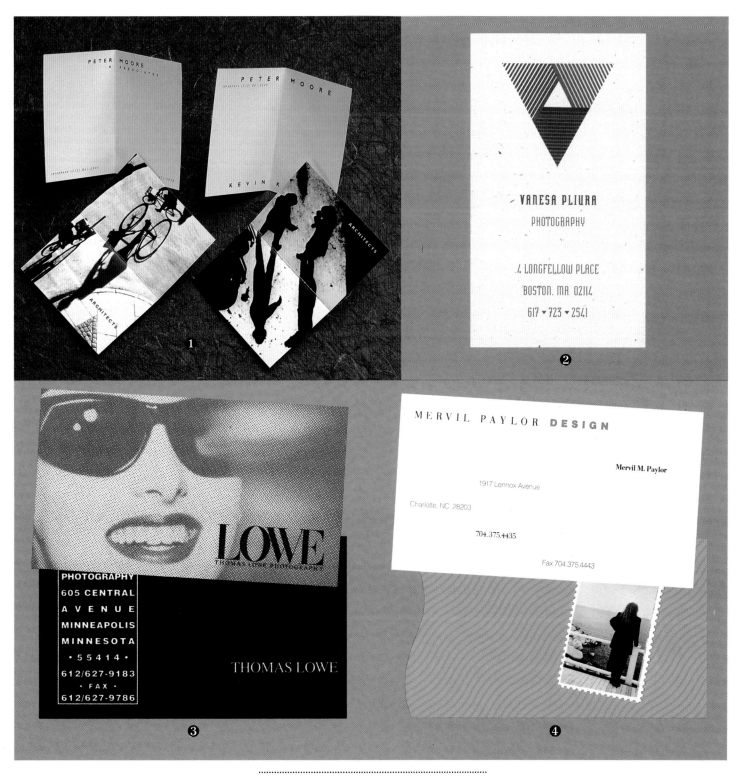

**❶**
**DESIGN FIRM**
PINKHAUS DESIGN
CORP.
**ART DIRECTOR**
JOEL FULLER
**DESIGNER**
LAURA LATHAM
**CLIENT**
ROBERT FLANDERS

**❷**
**DESIGN FIRM**
Q4L MARKETING
**DESIGNER**
JUDY RUMBLE
**ILLUSTRATOR**
JACK KAUFFMAN
**CLIENT**
COPIER CARE
COMPANY

**❸**
**DESIGN FIRM**
PEGGY LAURITSEN DESIGN GROUP
**ART DIRECTOR**
ANOCHA GHOSHACHANDRA
**DESIGNER**
ANOCHA GHOSHACHANDRA
**PHOTOGRAPHER**
PEGGY LAURITSEN
**CLIENT**
PEGGY LAURITSEN
DESIGN GROUP

**❹**
**DESIGN FIRM**
MARKETING BY
DESIGN
**ART DIRECTOR**
JOEL STINGHEN
**DESIGNER**
LINDA JOHNSON
**CLIENT**
MARKETING BY
DESIGN

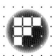
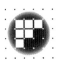
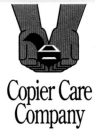
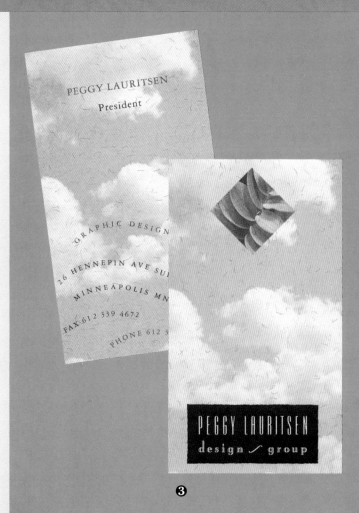

**❶**
**DESIGN FIRM**
PEDERSEN GESK
**DESIGNER**
MITCHELL LINDGREN
**CLIENT**
ANTOINETTE
MASSAGE

**❷**
**DESIGN FIRM**
MCI DESIGN GMBH
**ART DIRECTOR**
MARTIN DOBLER
**DESIGNER**
EUGEN KORTMANN
**CLIENT**
MCI DESIGN GMBH

**❸**
**DESIGN FIRM**
QUALLY & COMPANY
INC.
**ART DIRECTOR**
ROBERT QUALLY
**DESIGNER**
ROBERT QUALLY
**CLIENT**
ROBIN STEVENS
ARTIST AGENT

**❹**
**DESIGN FIRM**
LETTER PRESS
**CLIENT**
OPUS RESTAURANT

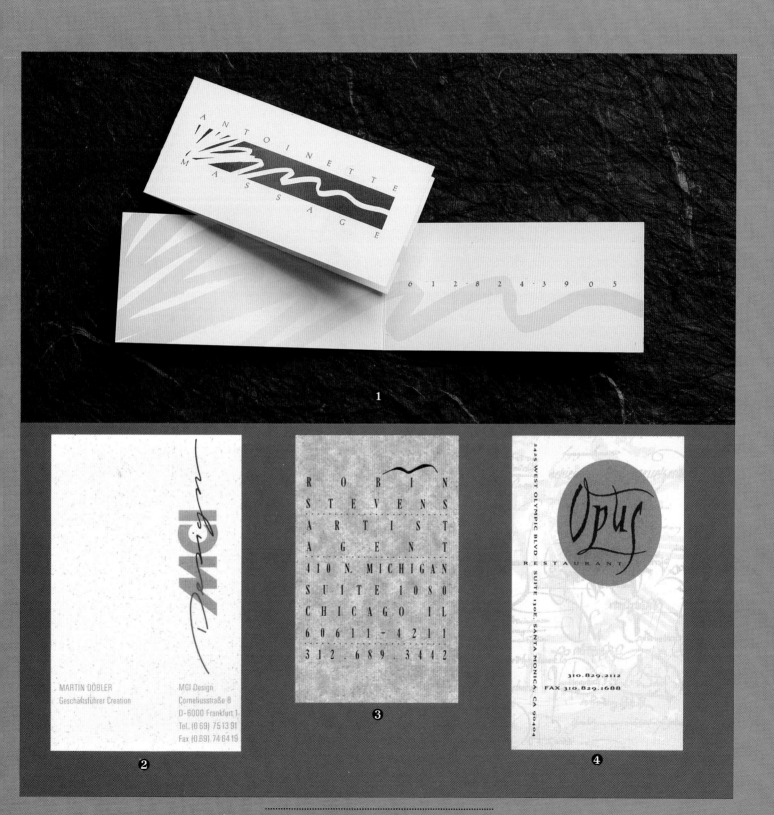

❶
**DESIGN FIRM**
SIEBERT DESIGN
ASSOCIATES
**ART DIRECTOR**
LORI SIEBERT
**DESIGNER**
LORI SIEBERT, DAVID
CARROLL
**CLIENT**
PORTER PRINTING

❷
**DESIGN FIRM**
GLAZER GRAPHICS
**ART DIRECTOR**
NANCY GLAZER
**DESIGNER**
NANCY GLAZER
**CLIENT**
GLAZER GRAPHICS

❸
**DESIGN FIRM**
INTEGRATE INC.
**ART DIRECTOR**
STEPHEN E. QUINN
**DESIGNER**
DAN SHUST,
STEPHEN QUINN
**ILLUSTRATOR**
DAN SHUST
**CLIENT**
THE BOULEVARD
BROCHETTERIE

❹
**DESIGN FIRM**
THARP DID IT
**DESIGNER**
RICK THARP & JEAN
MOGANNAM
**CLIENT**
INVOKE SOFTWARE

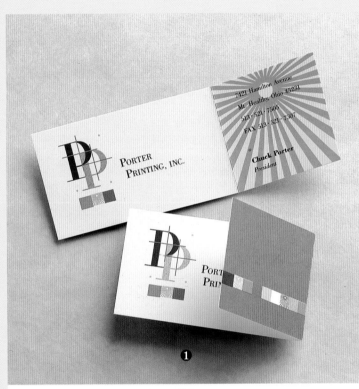

❶

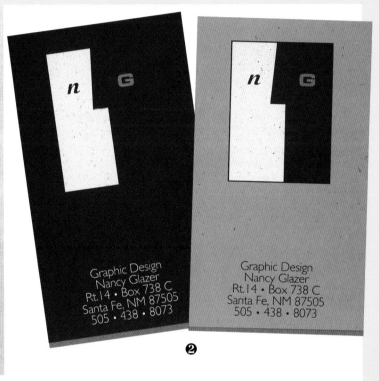

❷

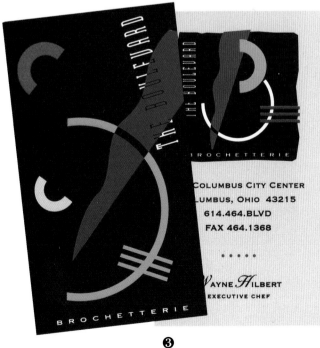

❸

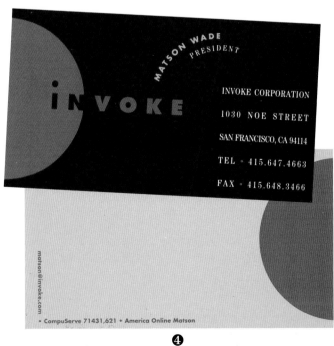

❹

**❶**
**DESIGN FIRM**
LORNA STOVALL
DESIGN
**ART DIRECTOR**
LORNA STOVALL
**DESIGNER**
LORNA STOVALL
**CLIENT**
MACHINE HEAD

**❷**
**DESIGN FIRM**
LIMA DESIGN
**ART DIRECTOR**
MARY KIENE,
LISA MCKENNA
**DESIGNER**
MARY KIENE,
LISA MCKENNA
**CLIENT**
LIMA DESIGN

**❸**
**DESIGN FIRM**
GARFINKLE DESIGN
**ART DIRECTOR**
NINA GARFINKLE
**DESIGNER**
NINA GARFINKLE
**CLIENT**
GARFINKLE DESIGN

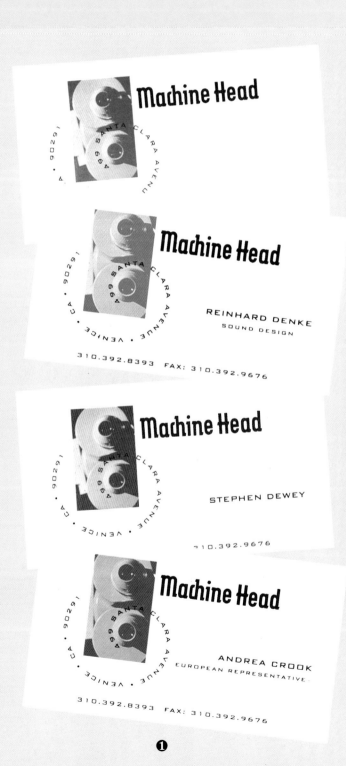

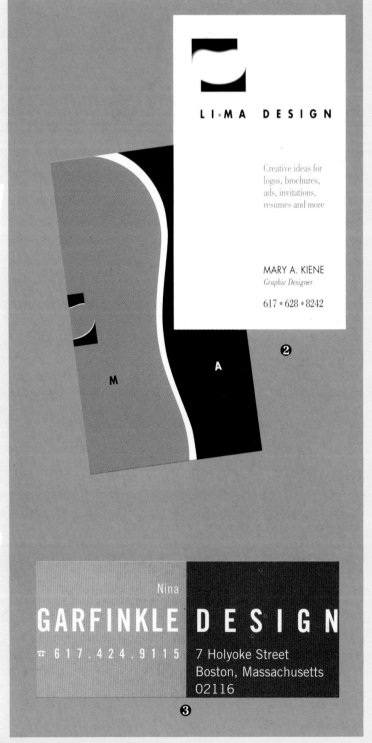

❶
**DESIGN FIRM**
MERVIL PAYLOR
DESIGN
**DESIGNER**
MERVIL M. PAYLOR
**CLIENT**
JOHNSON-POWELL

❷
**DESIGN FIRM**
STUDIO MD
**ART DIRECTOR**
JESSE DOQUILO,
RANDY LIM, GLENN
MITSUI
**DESIGNER**
JESSE DOQUILLO,
RANDY LIM, GLEN
MUTSUI
**ILLUSTRATOR**
GLENN MITSUI
**CLIENT**
COLAIZZO OPTICIANS

❸
**DESIGN FIRM**
MCMONIGLE &
SPOONER
**DESIGNER**
STAN SPOONER
**CLIENT**
FOREMOST
PACKAGING

❹
**DESIGN FIRM**
ERIC ROINSTAD
DESIGN
**ART DIRECTOR**
ERIC ROINSTAD
**DESIGNER**
ERIC ROINSTAD
**CLIENT**
CLAUDINE
BLACKWELL

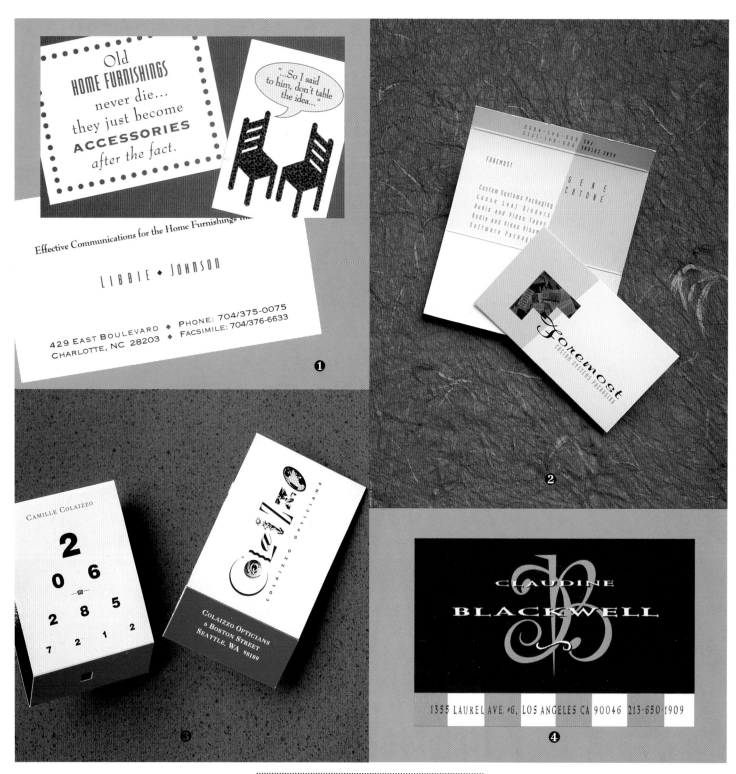

❶
**DESIGN FIRM**
BLIND MICE
**ART DIRECTOR**
ERIC RUFFING
**DESIGNER**
ERIC RUFFING
**CLIENT**
BLIND MICE

❷
**DESIGN FIRM**
PINKHAUS DESIGN CORP.
**ART DIRECTOR**
JOEL FULLER, MARK CANTOR
**DESIGNER**
TOM STERLIN20

❸
**DESIGN FIRM**
SPIRIT RIVER DESIGN
**ART DIRECTOR**
STEVEN PIKALA
**DESIGNER**
STEVEN PIKALA
**ILLUSTRATOR**
STEVEN PIKALA
**CLIENT**
SPIRIT RIVER DESIGN

❹
**DESIGN FIRM**
THARP DID IT
**DESIGNER**
RICK THARP,
COLLEEN
SULLIVAN,
SANDY
RUSSELL
**CLIENT**
STODDARD'S
BREWHOUSE
& EATERY

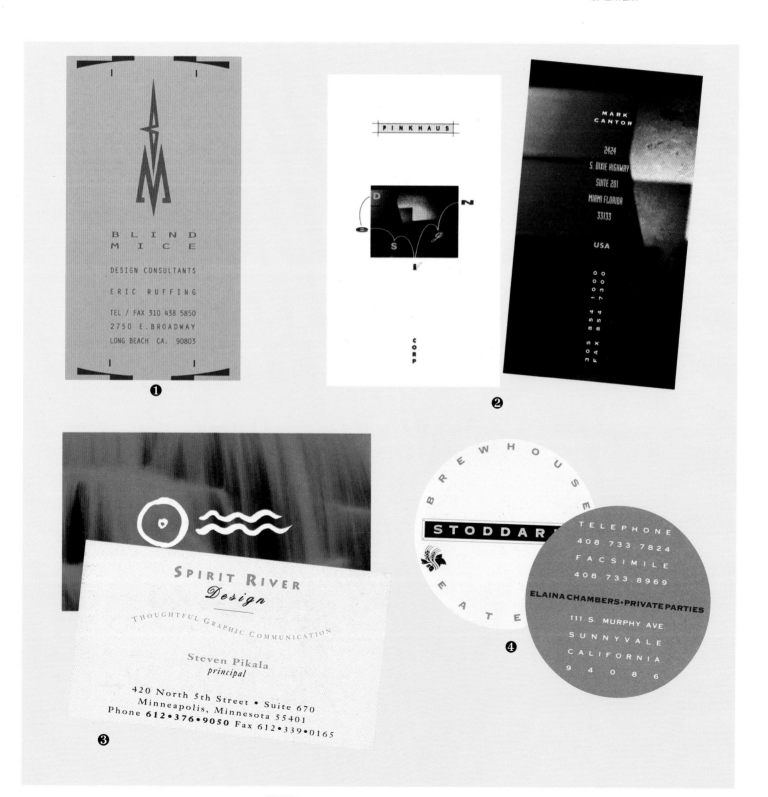

❶
**DESIGN FIRM**
LEAH LOCOCO
**DESIGNER**
LEAH LOCOCO
**CLIENT**
LEAH LOCOCO

❷
**DESIGN FIRM**
BLIND MICE
**ART DIRECTOR**
ERIC RUFFING
**DESIGNER**
ERIC RUFFING
**CLIENT**
MARY WILSON
PHOTOGRAPHY

❸
**DESIGN FIRM**
PLANET DESIGN CO.
**ART DIRECTOR**
PLANET DESIGN CO.
**DESIGNER**
PLANET DESIGN CO.
**CLIENT**
REBHOLZ
PHOTOGRAPHERS

❹
**DESIGN FIRM**
GABLE DESIGN
GROUP
**ART DIRECTOR**
TONY GABLE
**DESIGNER**
TONY GABLE, JANA
S. NISHI
**CLIENT**
GABLE DESIGN
GROUP

❺
**DESIGN FIRM**
MURRIE LIENHART
RYSNER &
ASSOCIATES
**ART DIRECTOR**
KATE MCSHERRY
**DESIGNER**
KATE MCSHERRY
**CLIENT**
RUNG PHOTOGRAPHY

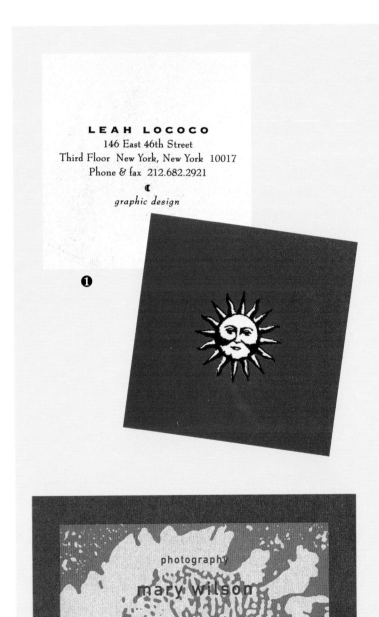

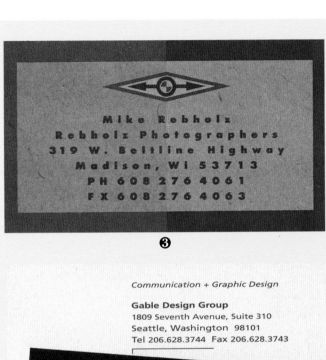

**❶**
**DESIGN FIRM**
QUALLY & COMPANY
INC.
**ART DIRECTOR**
ROBERT QUALLY
**DESIGNER**
ROBERT QUALLY
**ILLUSTRATOR**
BOB ZIERING
**CLIENT**
ASSOCIATED PIPING
& ENGINEERING CO.

**❷**
**DESIGN FIRM**
TIM HARRIS DESIGN
**ART DIRECTOR**
TIM HARRIS, ALAN
DISPARTE
**DESIGNER**
ALAN DISPARTE, TIM
HARRIS
**ILLUSTRATOR**
ALAN DISPARTE
**CLIENT**
URBAN EYES
OPTOMETRY

**❸**
**DESIGN FIRM**
MORLA DESIGN
**ART DIRECTOR**
JENNIFER MORLA
**DESIGNER**
JENNIFER MORLA,
CRAIG BAILEY
**ILLUSTRATOR**
CRAIG BAILEY
**CLIENT**
RISTORANTE ECCO

**❹**
**DESIGN FIRM**
KOMAROW DESIGN
**ART DIRECTOR**
RONNI KOMAROW
**DESIGNER**
RONNI KOMAROW
**ILLUSTRATOR**
JULIA TALCOTT
**CLIENT**
KOMAROW DESIGN

❶

101 South Park
San Francisco
CA 94107
415.495.3291

❷

❸

KOMAROW DESIGN

THE DESIGN STUDIO
THAT LISTENS.

214 LINCOLN STREET
BOSTON, MA 02134
617.254.9083

RONNI KOMAROW

❹

**❶**
**DESIGN FIRM**
PINKHAUS DESIGN CORP.
**ART DIRECTOR**
JOEL FULLER, LISA ASHWORTH
**DESIGNER**
LISA ASHWORTH
**ILLUSTRATOR**
ROLF SCHUETZ
**CLIENT**
REX THREE, INC.

**❷**
**DESIGN FIRM**
HORNALL ANDERSON DESIGN WORKS, INC.
**ART DIRECTOR**
JULIA LAPINE
**DESIGNER**
JULIA LAPINE, LINDA MUGGLI
**ILLUSTRATOR**
JULIA LAPINE
**CLIENT**
PACIFIC GUEST SUITES

**❸**
**DESIGN FIRM**
BEAUCHAMP DESIGN
**ART DIRECTOR**
MICHELE BEAUCHAMP
**DESIGNER**
MICHELE BEAUCHAMP
**CLIENT**
BEAUCHAMP DESIGN

**❹**
**DESIGN FIRM**
THE DESIGN COMPANY
**ART DIRECTOR**
MARCIA ROMANUCK
**DESIGNER**
MARCIA ROMANUCK
**CLIENT**
THE DESIGN COMPANY

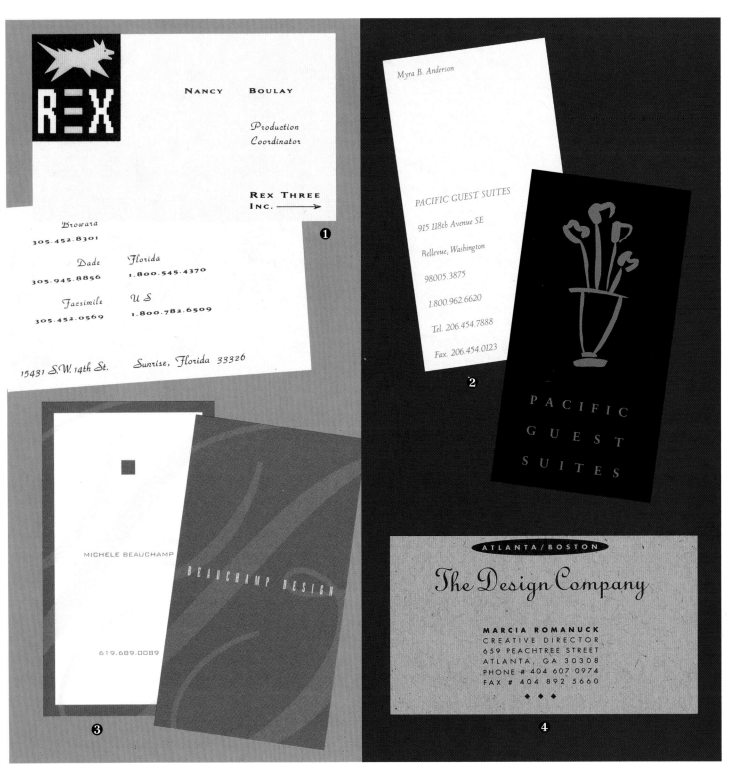

**❶**

**DESIGN FIRM**
EILTS ANDERSON
TRACY
**ART DIRECTOR**
PATRICE EILTS
**DESIGNER**
PATRICE EILTS
**ILLUSTRATOR**
PATRICE EILTS
**CLIENT**
MICHAEL WEAVER

**❷**

**DESIGN FIRM**
RICHARDSON OR
RICHARDSON
**ART DIRECTOR**
FORREST
RICHARDSON, DEBI
YOUNG MEES
**DESIGNER**
DEBI YOUNG MEES,
NEILL FOX
**CLIENT**
DARCY PAPER CO.,
INC.

**❸**

**DESIGN FIRM**
EILTS ANDERSON
TRACY
**ART DIRECTOR**
PATRICE EILTS, JAN
TRACY
**DESIGNER**
PATRICE EILTS, JAN
TRACY
**CLIENT**
EILTS ANDERSON
TRACY DESIGN

**❹**

**DESIGN FIRM**
MORLA DESIGN
**CLIENT**
MITRA TYREE

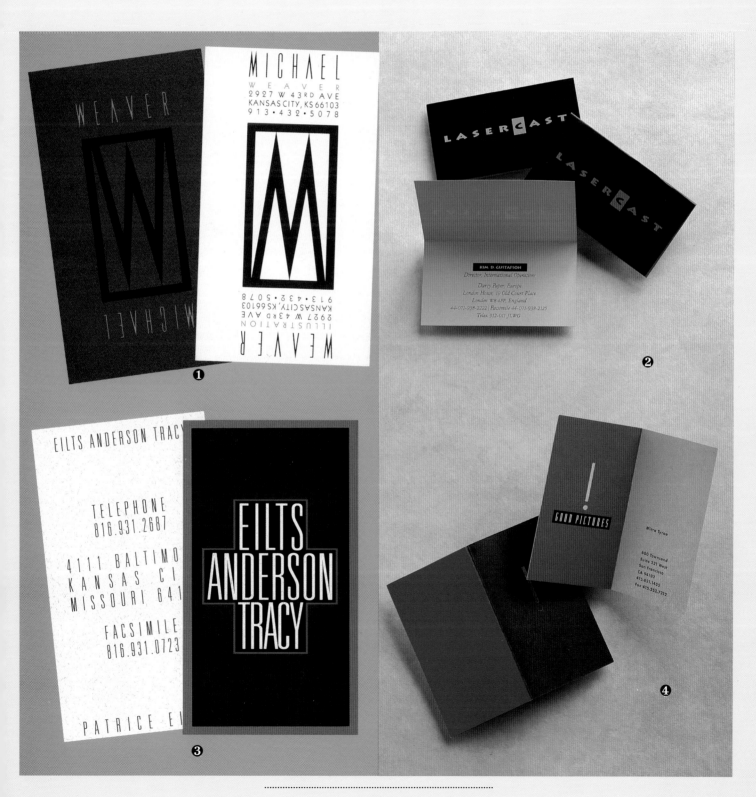

❶

❷

❸

❹

❶
**DESIGN FIRM**
PETER
HOLLINGSWORTH &
ASSOCIATES
**DESIGNER**
STEVEN JOHN
WAMMACK
**CLIENT**
ALAN DAVIS, INC.

❷
**DESIGN FIRM**
ERIC ROINESTAD
DESIGN
**ART DIRECTOR**
ERIC ROINESTAD
**DESIGNER**
ERIC ROINESTAD
**CLIENT**
CLUB SHELTER

❸
**DESIGN FIRM**
LESLIE CHAN DESIGN
CO., LTD.
**ART DIRECTOR**
LESLIE CHAN
WING KEI
**DESIGNER**
LESLIE CHAN
WING KEI,
TONY SONG WEI
**CLIENT**
LESLIE CHAN DESIGN
CO., LTD.

❹
**ART DIRECTOR**
TAMAR LOURIE
**DESIGNER**
TAMAR LOURIE
**ILLUSTRATOR**
DORIT RABINOVITCH
**CLIENT**
DORITART

❺
**DESIGN FIRM**
CHERYL WALIGORY
DESIGN
**DESIGNER**
CHERYL WALIGORY
**CLIENT**
MICHELE BARTRAN
PHOTOGRAPHY

❻
**DESIGN FIRM**
EYMONT KIN-YEE
HULETT
**ART DIRECTOR**
ALISON HULETT
**DESIGNER**
ALISON HULETT
**CLIENT**
COMPASS
ADVERTISING

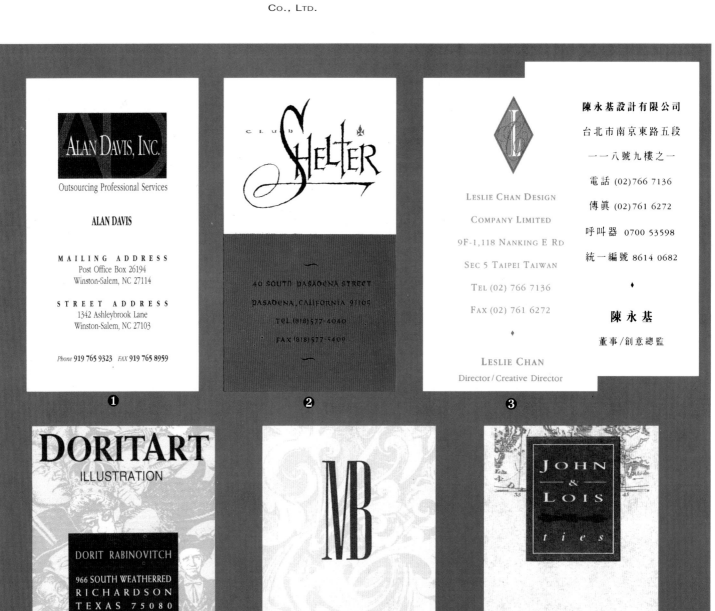

**❶**
**DESIGN FIRM**
PEDERSEN GESK
**DESIGNER**
MITCHELL LINDGREN
**CLIENT**
CHRISTOPHER
BAGLIEN

**❷**
**DESIGN FIRM**
PUNCH DESIGN
**ART DIRECTOR**
RICK KORAB
**DESIGNER**
RICK KORAB
**ILLUSTRATOR**
RICK KORAB
**CLIENT**
PUNCH DESIGN

**❸**
**DESIGN FIRM**
SIEBERT DESIGN
ASSOCIATES
**ART DIRECTOR**
LORI SIEBERT
**DESIGNER**
LISA BALLARD
**PHOTOGRAPHER**
BRAD SMITH
**CLIENT**
SIEBERT DESIGN
ASSOCIATES

**❹**
**DESIGN FIRM**
INDUSTRIA STUDIO
**ART DIRECTOR**
GIBRAN EVANS
**DESIGNER**
GIBRAN EVANS
**ILLUSTRATOR**
GIBRAN EVANS
**CLIENT**
DANIEL J.
MARTINEZ

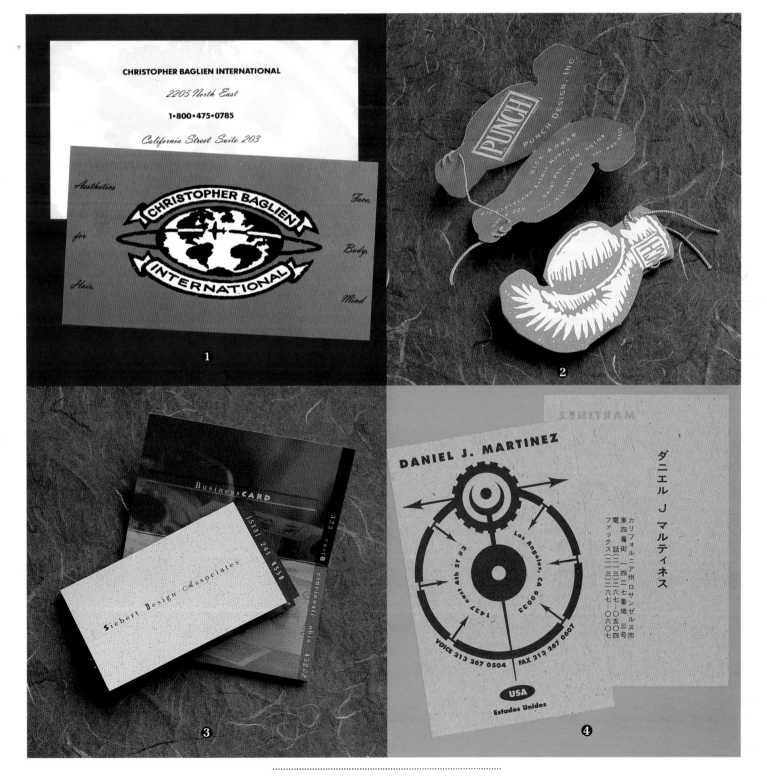

❶
**DESIGN FIRM**
LEE & YIN
**ART DIRECTOR**
CHRIS YIN
**DESIGNER**
MARIA LEE,
CHRIS YIN
**CLIENT**
LEE & YIN

❷
**DESIGN FIRM**
THINMEN DESIGN
**ART DIRECTOR**
HARRY SEGAL
**DESIGNER**
HARRY SEGAL
**CLIENT**
THINMEN DESIGN
CONSULTANTS

❸
**DESIGN FIRM**
MERVIL PAYLOR
DESIGN
**DESIGNER**
MERVIL M. PAYLOR
**CLIENT**
SUMMIT STUDIO

❹
**DESIGN FIRM**
EILTS ANDERSON TRACY
**ART DIRECTOR**
PATRICE ELITZ, JAN TRACY
**DESIGNER**
PATRICE ELITZ, JAN TRACY
**CLIENT**
EILTS & TRACY DESIGN

❺
**DESIGN FIRM**
POWER DESIGN
**DESIGNER**
PAT POWER
**CLIENT**
PAT POWER

Y+I

Chris Yin
Graphic Designer

Fifty-Six
Livingston Street
Brooklyn
New York
11201

Phone+Fax
718 858 4209

❶

THINMEN

Harry Segal
(212)880·8318 Fax:880·8883

DESIGN CONSULTANTS

❷

David
Dickerson
Photographic
Illustration
1212 South Blvd.
Suite 202
Charlotte, NC
28203
704.334.4717

SUMMIT STUDIO

❸

PATRICE EILTS  JAN TRACY
5638 HOLMES.KCMO .64110 816.384.3114

❹

EILTS & TRACY

des-
pp
ign

Pat Power · Graphics · 212 · · 15 · NY NY 10009

❺

**❶**

**DESIGN FIRM**
DEAN JOHNSON
DESIGN
**ART DIRECTOR**
SCOTT JOHNSON
**DESIGNER**
SCOTT JOHNSON
**ILLUSTRATOR**
SCOTT JOHNSON
**CLIENT**
LEWIS &
ASSOCIATES

**❷**

**DESIGN FIRM**
LESLIE CHAN DESIGN
CO., LTD.
**ART DIRECTOR**
LESLIE CHAN
WING KEI
**DESIGNER**
LESLIE CHAN
WING KEI,
TONG SONG WEI
**CLIENT**
TOPLINE
COMMUNICATION INC.

**❸**

**DESIGN FIRM**
SAYLES GRAPHIC
DESIGN
**CLIENT**
SHEREE CLARK

**❹**

**DESIGN FIRM**
THE RIORDON
DESIGN GROUP INC.
**ART DIRECTOR**
RIC RIORDON
**DESIGNER**
DAN WHEATON
**ILLUSTRATOR**
BILL FRAMPTON
**CLIENT**
THE RIORDON
DESIGN GROUP INC.

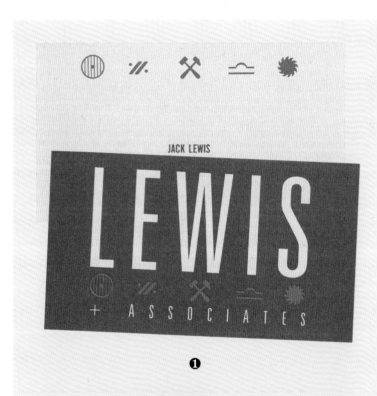

**❶**

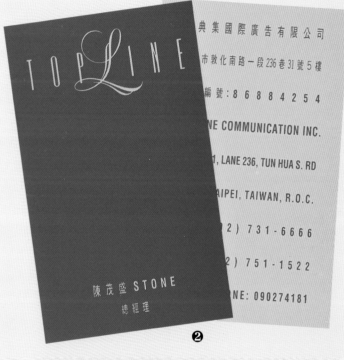

**❷**

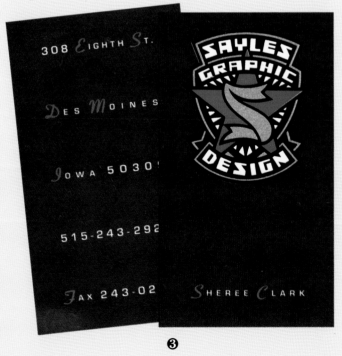

**❸**

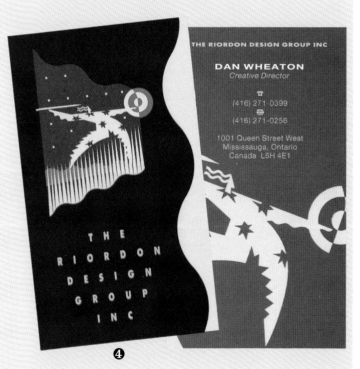

**❹**

**❶**

**DESIGN FIRM**
GLENN MARTINEZ &
ASSOCIATES
**ART DIRECTOR**
KATHLEEN NELSON
**DESIGNER**
GLENN MARTINEZ
**ILLUSTRATOR**
GLENN MARTINEZ
**CLIENT**
TOMASI, LAWRY,
COKER, DESILVA
ARCHITECTS

**❷**

**DESIGN FIRM**
IMAGE CONSULTANTS
ADVERTISING, INC.
**ART DIRECTOR**
HENRY SCOT BRENT
**DESIGNER**
HENRY SCOT BRENT
**CLIENT**
HENRY SCOT BRENT

**❸**

**DESIGN FIRM**
GRAPHIC PARTNERS
**DESIGNER**
GRAHAM DUFFY
**CLIENT**
THE PETER J.
RUSSELL GROUP

**❹**

**DESIGN FIRM**
AGNEW MOYER
SMITH INC.
**ART DIRECTOR**
REED AGNEW
**DESIGNER**
RAND ZIEGLER
**CLIENT**
RODGER MORROW
AND BRUCE DUFFY

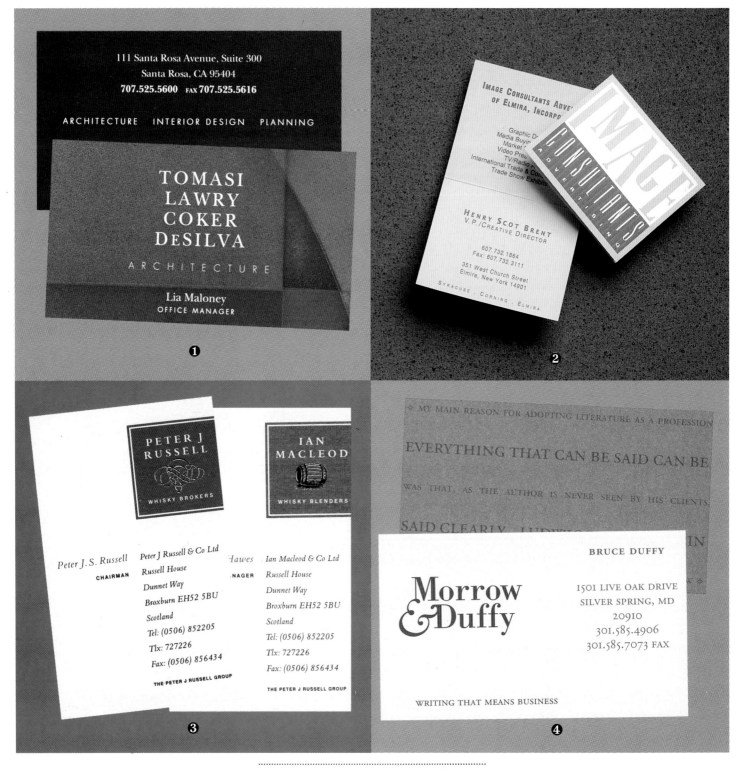

**❶**
**DESIGN FIRM**
MERVIL PAYLOR
DESIGN
**DESIGNER**
MERVIL M. PAYLOR
**CLIENT**
GAIL GOFORTH

**❷**
**DESIGN FIRM**
THINMEN DESIGN
**ART DIRECTOR**
HARRY SEGAL
**DESIGNER**
HARRY SEGAL
**CLIENT**
VICTORIA FREEMAN
CATERING

**❸**
**DESIGN FIRM**
THARP DID IT
**DESIGNER**
RICK THARP, JEAN
MOGANNAM
**CLIENT**
BAKERIES BY THE
BAY

**❹**
**DESIGN FIRM**
MICHAEL STANARD, INC.
**ART DIRECTOR**
LISA FINGERHUT
**DESIGNER**
LISA FINGERHUT
**CLIENT**
ROSE, HAIRDRESSING FOR LADIES &
GENTLEMEN

**❺**
**DESIGN FIRM**
THE DESIGN
COMPANY
**ART DIRECTOR**
BUSHA HUSAK
**DESIGNER**
BUSHA HUSAK
**ILLUSTRATOR**
BUSHA HUSAK
**CLIENT**
THE MANNHEIM
QUARTET

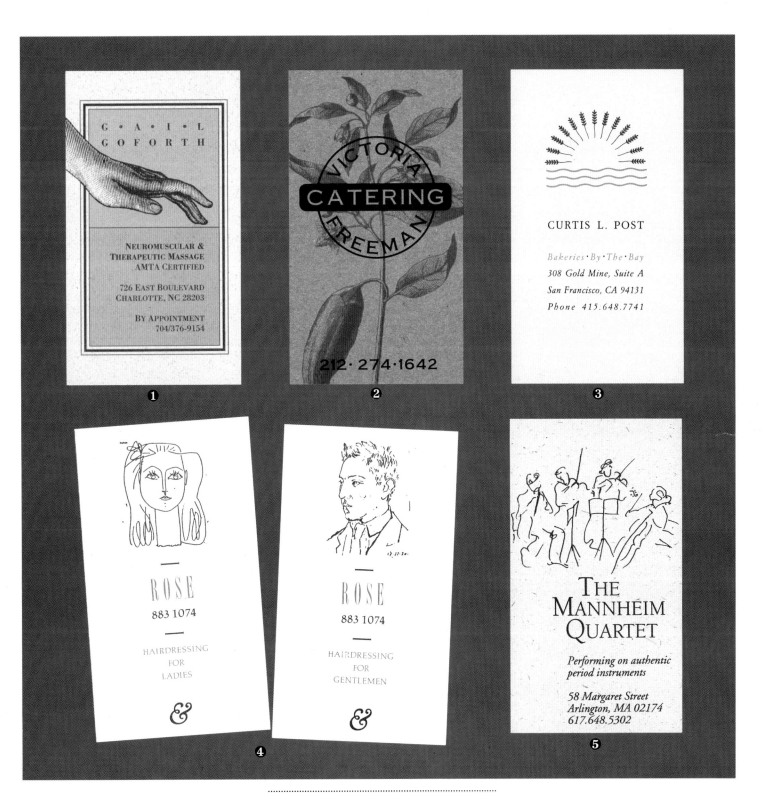

❶
**DESIGN FIRM**
WATSON/SWOPE
**ART DIRECTOR**
GEORGE WATSON
**DESIGNER**
GEORGE WATSON
**ILLUSTRATOR**
MIKE KLINGELSMITH
**CLIENT**
DON RUTT PHOTOGRAPHY

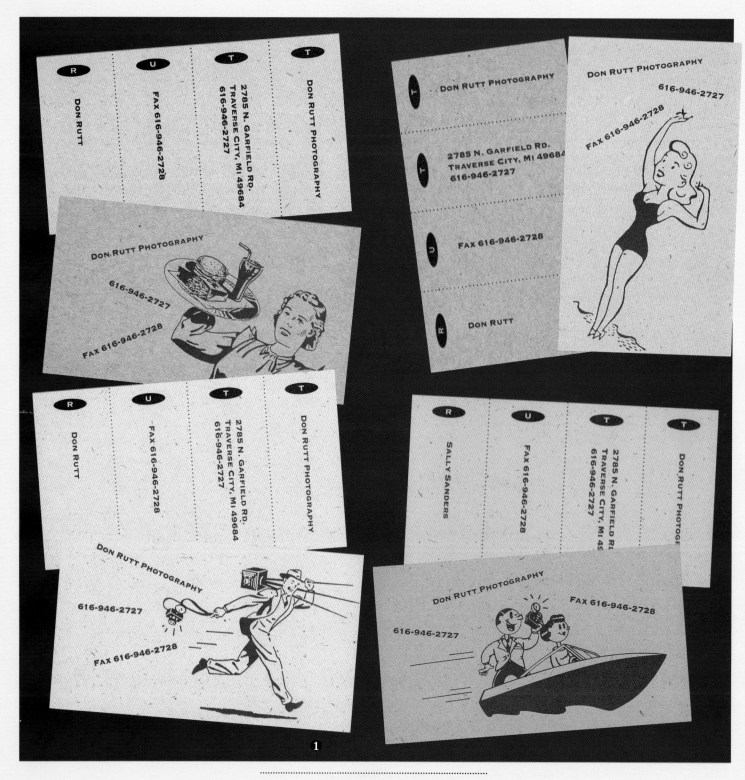

1

**❶**
**DESIGN FIRM**
PEDERSEN GESK
**DESIGNER**
MITCHELL LINDGREN
**CLIENT**
THE COAST

**❷**
**DESIGN FIRM**
ALL ABOUT
GRAPHICS
**CLIENT**
LOGO-MOTIVE INC.
SHELLY P. BRENTON

**❸**
**DESIGN FIRM**
SAYLES GRAPHIC
DESIGN
**ART DIRECTOR**
JOHN SAYLES
**DESIGNER**
JOHN SAYLES
**ILLUSTRATOR**
JOHN SAYLES
**CLIENT**
I.A. BEDFORD

**❹**
**DESIGN FIRM**
THARP DID IT
**DESIGNER**
RICK THARP, JEAN
MOGANNAM
**ILLUSTRATOR**
JANA HEER
**CLIENT**
PENINSULA FOUNTAIN
& GRILLE

**❶**
**DESIGN FIRM**
BEN & JERRY'S ART
DEPARTMENT
**ART DIRECTOR**
LYN SEVERANCE
**DESIGNER**
LYN SEVERANCE
**ILLUSTRATOR**
MELISSA SALENGO
**CLIENT**
BEN & JERRY'S
HOMEMADE, INC.

**❷**
**DESIGN FIRM**
BEN & JERRY'S ART
DEPARTMENT
**ART DIRECTOR**
LYN SEVERANCE
**DESIGNER**
MELISSA SALENGO
**ILLUSTRATOR**
MELISSA SALENGO
**CLIENT**
BEN & JERRY'S
HOMEMADE, INC.

**❸**
**DESIGN FIRM**
BEN & JERRY'S ART
DEPARTMENT
**ART DIRECTOR**
LYN SEVERANCE
**DESIGNER**
SARAH LEE TERRAT
**ILLUSTRATOR**
EDGAR STEWART
**CLIENT**
BEN & JERRY'S
HOMEMADE, INC.

**❹**
**DESIGN FIRM**
BEN & JERRY'S ART
DEPARTMENT
**ART DIRECTOR**
LYN SEVERANCE
**DESIGNER**
LYN SEVERANCE
**ILLUSTRATOR**
MELISSA SALENGO
**CLIENT**
BEN & JERRY'S
HOMEMADE, INC.

**❺**
**DESIGN FIRM**
BEN & JERRY'S ART
DEPARTMENT
**ART DIRECTOR**
LYN SEVERANCE
**DESIGNER**
LYN SEVERANCE
**ILLUSTRATOR**
MELISSA SALENGO
**CLIENT**
BEN & JERRY'S
HOMEMADE, INC.

**❻**
**DESIGN FIRM**
BEN & JERRY'S ART
DEPARTMENT
**ART DIRECTOR**
LYN SEVERANCE
**DESIGNER**
CATHERINE
DINSMORE
**ILLUSTRATOR**
MELISSA SALENGO
**CLIENT**
BEN & JERRY'S
HOMEMADE, INC.

❶

❷

❸

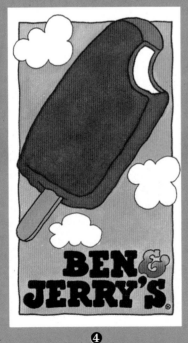

❹

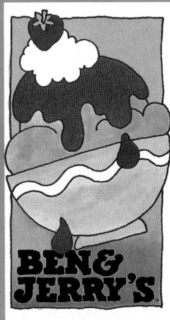

❺

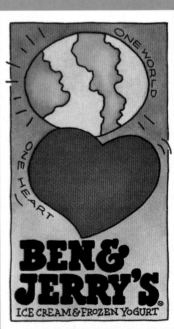

❻

**❶**

**DESIGN FIRM**
BEN & JERRY'S ART
DEPARTMENT
**ART DIRECTOR**
LYN SEVERANCE
**DESIGNER**
SPIKE
**ILLUSTRATOR**
EDGAR STEWART
**CLIENT**
BEN & JERRY'S
HOMEMADE, INC.

**❷**

**DESIGN FIRM**
BEN & JERRY'S ART
DEPARTMENT
**ART DIRECTOR**
LYN SEVERANCE
**DESIGNER**
EDGAR STEWART
**ILLUSTRATOR**
EDGAR STEWART
**CLIENT**
BEN & JERRY'S
HOMEMADE, INC.

**❸**

**DESIGN FIRM**
BEN & JERRY'S ART
DEPARTMENT
**ART DIRECTOR**
LYN SEVERANCE
**DESIGNER**
SARAH FORBES
**ILLUSTRATOR**
MELISSA SALENGO
**CLIENT**
BEN & JERRY'S
HOMEMADE, INC.

**❹**

**DESIGN FIRM**
BEN & JERRY'S ART
DEPARTMENT
**ART DIRECTOR**
LYN SEVERANCE
**DESIGNER**
EDGAR STEWART
**ILLUSTRATOR**
EDGAR STEWART
**CLIENT**
BEN & JERRY'S
HOMEMADE, INC

**❺**

**DESIGN FIRM**
DICK JONES DESIGN
**ART DIRECTOR**
DICK JONES
**DESIGNER**
DICK JONES
**ILLUSTRATOR**
R.O. BLECHMAN
**CLIENT**
DICK JONES DESIGN

**❻**

**DESIGN FIRM**
JEFF SHELLY
**DESIGNER**
JEFF SHELLY
**CLIENT**
JEFF SHELLY

❶

❷

❸

❹

5

6

**❶**

**DESIGN FIRM**
SOMMESE DESIGN
**ART DIRECTOR**
LANNY SOMMESE
**DESIGNER**
LANNY SOMMESE
**ILLUSTRATOR**
LANNY SOMMESE
**CLIENT**
LANNY SOMMESE

**❷**

**DESIGN FIRM**
SIEBERT DESIGN
ASSOCIATES
**ART DIRECTOR**
LORI SIEBERT
**DESIGNER**
LISA BALLARD
**ILLUSTRATOR**
DAVID SHELDON
**CLIENT**
THE CHARTREUSE
MOOSE

**❸**

**DESIGN FIRM**
SCRAMBLED EGGZ PRODUCTIONS
**ART DIRECTOR**
LAUREN SMITH
**DESIGNER**
TOM WATTERS
**ILLUSTRATOR**
TOM WATTERS
**CLIENT**
SCRAMBLED EGGZ PRODUCTIONS

**❹**

**DESIGN FIRM**
TYPO GRAPHIC
**ART DIRECTOR**
ULRICH LANDSHERR
**DESIGNER**
ULRICH LANDSHERR
**CLIENT**
HAARSCHNITT

**❺**

**DESIGN FIRM**
REINER DESIGN
CONSULTANTS, INC.
**ART DIRECTOR**
ROGER J. GORMAN
**DESIGNER**
ROGER J. GORMAN
**CLIENT**
REINER DESIGN
CONSULTANTS, INC.

**❶**

**DESIGN FIRM**
CARPENTER &
COMPANY DESIGN
INC.
**ART DIRECTOR**
JIM CARPENTER
**DESIGNER**
JIM CARPENTER
**ILLUSTRATOR**
JIM CARPENTER
**CLIENT**
CARPENTER &
COMPANY

**❷**

**ART DIRECTOR**
JO OBAROWSKI
**DESIGNER**
JO OBAROWSKI
**CLIENT**
AKIVA FILMS

**❸**

**DESIGN FIRM**
BULLET
COMMUNICATIONS
**ART DIRECTOR**
TIM SCOTT
**DESIGNER**
TIM SCOTT
**ILLUSTRATOR**
TIM SCOTT
**CLIENT**
TAXI (ROCK'N ROLL
BAND)

**❹**

**DESIGN FIRM**
ROBERT BAILEY
INCORPORATED
**ART DIRECTOR**
ROBERT BAILEY
**DESIGNER**
CAROLYN COGHLAN
**CLIENT**
ROBERT BAILEY

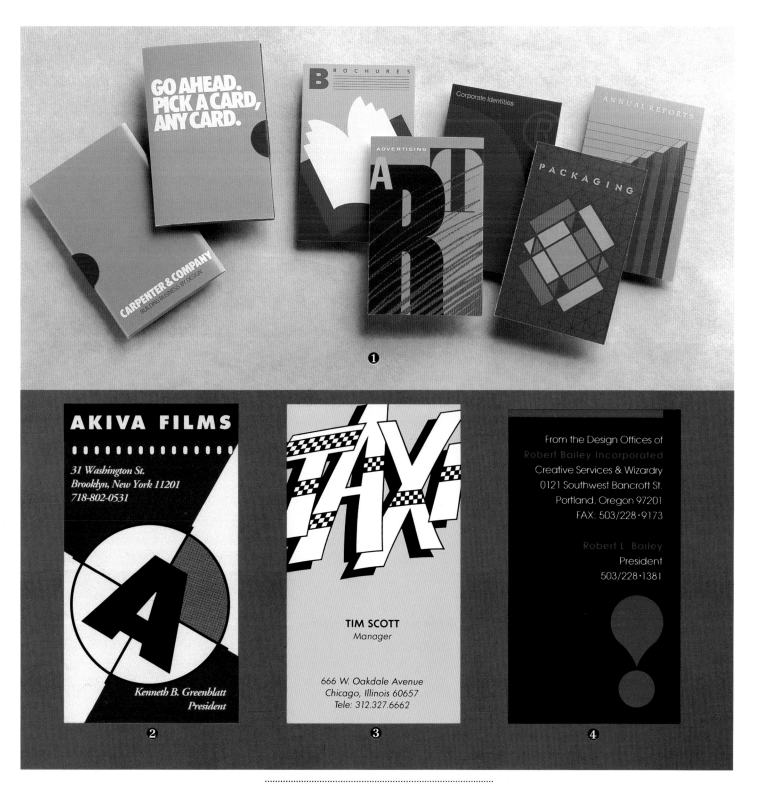

**❶**
**DESIGN FIRM**
RUPERT JENSEN &
ASSOCIATES
**ART DIRECTOR**
JOHN RUPERT
**DESIGNER**
KEVIN SCHOLBERG
**CLIENT**
RUPERT JENSEN &
ASSOCIATES

**❷**
**DESIGNER**
JODIE STOWE
**CLIENT**
JODIE STOWE

**❸**
**DESIGN FIRM**
GREGORY SMITH DESIGN
**ART DIRECTOR**
GREGORY L. SMITH
**DESIGNER**
GREGORY L. SMITH
**ILLUSTRATOR**
GREGORY L. SMITH
**CLIENT**
JOHN EMMERLING PHOTOGRAPHY

**❹**
**DESIGN FIRM**
EARL GEE DESIGN
**ART DIRECTOR**
EARL GEE
**DESIGNER**
EARL GEE
**CLIENT**
EARL GEE DESIGN

**❺**
**DESIGN FIRM**
PLANET DESIGN CO.
**ART DIRECTOR**
PLANET DESIGN CO.
**DESIGNER**
PLANET DESIGN CO.
**CLIENT**
LA MOP HAIR
STUDIO

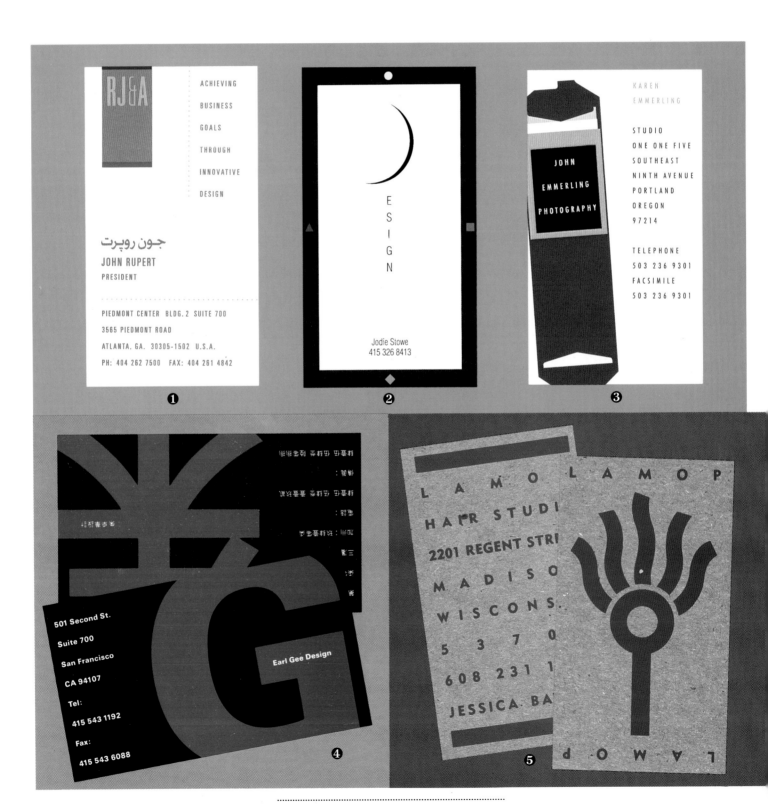

**❶**
**DESIGN FIRM**
PLANET DESIGN CO.
**ART DIRECTOR**
PLANET DESIGN CO.
**DESIGNER**
PLANET DESIGN CO.
**CLIENT**
A & D INTERIOR
DESIGN, INC.

**❷**
**DESIGN FIRM**
ALAN DISPARTE
DESIGN
**ART DIRECTOR**
ALAN DISPARTE
**DESIGNER**
ALAN DISPARTE
**CLIENT**
UNDER ONE ROOF
(L.A.)

**❸**
**DESIGN FIRM**
PLANET DESIGN CO.
**ART DIRECTOR**
PLANET DESIGN CO.
**DESIGNER**
PLANET DESIGN CO.
**CLIENT**
LORI O' PROJECTS

**❹**
**DESIGN FIRM**
VISTA GRAPHICS
**DESIGNER**
REGINA CHEONG,
KAI SIANG TOH
**CLIENT**
VISTA GRAPHICS

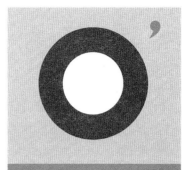

❶ ❷ ❸

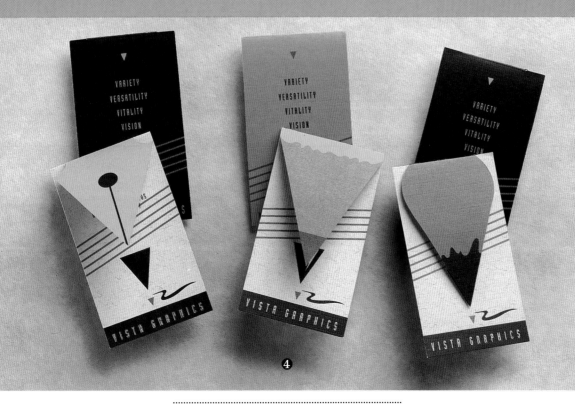

❹

| **❶** | **❷** | **❸** | **❹** |
|---|---|---|---|
| **DESIGN FIRM** | **DESIGN FIRM** | **DESIGN FIRM** | **DESIGN FIRM** |
| CLIFFORD SELBERT | CHAMP/COTTER | TYPO GRAPHIC | MICHAEL HUDSON, |
| DESIGN | **DESIGNER** | **ART DIRECTOR** | LTD. |
| **ART DIRECTOR** | HEATHER CHAMP | ULRICH LANDSHERR | **ART DIRECTOR** |
| CLIFFORD SELBERT, | **CLIENT** | **DESIGNER** | MICHAEL HUDSON |
| MELANIE LOWE | HEATHER CHAMP | ULRICH LANDSHERR | **DESIGNER** |
| **DESIGNER** | | | MICHAEL HUDSON |
| MELANIE LOWE | | | **CLIENT** |
| **CLIENT** | | | MICHAEL HUDSON, |
| NATIONAL PARK | | | LTD. |
| SERVICE | | | |

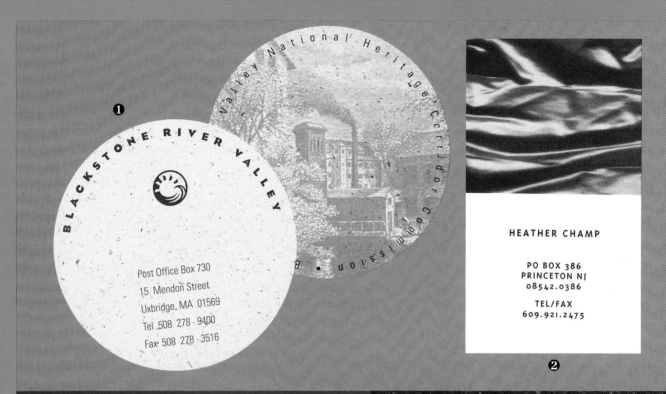

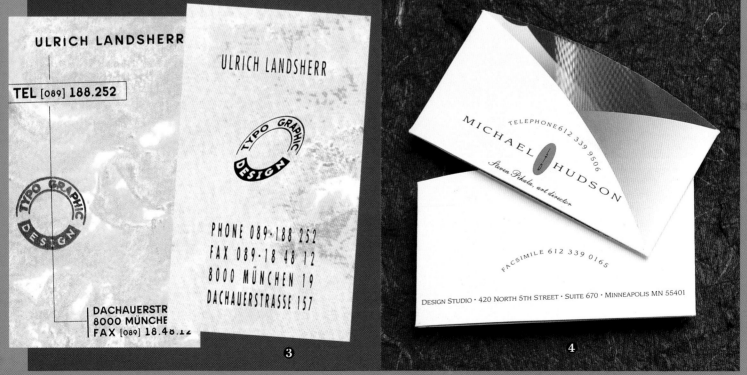

**❶**
**DESIGN FIRM**
PLANET DESIGN CO.
**ART DIRECTOR**
PLANET DESIGN CO.
**DESIGNER**
PLANET DESIGN CO.
**CLIENT**
CHUCK BECKWITH,
ARTIST IN MOSAIC

**❷**
**DESIGN FIRM**
POWER DESIGN
**DESIGNER**
PAT POWER
**CLIENT**
WHISTLING DIXIE
PRODUCTIONS

**❸**
**DESIGN FIRM**
CHRISTINE HABERSTOCK ILLUSTRATION
**ART DIRECTOR**
CHRISTINE HABERSTOCK
**DESIGNER**
CHRISTINE HABERSTOCK
**ILLUSTRATOR**
CHRISTINE HABERSTOCK
**CLIENT**
CHRISTINE HABERSTOCK

**❹**
**DESIGN FIRM**
ERIC ROINESTAD
DESIGN
**ART DIRECTOR**
ERIC ROINESTAD
**DESIGNER**
ERIC ROINESTAD
**CLIENT**
THE ESTILO AGENCY

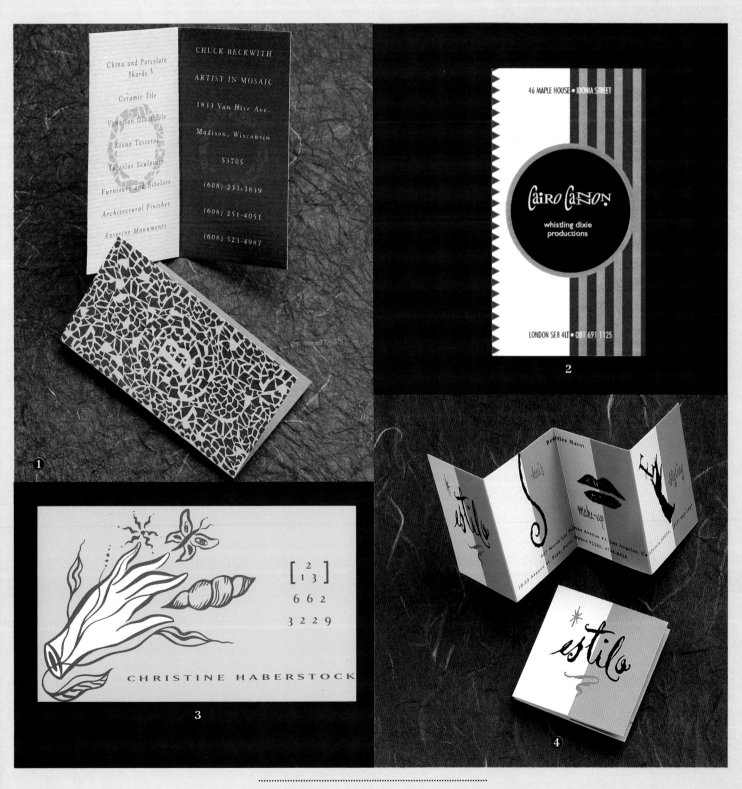

❶
**DESIGN FIRM**
LEE COMMUNICATIONS, INC.
**ART DIRECTOR**
BOB LEE
**DESIGNER**
BOB LEE, DENNIS DEFRANCESCO
**CLIENT**
ARGYLE ASSOCIATES, INC.

❷
**DESIGN FIRM**
BEAUCHAMP DESIGN
**ART DIRECTOR**
MICHELE BEAUCHAMP
**DESIGNER**
MICHELE BEAUCHAMP
**CLIENT**
STEVEN SMITH LANDSCAPE INC.

❸
**DESIGN FIRM**
MARKETING BY DESIGN
**ART DIRECTOR**
DELLA GILLERAN
**DESIGNER**
JOEL STINGHEN
**CLIENT**
VIRIDIAN TECHNOLOGIES INC.

❹
**DESIGN FIRM**
DEBRA NICHOLS DESIGN
**ART DIRECTOR**
DEBRA NICHOLS
**DESIGNER**
DEBRA NICHOLS, KELAN SMITH
**CLIENT**
RICHARD MENDELSOHN

❺
**DESIGN FIRM**
PLANET DESIGN CO.
**ART DIRECTOR**
PLANET DESIGN CO.
**DESIGNER**
PLANET DESIGN CO.
**CLIENT**
CAMDEN PARTNERS, INTERNATIONAL

❻
**DESIGN FIRM**
POLLMAN MARKETING ARTS, INC.
**ART DIRECTOR**
JENNIFER POLLMAN
**DESIGNER**
JENNIFER DAVIS
**CLIENT**
EUPHONICS

---

49 Locust Avenue
New Canaan, CT 06840
203 966-7015

Argyle Associates, Inc.

Roger G. Langevin
President

❶

---

RICHARD MENDELSOHN

8 Third Avenue
San Francisco
California 94118

415 221 1521

415 221 2152 Fax

❹

---

STEVEN
SMITH
LANDSCAPE
INC.

STEVEN SMITH
PRESIDENT

1265 FELICITA LANE
ESCONDIDO, CALIFORNIA 92029
LICENSE NO. 456160
TEL 619.745.9916
FAX 619.745.1982

❷

---

CAMDEN PARTNERS INTERNATIONAL, INC.

BRUCE W. GEIGER
SENIOR CONSULTANT

121 MOHAWK DRIVE
NORTH BARRINGTON, ILLINOIS 60010
P.O. BOX 81 BARRINGTON, ILLINOIS 60011
PH 708 304 1414 HM 608 233 6621 FX 708 304 1514

❺

---

VIRIDIAN

Viridian          John Santora
                  *Principal*
Technologies

Incorporated

2 Tanglewood      Phone and
Laguna Hills      Facsimile
California 92656  714/362-0263

❸

---

EUPHONICS

RESEARCH & DEVELOPMENT
IN DIGITAL AUDIO AND
DIGITAL MUSIC SYNTHESIS

Mic Chorn
DSP Engineer

61 PINE TREE LANE
BOULDER, COLORADO 80304
TEL (303) 938-8448
FAX (303) 938-8885
EMAIL: mic@EuPhonics.COM

❻

---

❶
**DESIGN FIRM**
KEVERSHAN
DESIGN/QUORUM
**DESIGNER**
PATTY KEVERSHAN
**PRODUCTION**
LESLEY ROMARY
**CLIENT**
EHM ARCHITECTURE

❷
**ART DIRECTOR**
RAUL VARELA
**DESIGNER**
RAUL VARELA
**ILLUSTRATOR**
RAUL VARELA
**CLIENT**
RAUL VARELA

❸
**DESIGN FIRM**
M$^2$ ART
**ART DIRECTOR**
MICHAEL MARLOWE,
MICHA RISS
**DESIGNER**
MICHAEL MARLOWE,
MICHA RISS
**CLIENT**
M$^2$ ART

❹
**DESIGN FIRM**
HOLDEN & CO.
**ART DIRECTOR**
CATHE HOLDEN
**DESIGNER**
CATHE HOLDEN
**CLIENT**
COLORWISE
PRINTING

**❶**
**DESIGN FIRM**
LEHMAN GRAPHIC DESIGN
**ART DIRECTOR**
KAREN GOURLEY LEHMAN
**DESIGNER**
KAREN GOURLEY LEHMAN
**CLIENT**
LEHMAN GRAPHIC DESIGN

**❷**
**DESIGN FIRM**
MCMONIGLE &
SPOONER
**DESIGNER**
STAN SPOONER
**CLIENT**
TYPE GALLERY
PRINTERS

**❸**
**DESIGN FIRM**
EARL GEE DESIGN
**ART DIRECTOR**
EARL GEE
**DESIGNER**
EARL GEE
**ILLUSTRATOR**
EARL GEE
**CLIENT**
DAVEN FILM &
VIDEO

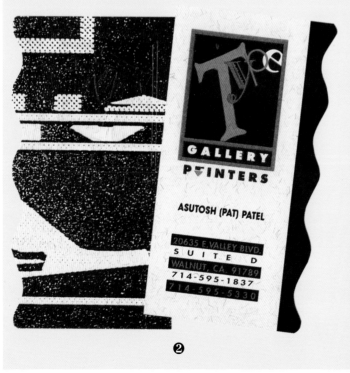

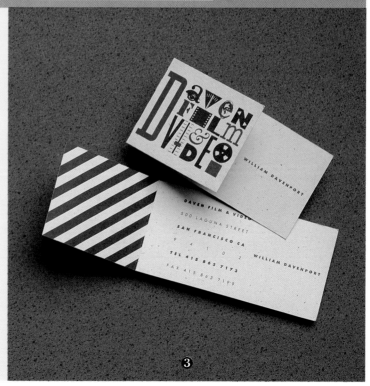

**❶**
**DESIGN FIRM**
FASSINO DESIGN
**ART DIRECTOR**
JENNIFER MASSARO
**DESIGNER**
JENNIFER MASSARO
**ILLUSTRATOR**
JENNIFER MASSARO
**CLIENT**
ANDREW SCHMETTERLING-AUDIO TECHNICIAN

**❷**
**DESIGN FIRM**
MICHAEL MABRY
DESIGN
**ART DIRECTOR**
MICHAEL MABRY
**DESIGNER**
MICHAEL MABRY
**ILLUSTRATOR**
MICHAEL MABRY
**CLIENT**
IL FORNAIO

**❸**
**DESIGN FIRM**
PLANET DESIGN CO.
**ART DIRECTOR**
PLANET DESIGN CO.
**DESIGNER**
PLANET DESIGN CO.
**CLIENT**
FX KELLY SHOES &
ACCESSORIES

**❹**
**DESIGNER**
DON BAKER
**ILLUSTRATOR**
DON BAKER
**CLIENT**
DON BAKER

**❺**
**DESIGN FIRM**
BLIND MICE
**ART DIRECTOR**
ERIC RUFFING
**DESIGNER**
ERIC RUFFING
**CLIENT**
SUSAN FRANK,
DAVID FRISCH

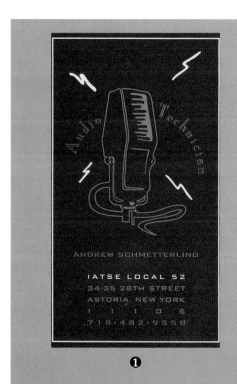

❶

❷

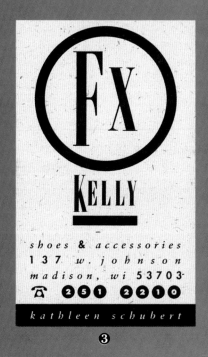

❸

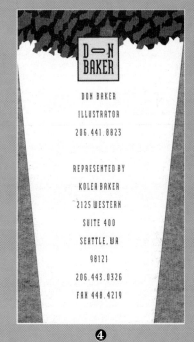

❹

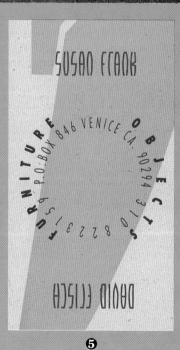

❺

❶
**DESIGN FIRM**
BLIND MICE
**ART DIRECTOR**
ERIC RUFFING
**DESIGNER**
ERIC RUFFING
**CLIENT**
URB
ARCHITECTURE/
DESIGN

❷
**DESIGN FIRM**
PEDERSEN GESK
**DESIGNER**
MITCHELL LINDGREN
**CLIENT**
BLAZE PRODUCTIONS

❸
**DESIGN FIRM**
PLANET DESIGN CO.
**ART DIRECTOR**
PLANET DESIGN CO.
**DESIGNER**
PLANET DESIGN CO.
**CLIENT**
LESLIE BARTON
PHOTOGRAPHY

❹
**DESIGN FIRM**
DEAN JOHNSON
DESIGN
**ART DIRECTOR**
R. LLOYD BROOKS
**DESIGNER**
R. LLOYD BROOKS
**ILLUSTRATOR**
R. LLOYD BROOKS
**CLIENT**
PATRICK BENNETT

❺
**DESIGN FIRM**
APEX DESIGN
**DESIGNER**
JOHN ARELLANO
**CLIENT**
JOHN ARELLANO

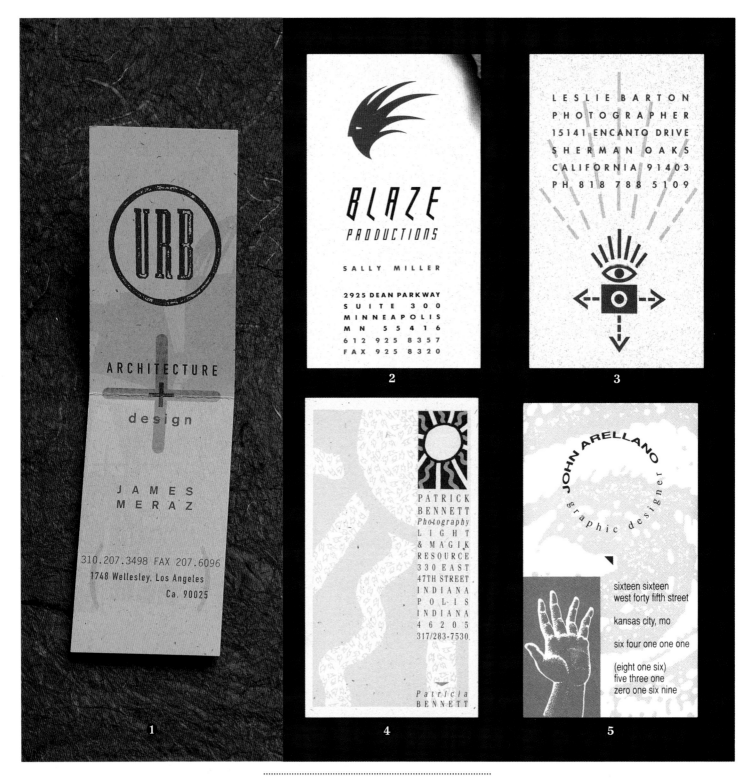

**❶**

**DESIGN FIRM**
DESIGN GROUP
COOK
**ART DIRECTOR**
KEN COOK
**DESIGNER**
KEN COOK
**ILLUSTRATOR**
KEN COOK
**CLIENT**
HOBSON ULTIMATE
SOUND

**❷**

**DESIGN FIRM**
QUALLY & COMPANY
INC.
**ART DIRECTOR**
ROBERT QUALLY
**DESIGNER**
ROBERT QUALLY
**ILLUSTRATOR**
ALEX MURAWSKI
**CLIENT**
ROBERT QUALLY
LTD.

**❸**

**DESIGN FIRM**
SUE SPRINKLE
**CLIENT**
TERESE WINSLOW

**❹**

**DESIGN FIRM**
LINDEN LANE
DESIGN, INC.
**ART DIRECTOR**
ROSEMARY TAYLOR
**DESIGNER**
ROSEMARY TAYLOR
**CLIENT**
ROSEMARY TAYLOR

**❺**

**DESIGN FIRM**
EYMONT KIN-YEE
HULETT
**ART DIRECTOR**
MYRIAM KIN-YEE
**DESIGNER**
FRANK CHIN
**ILLUSTRATOR**
FRANK CHIN
**CLIENT**
MEZZALUNA
RESTAURANT & BAR

❶

❷

❸

❹

❺

❶
**DESIGN FIRM**
THE WELLER INSTI-
TUTE FOR THE CURE
OF DESIGN, INC.
**ART DIRECTOR**
DON WELLER
**DESIGNER**
DON WELLER
**ILLUSTRATOR**
DON WELLER
**CLIENT**
THE WELLER INSTI-
TUTE FOR THE CURE
OF DESIGN, INC.

❷
**DESIGN FIRM**
FOX DESIGN
**DESIGNER**
ANNE FOX
**ILLUSTRATOR**
ANNE FOX
**CLIENT**
FOX DESIGN

❸
**DESIGN FIRM**
REGINALD WADE
RICHEY
**ART DIRECTOR**
REGINALD WADE
RICHEY
**DESIGNER**
KARL HIRSCHMANN
**ILLUSTRATOR**
KARL HIRSCHMANN
**CLIENT**
MALL ST.
MATTHEWS

❹
**DESIGN FIRM**
CAROL LASKY
STUDIO
**ART DIRECTOR**
CAROL LASKY
**DESIGNER**
LAURA HERRMANN
**ILLUSTRATOR**
LAURA HERRMANN
**CLIENT**
BIONOL
CORPORATION

❺
**DESIGN FIRM**
PLATINUM DESIGN
**ART DIRECTOR**
VICTORIA PESLAK
**DESIGNER**
SANDY QUINN
**CLIENT**
JOE STANDART/RED
CIRCLE STUDIOS,
INC.

❻
**DESIGN FIRM**
RELIV, INC.
**ART DIRECTOR**
JAY SMITH
**DESIGNER**
JAY SMITH
**ILLUSTRATOR**
CINDY WROBEL
**CLIENT**
NUTRITION 2000

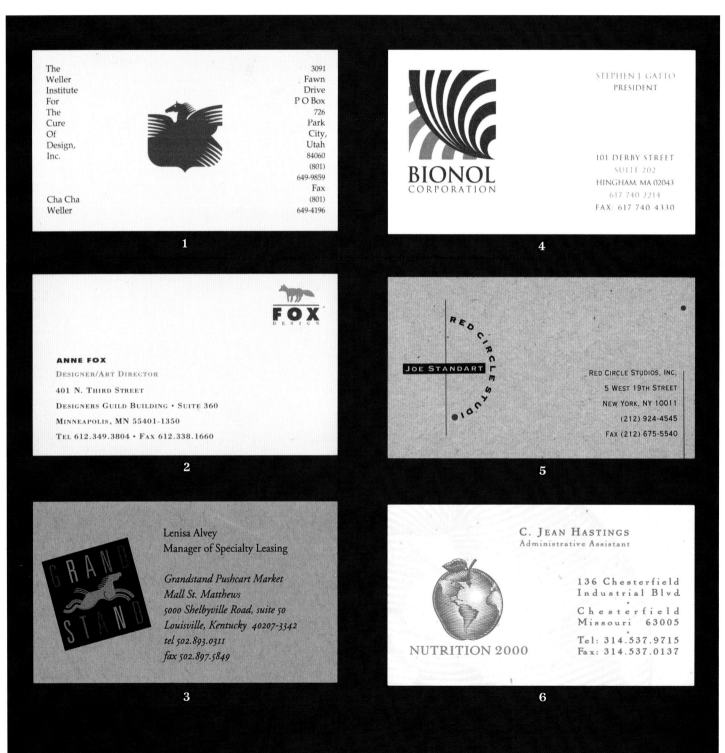

**❶**

**DESIGN FIRM**
THE WELLER
INSTITUTE FOR THE
CURE OF DESIGN,
INC.
**ART DIRECTOR**
DON WELLER
**DESIGNER**
DON WELLER
**ILLUSTRATOR**
DON WELLER
**CLIENT**
TODD WARE
MASSAGE

**❷**

**DESIGN FIRM**
EARL GEE DESIGN
**ART DIRECTOR**
FANI CHUNG
**DESIGNER**
FANI CHUNG
**ILLUSTRATOR**
FANI CHUNG
**CLIENT**
COMMUNITY
PARTNERSHIP OF
SANTA CLARA
COUNTY

**❸**

**DESIGN FIRM**
DICK JONES
**ART DIRECTOR**
DICK JONES
**DESIGNER**
DICK JONES
**ILLUSTRATOR**
DICK JONES
**CLIENT**
CHRISTINE JONES
INTERIORS

**❹**

**DESIGN FIRM**
DELANCEY DESIGN
**ART DIRECTOR**
JANE DELANCEY
**DESIGNER**
JANE DELANCEY
**ILLUSTRATOR**
JANE DELANCEY
**CLIENT**
CREATIVE ARTS
THERAPIES, INC.

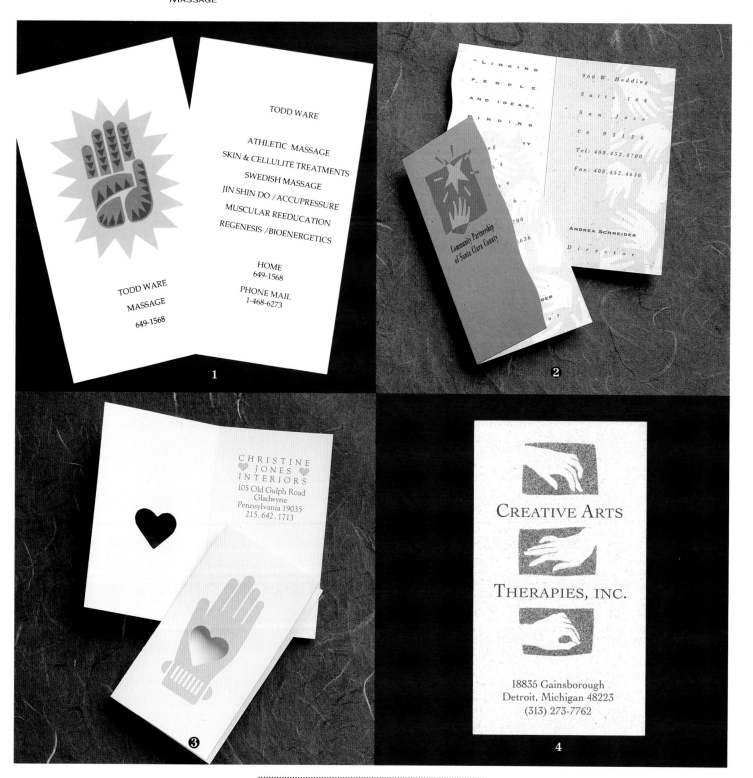

**❶**
**DESIGN FIRM**
BB & K DESIGN
INC.
**ART DIRECTOR**
CATHERINE KIMBALL
**DESIGNER**
CATHERINE KIMBALL
**CLIENT**
BILLY BOB
PRODUCTIONS

**❷**
**DESIGN FIRM**
INDUSTRIA STUDIO
**ART DIRECTOR**
GIBRAN EVANS
**DESIGNER**
GIBRAN EVANS
**ILLUSTRATOR**
GIBRAN EVANS
**CLIENT**
GIBRAN EVANS

**❸**
**DESIGN FIRM**
LJP DESIGN
**ART DIRECTOR**
LORAINE JESSI
PRINCIOTTO
**DESIGNER**
LORAINE JESSI
PRINCIOTTO
**CLIENT**
LJP DESIGN

**❹**
**DESIGN FIRM**
HORNALL ANDERSON
DESIGN WORKS,
INC.
**ART DIRECTOR**
JACK ANDERSON
**DESIGNER**
JACK ANDERSON,
JULIA LAPINE, DAVID
BATES, MARY
HERMES, LIAN NG
**CLIENT**
ACTIVE VOICE

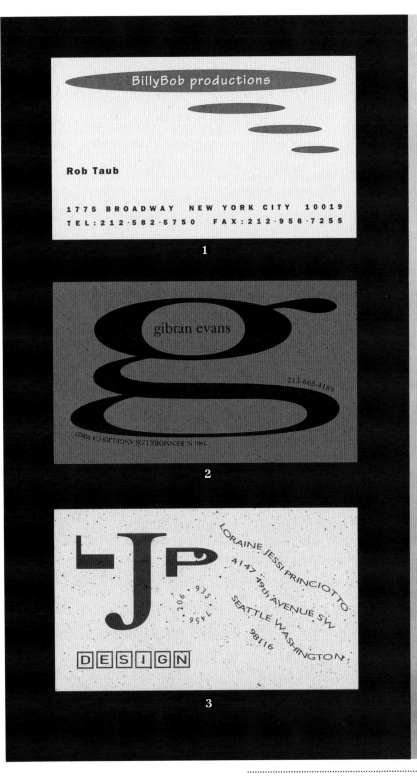

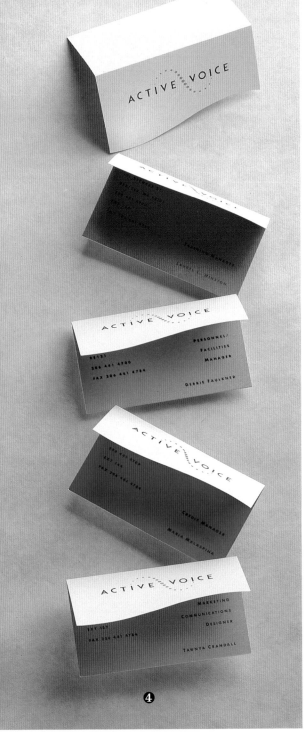

**❶**

**DESIGN FIRM**
PLANET DESIGN CO.
**ART DIRECTOR**
PLANET DESIGN CO.
**DESIGNER**
PLANET DESIGN CO.
**CLIENT**
PLANET DESIGN CO.

**❷**

**DESIGN FIRM**
SIEBERT DESIGN
ASSOCIATES
**ART DIRECTOR**
LORI SIEBERT
**DESIGNER**
LORI SIEBERT,
MICHAEL MCCUSKEY
**CLIENT**
FACILITY SOLUTIONS,
INC.

**❸**

**DESIGN FIRM**
JODIE STOWE
**DESIGNER**
JODIE STOWE
**CLIENT**
PHONE WORKS

**❹**

**DESIGN FIRM**
LJP DESIGN
**ART DIRECTOR**
LORAINE JESSI
PRINCIOTTO
**DESIGNER**
LORAINE JESSI
PRINCIOTTO
**CLIENT**
TYLER BOLEY
PHOTOGRAPHY

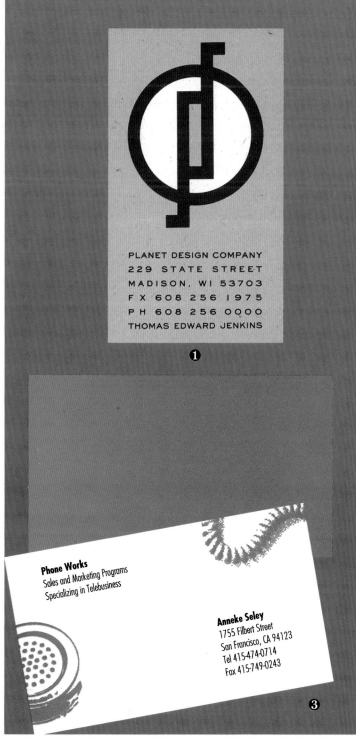

❶

❸

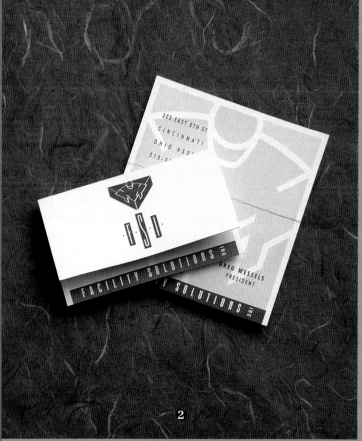

2

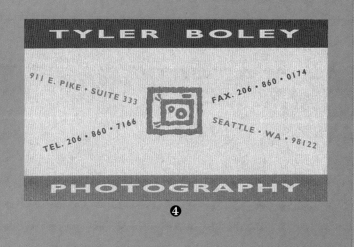

❹

**❶**

**DESIGN FIRM**
CANDY
NORTON/GRAPHIC
DESIGN
**ART DIRECTOR**
CANDY NORTON
**DESIGNER**
CANDY NORTON
**ILLUSTRATOR**
CANDY NORTON
**CLIENT**
MEDICINE HORSE
ARTS

**❷**

**DESIGN FIRM**
HORNALL ANDERSON DESIGN WORKS, INC.
**ART DIRECTOR**
JACK ANDERSON
**DESIGNER**
JACK ANDERSON, BRIAN O'NEILL, LIAN NG
**ILLUSTRATOR**
JOHN FRETZ
**CLIENT**
THE CENTER FOR ORAL AND MAXILLOFACIAL
SURGERY

**❸**

**DESIGN FIRM**
EILTS ANDERSON TRACY
**ART DIRECTOR**
PATRICE EILTS
**DESIGNER**
PATRICE EILTS, TONI O'BRYAN
**ILLUSTRATOR**
MICHAEL WEAVER
**CLIENT**
THEISS DOOLITTLE & ASSOCIATES
AN ARCHITECTURAL & LANDSCAPE
ARCHITECTURAL FIRM

**❹**

**DESIGN FIRM**
LEEANN BROOK
DESIGN
**ART DIRECTOR**
LEEANN BROOK
**ILLUSTRATOR**
LEEANN BROOK
**CLIENT**
LYNDA RICHTER

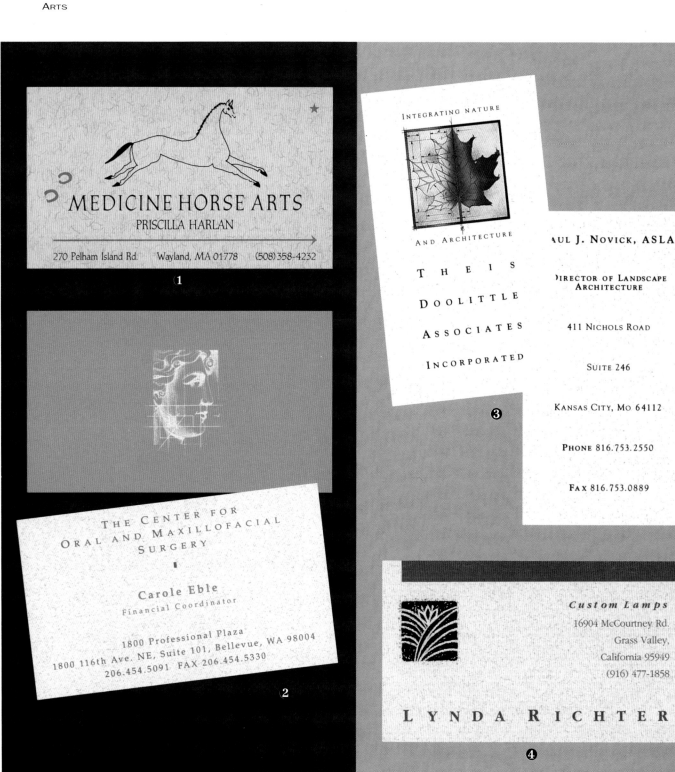

**❶**

**DESIGN FIRM**
ECLIPSE DESIGN
GROUP
**ART DIRECTOR**
CYNTHIA WIDMER
**DESIGNER**
CYNTHIA WIDMER
**CLIENT**
ECLIPSE DESIGN
GROUP

**❷**

**DESIGN FIRM**
MARKETING BY
DESIGN
**ART DIRECTOR**
DELLA GILLERAN
**DESIGNER**
JOEL STINGHEN
**CLIENT**
WENELL MATTHEIS
BOWE

**❸**

**DESIGN FIRM**
CLIFFORD SELBERT
DESIGN
**ART DIRECTOR**
MELANIE LOWE
**DESIGNER**
MELANIE LOWE
**CLIENT**
SUSIE CUSHNER
PHOTOGRAPHY

**❹**

**DESIGN FIRM**
HIXSON DESIGN
**DESIGNER**
GARY HIXSON
**CLIENT**
SHOOK DESIGN
GROUP, INC.

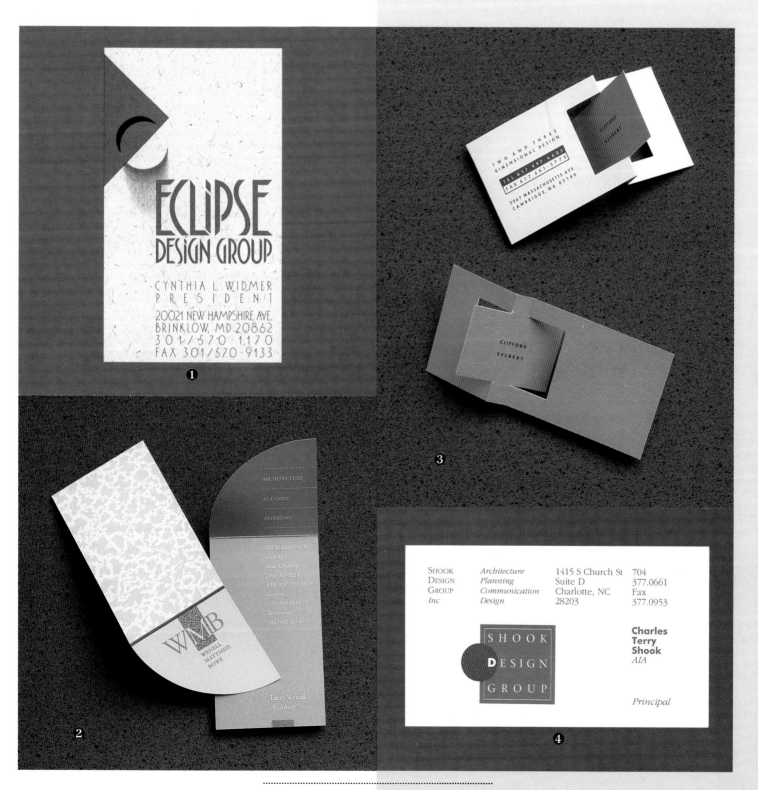

**❶**

**DESIGN FIRM**
DEAN JOHNSON
DESIGN
**ART DIRECTOR**
SCOTT JOHNSON
**DESIGNER**
SCOTT JOHNSON
**ILLUSTRATOR**
SCOTT JOHNSON
**CLIENT**
MARKET SQUARE
ARENA

**❷**

**DESIGN FIRM**
PLATINUM DESIGN
**ART DIRECTOR**
VICTORIA PESLAK
**DESIGNER**
SANDY QUINN,
KATHLEEN PHELPS
**CLIENT**
ARTE' SALON

**❸**

**DESIGN FIRM**
DEAN JOHNSON
DESIGN
**ART DIRECTOR**
SCOTT JOHNSON
**DESIGNER**
SCOTT JOHNSON
**ILLUSTRATOR**
SCOTT JOHNSON
**CLIENT**
CENTRAL INDIANA
POWER

**❹**

**DESIGN FIRM**
DEAN JOHNSON
DESIGN
**ART DIRECTOR**
SCOTT JOHNSON
**DESIGNER**
SCOTT JOHNSON
**ILLUSTRATOR**
SCOTT JOHNSON
**CLIENT**
WORLD ROWING
CHAMPIONS

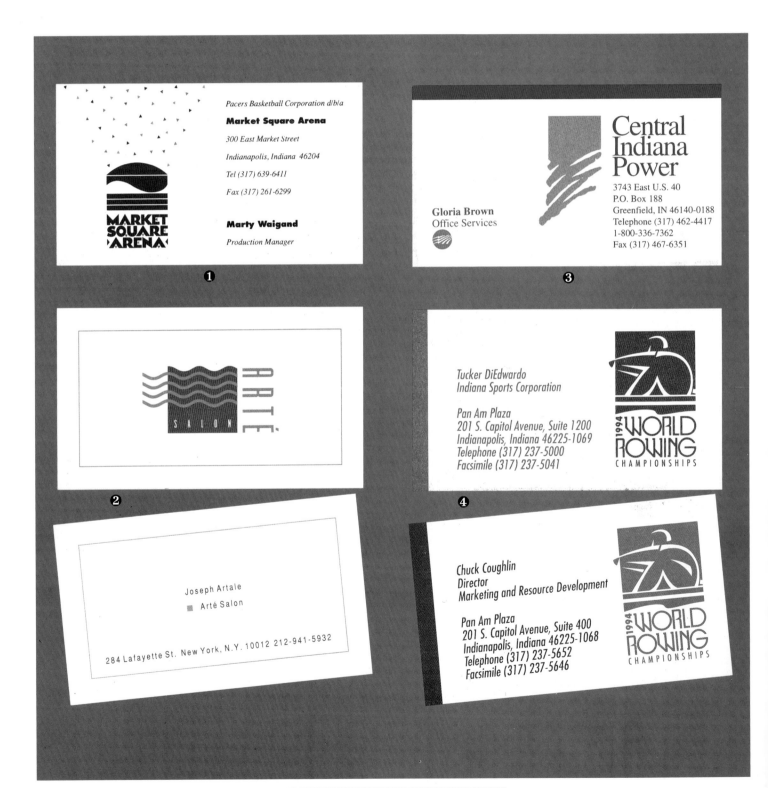

❶

Pacers Basketball Corporation d/b/a
**Market Square Arena**
300 East Market Street
Indianapolis, Indiana 46204
Tel (317) 639-6411
Fax (317) 261-6299

**Marty Waigand**
Production Manager

❸

Gloria Brown
Office Services

Central
Indiana
Power
3743 East U.S. 40
P.O. Box 188
Greenfield, IN 46140-0188
Telephone (317) 462-4417
1-800-336-7362
Fax (317) 467-6351

❷

Joseph Artale
Arté Salon

284 Lafayette St. New York, N.Y. 10012 212-941-5932

❹

Tucker DiEdwardo
Indiana Sports Corporation

Pan Am Plaza
201 S. Capitol Avenue, Suite 1200
Indianapolis, Indiana 46225-1069
Telephone (317) 237-5000
Facsimile (317) 237-5041

1994 WORLD ROWING CHAMPIONSHIPS

Chuck Coughlin
Director
Marketing and Resource Development

Pan Am Plaza
201 S. Capitol Avenue, Suite 400
Indianapolis, Indiana 46225-1068
Telephone (317) 237-5652
Facsimile (317) 237-5646

1994 WORLD ROWING CHAMPIONSHIPS

**❶**

**DESIGN FIRM**
TANGRAM STRATEGIC
DESIGN
**ART DIRECTOR**
ENRICO SEMPI
**DESIGNER**
ANTONELLA TREVISAN
**CLIENT**
ARKSTUDIOASSOCIATI

**❷**

**DESIGN FIRM**
ROBERT BAILEY
INCORPORATED
**ART DIRECTOR**
ROBERT BAILEY
**DESIGNER**
JOHN WILLIAMS
**CLIENT**
CMSI
INCORPORATED

**❸**

**DESIGN FIRM**
TANGRAM STRATEGIC
DESIGN
**ART DIRECTOR**
ENRICO SEMPI
**DESIGNER**
ENRICO SEMPI,
ROBERTO BEGOZZI
**CLIENT**
COMPACT

**❹**

**DESIGN FIRM**
Q4L MARKETING
**DESIGNER**
JACK KAUFFMAN
**ILLUSTRATOR**
JACK KAUFFMAN
**CLIENT**
Q4L MARKETING

**❺**

**DESIGN FIRM**
MEDIAWERKS
**ART DIRECTOR**
RICH HULTMAN
**DESIGNER**
RICH HULTMAN
**CLIENT**
SANFILIPPO
FURNITURE &
DESIGN

**Arkstudioassociati**

**Alberto Sempi**
architetto

Corso Cavour 17, 28100 Novara, Italia
0321 36368
Partita IVA 00616490033

1

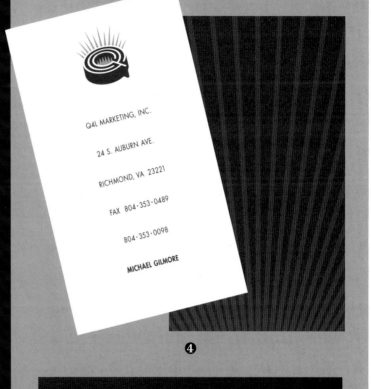

Q4L MARKETING, INC.

24 S. AUBURN AVE.

RICHMOND, VA 23221

FAX 804·353·0489

804·353·0098

**MICHAEL GILMORE**

❹

**CMSI**
INCORPORATED

**Michael S. Wall**
Senior Executive Vice President

0234 SW Bancroft
Portland, Oregon 97201
503.227.0600
Fax 503.222.5238

2

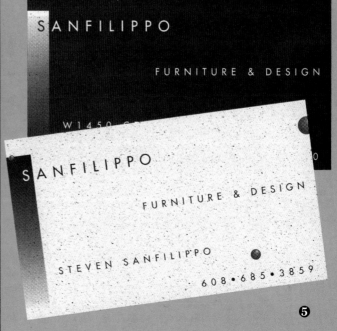

SANFILIPPO

FURNITURE & DESIGN

W1450

SANFILIPPO

FURNITURE & DESIGN

STEVEN SANFILIPPO

608·685·3859

❺

Zenjiro F. Miyakawa

**COMPACT**

Compact s.r.l.
Corso Galileo Ferraris 71
10128 Torino, Italia
Tel. 011 597096/589585
Fax 011 595516

3

❶
**DESIGN FIRM**
SCHOWALTER² DESIGN
**ART DIRECTOR**
TONI SCHOWALTER
**DESIGNER**
TONI SCHOWALTER, ILENE PRICE
**ILLUSTRATOR**
TONI SCHOWALTER, ILENE PRICE
**CLIENT**
DINING SMART, INC.

❷
**DESIGN FIRM**
MICHAEL STANARD, INC.
**ART DIRECTOR**
MICHAEL STANARD
**DESIGNER**
ANN WERNER
**CLIENT**
SWEEPING CHANGES, INC., BROOM MANUFACTURERS

❸
**DESIGN FIRM**
PETER HOLLINGSWORTH & ASSOCIATES
**DESIGNER**
PETER HOLLINGSWORTH
**CLIENT**
PETER HOLLINGSWORTH & ASSOCIATES

❹
**DESIGN FIRM**
EYMONT KIN-YEE HULETT
**ART DIRECTOR**
ALISON HULETT
**DESIGNER**
ALISON HULETT
**ILLUSTRATOR**
ALISON HULETT
**CLIENT**
COMPASS ADVERTISING

❺
**DESIGN FIRM**
EYMONT KIN-YEE HULETT PTY. LTD.
**ART DIRECTOR**
A. EYMONT
**DESIGNER**
SHARON PEARSON
**ILLUSTRATOR**
SHARON PEARSON
**CLIENT**
EYMONT KIN-YEE HULETT

❻
**DESIGN FIRM**
GLENN MARTINEZ & ASSOCIATES
**ART DIRECTOR**
KATHLEEN NELSON
**DESIGNER**
GLENN MARTINEZ
**CLIENT**
DATA FLOW COMPUTER RESOURCE MANAGEMENT

DINING SMART

150 East 73rd Street

New York, NY 10021

212.988.3098

❶

BRUCE N. CORSON

**SWEEPING CHANGES, INC.**
990 WEST FULLERTON, SUITE 180
CHICAGO, ILLINOIS 60614

312-975-6691

❷

PHONE  919 773 0201
FAX    919 773 0223

STEVE WAMMACK

DESIGN COMMUNICATIONS
233 W 5TH ST. WINSTON-SALEM, NC 27101 2825

❸

ANNABELLE JAMES
DIRECTOR

COMPASS ADVERTISING PTY LTD
79 PITT STREET, REDFERN,
NSW 2016, AUSTRALIA
TEL: (02) 319 5034
FAX: (02) 319 4596

❹

EYMONT
KINYEE
HULETT

Eymont Kin-Yee Hulett Pty Ltd
8 Soudan Lane, Paddington
NSW 2021, Australia
Telephone: (02) 361 5323
Facsimile: (02) 361 6103

❺

Janet Arend

DataFlow

Computer
Resource
Management , Inc.
435 E Street at 7th
Santa Rosa, CA 95404

707.575.9709
800.245.8463
FAX 707.575.7853

❻

❶
**DESIGN FIRM**
ALTERNATIVES
**ART DIRECTOR**
MARK KOCH
**DESIGNER**
KEVIN YATES
**CLIENT**
LEDAN, INC.

❷
**DESIGN FIRM**
MO VIELE, INC.
**ART DIRECTOR**
MO VIELE
**DESIGNER**
MO VIELE
**CLIENT**
SUPERCOMPUTING
'93

❸
**DESIGN FIRM**
COMMUNICATION
ARTS INCORPORATED
**ART DIRECTOR**
RICHARD FOY
**DESIGNER**
MARK TWEED, DAVID
TWEED
**CLIENT**
CITY OF BOULDER,
BOULDER, CO

❹
**DESIGN FIRM**
PETER
HOLLINGSWORTH &
ASSOCIATES
**DESIGNER**
PETER
HOLLINGSWORTH
**CLIENT**
BLUE BIRD CABS

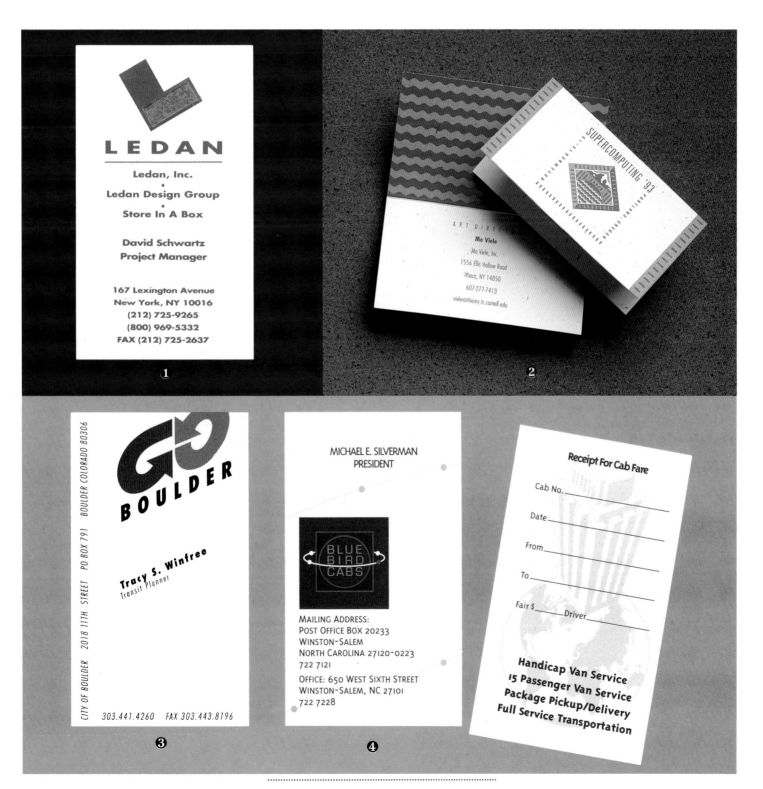

**❶**
**DESIGN FIRM**
DESIGN SEVEN
**DESIGNER**
BILL CALDER,
DEBBIE MCKINNEY
**CLIENT**
COMMUNICATION
STRATEGIES

**❷**
**DESIGN FIRM**
E. CHRISTOPHER
KLUMB ASSOCIATES,
INC.
**ART DIRECTOR**
CHRISTOPHER KLUMB
**DESIGNER**
CHRISTOPHER KLUMB
**CLIENT**
STADIA GROUP

**❸**
**DESIGN FIRM**
MARK PALMER
DESIGN
**ART DIRECTOR**
MARK PALMER
**DESIGNER**
MARK PALMER
**PRODUCTION**
CURTIS PALMER,
THERESA SPENCER
**CLIENT**
CH SALES

**❹**
**DESIGN FIRM**
CHEE WANG NG
**ART DIRECTOR**
CHEE WANG NG
**DESIGNER**
CHEE WANG NG
**CLIENT**
WONG & PAU,
C.P.A.s

**❺**
**DESIGN FIRM**
DESIGN SEVEN
**DESIGNER**
BILL CALDER,
DEBBIE MCKINNEY
**CLIENT**
DESIGN SEVEN

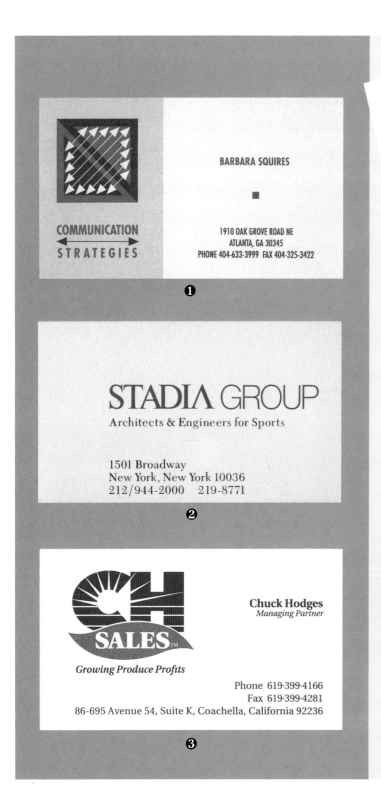

**❶**
**DESIGN FIRM**
HARTMANN &
MEHLER DESIGNERS
GMBH
**ART DIRECTOR**
ROLAND MEHLER
**DESIGNER**
ROLAND MEHLER
ILLUSTRATOR
ROLAND MEHLER
**CLIENT**
STEIGENBERGER
CONSULTING

**❷**
**DESIGN FIRM**
JODIE STOWE
**DESIGNER**
JODIE STOWE
**CLIENT**
BAY AREA OUTREACH
& RECREATION
PROGRAM (BORP)

**❸**
**DESIGN FIRM**
DEBORAH ZEMKE
ILLUSTRATION
**DESIGNER**
DEBORAH ZEMKE
**ILLUSTRATOR**
DEBORAH ZEMKE
**CLIENT**
SILBERBERG
ARCHITECTS

**❹**
**DESIGN FIRM**
RICK EIBER DESIGN
**ART DIRECTOR**
RICK EIBER
**DESIGNER**
RICK EIBER
**CLIENT**
HOYT'S GREATER
RADIO COMMUNITY

**❶**
**DESIGN FIRM**
STUDIO M D
**ART DIRECTOR**
JESSE DOQUILO,
RANDY LIM,
GLENN MITSUI
**DESIGNER**
GLENN MITSUI
**ILLUSTRATOR**
JESSE DOQUILO
**CLIENT**
STUDIO M D

**❷**
**DESIGN FIRM**
DEAN JOHNSON
DESIGN
**ART DIRECTOR**
BRUCE DEAN
**DESIGNER**
BRUCE DEAN
**ILLUSTRATOR**
BRUCE DEAN
**CLIENT**
CREATIVE
LEADERSHIP GROUP,
INC.

**❸**
**DESIGN FIRM**
MCMONIGLE &
SPOONER
**DESIGNER**
STAN SPOONER
**ILLUSTRATOR**
STAN SPOONER
**CLIENT**
MCMONIGLE &
SPOONER

**❹**
**DESIGN FIRM**
DESIGN GROUP
COOK
**ART DIRECTOR**
KEN COOK
**DESIGNER**
KEN COOK
**CLIENT**
RUTH TAUBMAN
JEWELRY DESIGNER

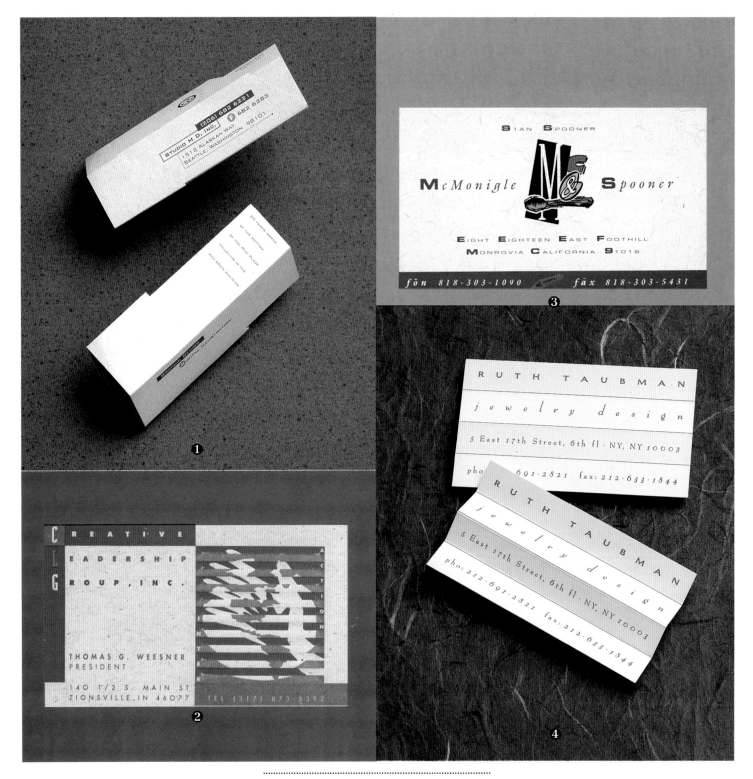

| ❶ | ❷ | ❸ | ❹ | ❺ | ❻ |
|---|---|---|---|---|---|
| **DESIGN FIRM** | **DESIGN FIRM** | **DESIGN FIRM** | **DESIGN FIRM** | **DESIGN FIRM** | **DESIGN FIRM** |
| PITTARD SULLIVAN FITZGERALD | ADELE BASS & CO. DESIGN | DORNSIFE & ASSOCIATES | MICHAEL STANARD, INC. | COMMUNICATION ARTS INCORPORATED | DESIGN RESOURCES |
| **ART DIRECTOR** | **ART DIRECTOR** | **ART DIRECTOR** | **ART DIRECTOR** | **ART DIRECTOR** | **ART DIRECTOR** |
| WILLIAM PITTARD | ADELE BASS | CAROL ANNE CRAFT | MICHAEL STANARD | DAVID A. SHELTON | MICHELLE KIMBALL |
| **DESIGNER** | **DESIGNER** | **DESIGNER** | **DESIGNER** | **DESIGNER** | **DESIGNER** |
| BILL DAWSON | ADELE BASS | CAROL ANNE CRAFT | LYLE ZIMMERMAN | LYNN WILLIAMS | MICHELLE KIMBALL |
| **CLIENT** | **ILLUSTRATOR** | **CLIENT** | **CLIENT** | **CLIENT** | **ILLUSTRATOR** |
| PITTARD SULLIVAN FITZGERALD | ADELE BASS | DORNSIFE & ASSOCIATES | ULDIS SAULE PHOTOGRAPHY | RICHARD PETERSON | MICHELLE KIMBALL |
| | **CLIENT** | | | | **CLIENT** |
| | L'ATELIER | | | | INTERACTIVE AUDIO |

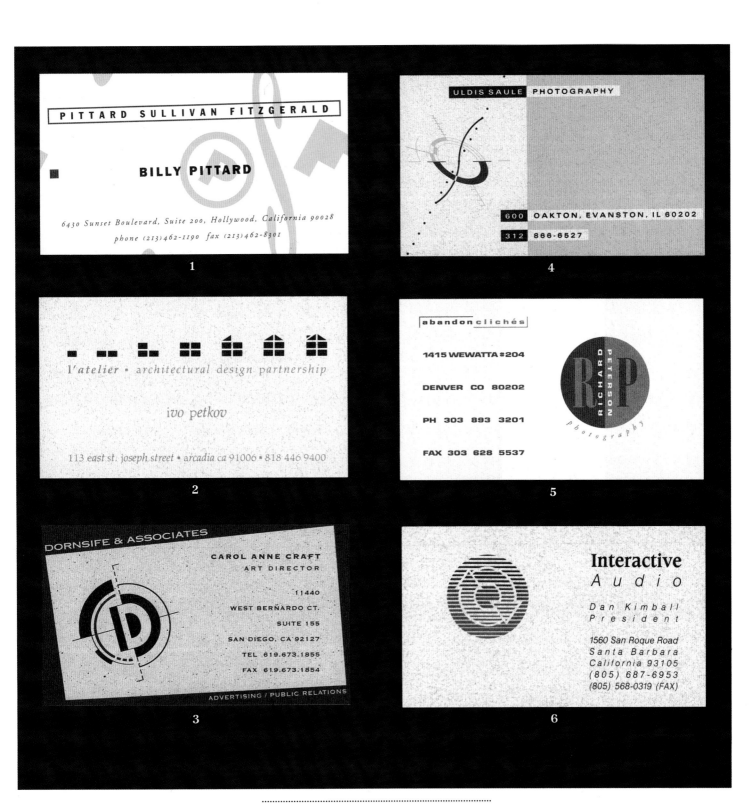

❶

**DESIGN FIRM**
MARSH, INC.
**ART DIRECTOR**
GREG CONYERS
**DESIGNER**
GREG CONYERS
**CLIENT**
CINCINNATI ART
MUSEUM

❷

**DESIGN FIRM**
ORTEGA DESIGN
**ART DIRECTOR**
SUSANN ORTEGA
**DESIGNER**
SUSANN ORTEGA
**CLIENT**
SIMI WINERY

❸

**DESIGN FIRM**
DEAN JOHNSON
DESIGN
**ART DIRECTOR**
SCOTT JOHNSON
**DESIGNER**
SCOTT JOHNSON
**ILLUSTRATOR**
SCOTT JOHNSON
**CLIENT**
V.P. CONSTRUCTION
CO., INC.

❹

**DESIGN FIRM**
MARC ENGLISH:
DESIGN
**DESIGNER**
MARC ENGLISH
**CLIENT**
DAVID BLOMQUIST
PHOTOGRAPHY

❺

**DESIGN FIRM**
MERVIL PAYLOR
DESIGN
**DESIGNER**
MERVIL M. PAYLOR
**CLIENT**
STOUT BECK &
ASSOCIATES

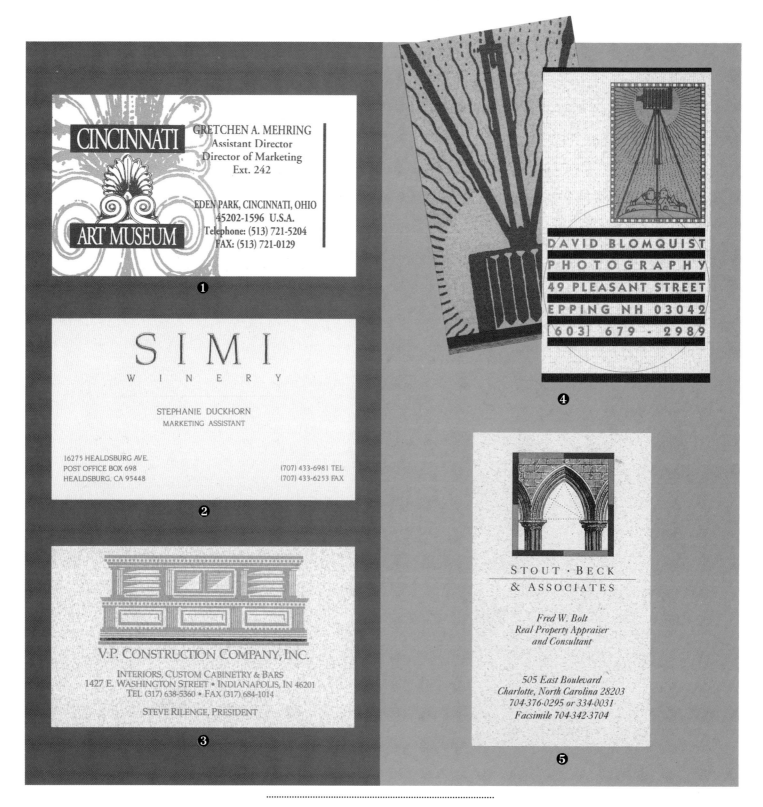

**❶**

**DESIGN FIRM**
GREGORY SMITH
DESIGN
**ART DIRECTOR**
GREGORY L. SMITH
**DESIGNER**
GREGORY L. SMITH
**ILLUSTRATOR**
NORRIS PETERSON
**CLIENT**
NORRIS PETERSON
ILLUSTRATION

**❷**

**DESIGN FIRM**
SPIRIT RIVER DESIGN
**ART DIRECTOR**
STEVEN PIKALA
**DESIGNER**
STEVEN PIKALA
**ILLUSTRATOR**
STEVEN PIKALA
**CLIENT**
PAINTER'S CREEK
STABLES

**❸**

**DESIGN FIRM**
QUALLY & COMPANY
INC.
**ART DIRECTOR**
ROBERT QUALLY
**DESIGNER**
ROBERT QUALLY
**CLIENT**
URBAN AMERICAN
CLUB

**❹**

**DESIGN FIRM**
SAYLES GRAPHIC
DESIGN
**ART DIRECTOR**
JOHN SAYLES
**DESIGNER**
JOHN SAYLES
**ILLUSTRATOR**
JOHN SAYLES
**CLIENT**
THE IOWA GROUP

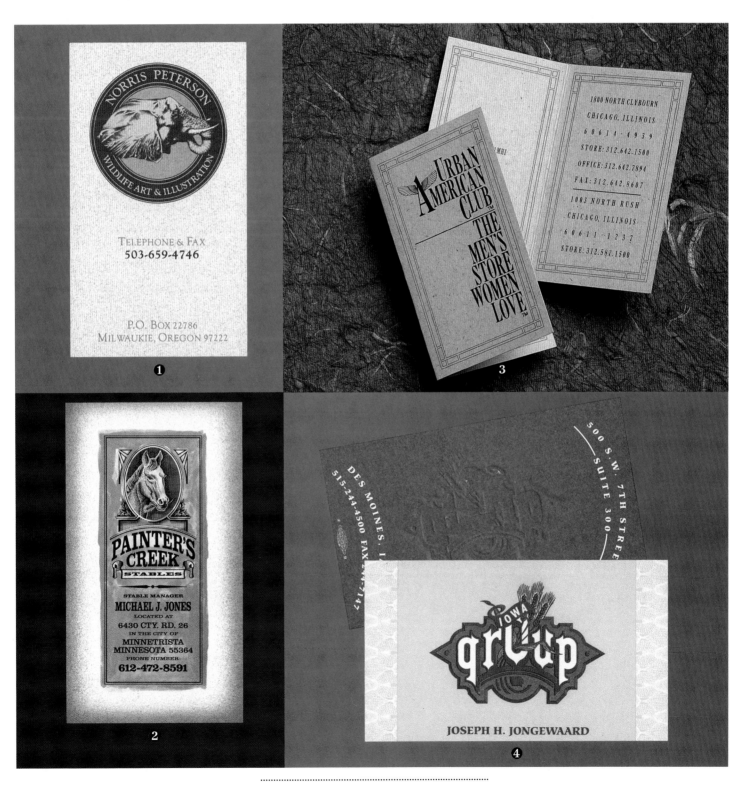

❶
**DESIGN FIRM**
SUE SPRINKLE
**ART DIRECTOR**
SUE SPRINKLE
**DESIGNER**
SUE SPRINKLE
**CLIENT**
PICTURESQUE

❷
**DESIGN FIRM**
KIRBAN TYPE &
DESIGN, INC.
**ART DIRECTOR**
EILEEN KIRBAN
**DESIGNER**
EILEEN KIRBAN
**CLIENT**
BARISH INTERIORS

❸
**DESIGN FIRM**
VICTOR CHEONG
DESIGN &
ASSOCIATES
**ART DIRECTOR**
VICTOR CHEONG
**DESIGNER**
VICTOR CHEONG
**CLIENT**
PARIS TREND LTD.

❹
**DESIGN FIRM**
DESIGN FARM INC.
**ART DIRECTOR**
SUSAN SYLVESTER
**DESIGNER**
SUSAN SYLVESTER
**ILLUSTRATOR**
SUSAN SYLVESTER
**CLIENT**
JUDY LEE

❺
**DESIGN FIRM**
COLONNA FARRELL
DESIGN
**ART DIRECTOR**
TONY AUSTON
**DESIGNER**
TONY AUSTON
**CLIENT**
VALLEY ARCHITECTS

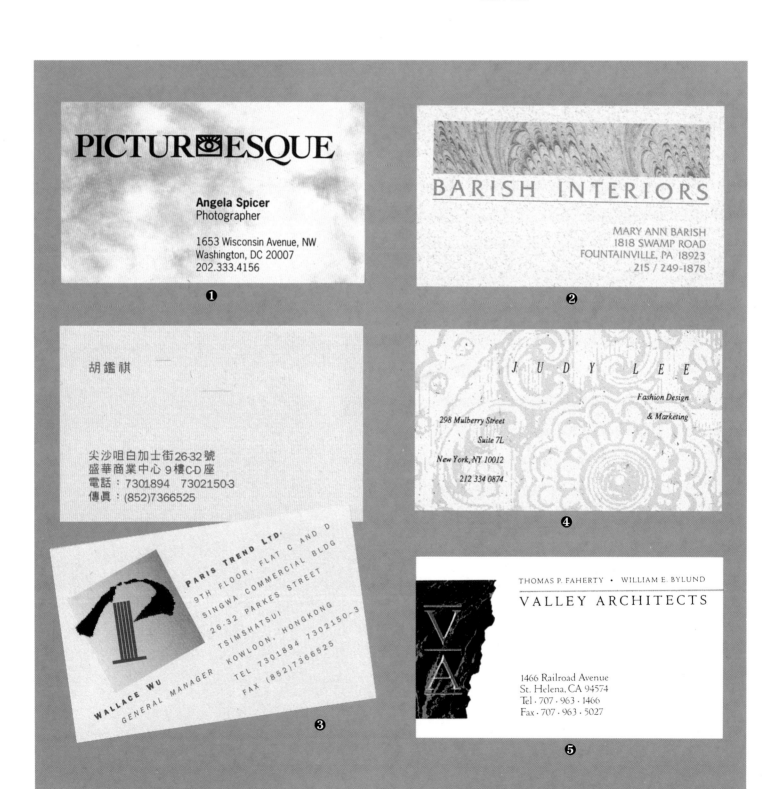

**❶**
**DESIGN FIRM**
BARRY POWER
GRAPHIC DESIGN
**ART DIRECTOR**
BARRY POWER
**DESIGNER**
BARRY POWER
**CLIENT**
JULIAN FAULKNER

**❷**
**DESIGN FIRM**
BESHARA
ASSOCIATES, INC.
**ART DIRECTOR**
STEVE BESHARA
**DESIGNER**
STEVE BESHARA
**ILLUSTRATOR**
STEVE BESHARA
**CLIENT**
FRENCH BRAY, INC.

**❸**
**DESIGN FIRM**
RICKABAUGH
GRAPHICS
**ART DIRECTOR**
ERIC RICKABAUGH
**DESIGNER**
ERIC RICKABAUGH
**CLIENT**
THE BECKETT
PAPER CO.

**❹**
**DESIGN FIRM**
NEW IDEA DESIGN
INC.
**DESIGNER**
RON BOLDT
**CLIENT**
PATRICK GOODIN
INTERIOR FINISHES

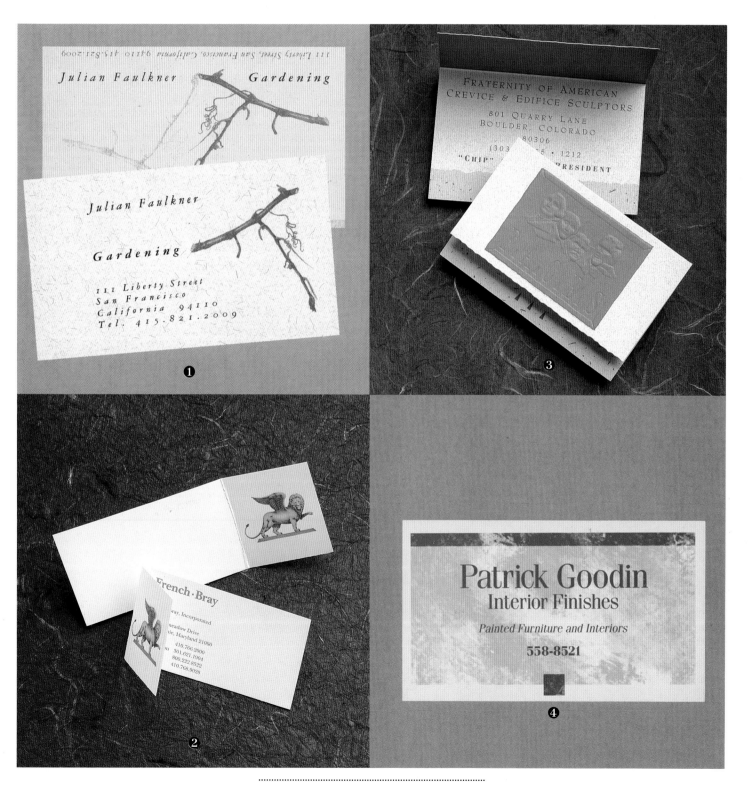

**❶**

**DESIGN FIRM**
WYCLIFFE SMITH
DESIGN/TORONTO
**ART DIRECTOR**
CLAUDIA NERI
**DESIGNER**
CLAUDIA NERI
**CLIENT**
JANET ROSENBERG &
ASSOCIATES

**❷**

**DESIGN FIRM**
TAMAR LOURIE
**ART DIRECTOR**
TAMAR LOURIE
**DESIGNER**
TAMAR LOURIE
**ILLUSTRATOR**
PORIT RABINOVITCH
**CLIENT**
DORITART
ILLUSTRATION

**❸**

**DESIGN FIRM**
DOGFISH DESIGN
**ART DIRECTOR**
KOREY PETERSON
**DESIGNER**
KOREY PETERSON
**ILLUSTRATOR**
KOREY PETERSON
**CLIENT**
SUSAN PETERSON

**❹**

**DESIGN FIRM**
SCHOWALTER$^2$
DESIGN
**ART DIRECTOR**
TONI SCHOWALTER
**CLIENT**
CARLISLE
RESTAURANT
ASSOCIATES

**❺**

**DESIGN FIRM**
SHAHASP HERARDIAN
DESIGN
**DESIGNER**
SHAHASP HERARDIAN
**CLIENT**
DEANA DARBY

**❻**

**DESIGN FIRM**
KIRBAN TYPE &
DESIGN, INC.
**ART DIRECTOR**
EILEEN KIRBAN
**DESIGNER**
EILEEN KIRBAN
**CLIENT**
KIRBAN TYPE &
DESIGN, INC.

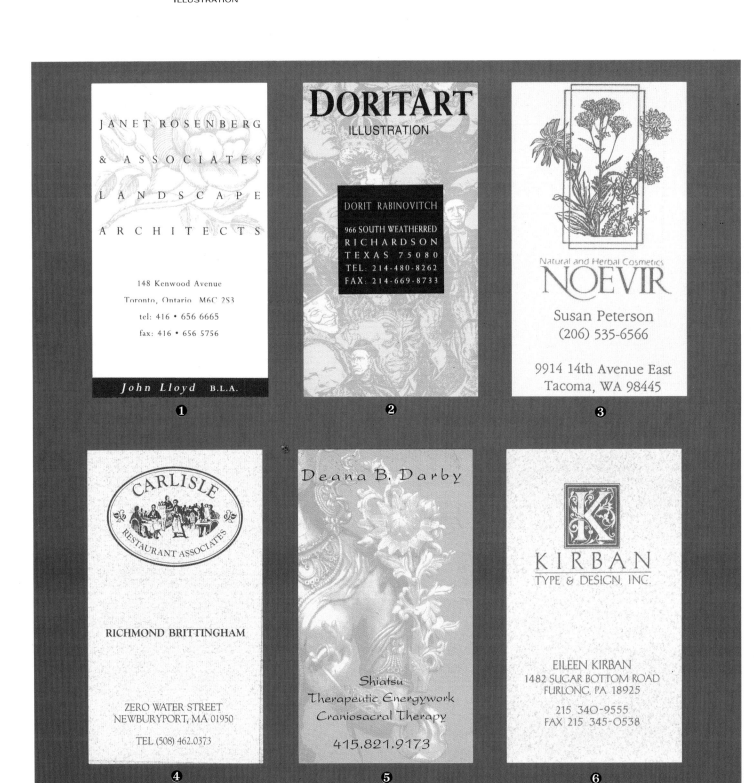

**❶**
**DESIGN FIRM**
HORNALL ANDERSON DESIGN WORKS, INC.
**ART DIRECTOR**
JACK ANDERSON, JULIA LAPINE
**DESIGNER**
JULIA LAPINE, DENISE WEIR
**ILLUSTRATOR**
JULIA LAPINE
**CLIENT**
EAGLE LAKE ON ORCAS ISLAND

**❷**
**DESIGN FIRM**
ASCENT
COMMUNICATIONS
**ART DIRECTOR**
ALLEN HAEGER
**DESIGNER**
ALLEN HAEGER
**CLIENT**
YELLOWSTONE
STOCK

**❸**
**DESIGN FIRM**
HORNALL ANDERSON DESIGN WORKS, INC.
**ART DIRECTOR**
JACK ANDERSON
**DESIGNER**
CLIFF CHUNG, DAVID BATES, LEO
RAYMUNDO,
DENISE WEIR, JACK ANDERSON
**ILLUSTRATOR**
GEORGE TANAGI (LETTERER)
**CLIENT**
MISSION RIDGE

**❹**
**DESIGN FIRM**
LORNA STOVALL
DESIGN
**ART DIRECTOR**
LORNA STOVALL
**DESIGNER**
LORNA STOVALL
**ILLUSTRATOR**
LORNA STOVALL
**CLIENT**
LORNA STOVALL
DESIGN

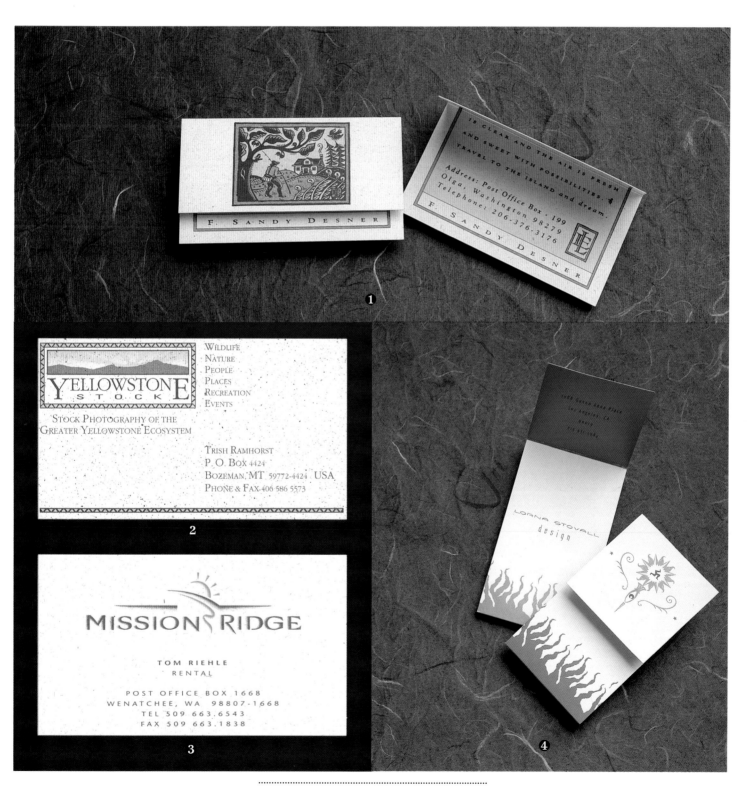

| ❶ | ❷ | ❸ | ❹ | ❺ | ❻ |
|---|---|---|---|---|---|
| **DESIGN FIRM** | **DESIGN FIRM** | **DESIGN FIRM** | **DESIGN FIRM** | **DESIGN FIRM** | **DESIGN FIRM** |
| PEDERSEN GESK | WELSH DESIGN | BALDINO DESIGN | ROBERT BAILEY | McGUIRE | LEEANN BROOK |
| **DESIGNER** | **ART DIRECTOR** | **ART DIRECTOR** | INCORPORATED | ASSOCIATES | DESIGN |
| MITCHELL LINDGREN | ANNE MARIE WELSH | PATT BALDINO | **ART DIRECTOR** | **ART DIRECTOR** | **ART DIRECTOR** |
| **CLIENT** | **DESIGNER** | **DESIGNER** | ROBERT BAILEY | JULIE GLEASON | LEEANN BROOK |
| WINDEMERE STUDIOS | JENNIFER DELANO | MARYANNE | **DESIGNER** | **DESIGNER** | **CLIENT** |
| | **CLIENT** | KACZMARKIEWICZ | MICHAEL | JULIE GLEASON | THE CEDARS |
| | KAY ASSOCIATES | **CLIENT** | LANCASHIRE | **CLIENT** | |
| | | RIVIERA PASTRY AND | **ILLUSTRATOR** | PHD | |
| | | MORE | CAROLYN COGHLAN | WALLCOVERINGS | |
| | | | **CLIENT** | | |
| | | | GROCERS INSURANCE | | |
| | | | GROUP | | |

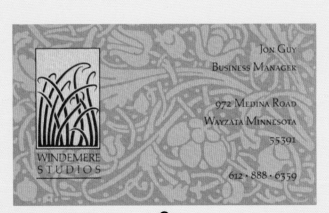

❶

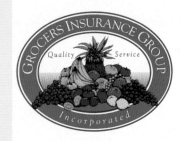

❹

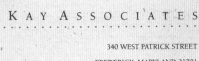

❷

❺

❸

❻

**❶**

**DESIGN FIRM**
TYLER BLIK DESIGN
**ART DIRECTOR**
TYLER BLIK
**DESIGNER**
RON FLEMING
**CLIENT**
CHRIS LINBACK
PHOTOGRAPHY

**❷**

**DESIGN FIRM**
MOSCATO
COMMUNICATIONS
**ART DIRECTOR**
GERALD MOSCATO
**DESIGNER**
GERALD MOSCATO
**ILLUSTRATOR**
GERALD MOSCATO
**CLIENT**
GERALD MOSCATO

**❸**

**DESIGN FIRM**
LESLIE KANE
**DESIGNER**
LESLIE KANE
**CLIENT**
LESLIE KANE

**❹**

**DESIGN FIRM**
MATISSE DESIGN
STUDIO
**ART DIRECTOR**
KENNY CHANG
**DESIGNER**
KENNY CHANG
**ILLUSTRATOR**
KENNY CHANG
**CLIENT**
ART & ARC.
INTERNATIONAL BOOK
CO. LTD.

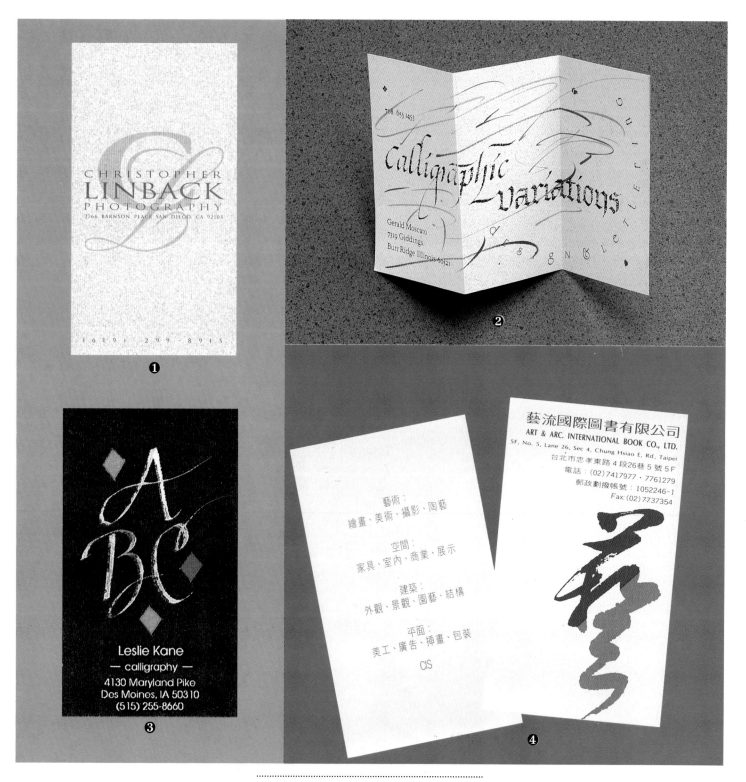

**❶**

**❷**

**❸**

**❹**

❶

**DESIGN FIRM**
MAMMOLITI CHAN DESIGN
**ART DIRECTOR**
TONY MAMMOLITI
**DESIGNER**
CHWEE KUAN CHAN
**ILLUSTRATOR**
SEBASTIAN GIACCOTTO, CHWEE KUAN CHAN
**CLIENT**
ESSENTIALLY SKIN BEAUTY CLINIC

❷

**DESIGN FIRM**
HOLDEN & COMPANY
**ART DIRECTOR**
CATHE HOLDEN
**DESIGNER**
CATHE HOLDEN
**ILLUSTRATOR**
CATHE HOLDEN
**CLIENT**
JENNIFER FARQUHAR

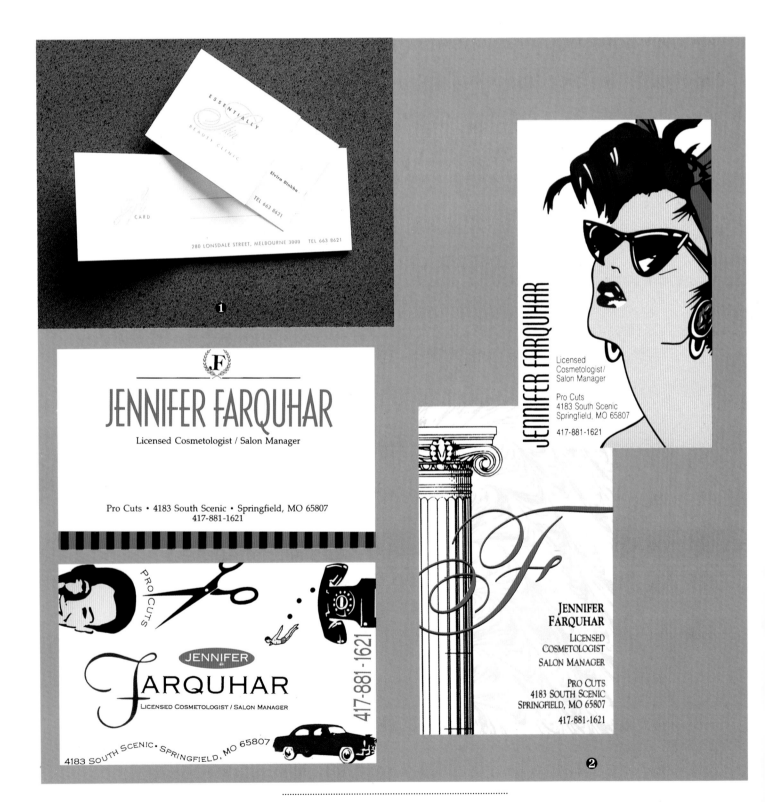

❶
**DESIGN FIRM**
FRANK BASEMAN
GRAPHIC DESIGN
**ART DIRECTOR**
FRANK BASEMAN
**DESIGNER**
FRANK BASEMAN
**PHOTOGRAPHER**
FRANK BASEMAN
**CLIENT**
JEFF COX POTTERY

❷
**DESIGN FIRM**
JRDC
**ART DIRECTOR**
JUDI RADICE
**DESIGNER**
LANCE ANDERSON
**ILLUSTRATOR**
FROM ANCIENT
FRENCH DICTIONARY
**CLIENT**
JRDC

❸
**DESIGN FIRM**
SIEBERT DESIGN
ASSOCIATES
**ART DIRECTOR**
LORI SIEBERT
**DESIGNER**
LORI SIEBERT, DAVID
CARROLL
**ILLUSTRATOR**
DAVID CARROLL
**CLIENT**
MUSICAL ARTS
CENTER

❹
**DESIGN FIRM**
THE PUSHPIN GROUP
**ART DIRECTOR**
GREG SIMPSON
**DESIGNER**
GREG SIMPSON
**CLIENT**
CRAIG CUTLER
PHOTOGRAPHY

❶

❷

❸

❹

**❶**

**DESIGN FIRM**
THE WOLDRING
COMPANY
**ART DIRECTOR**
LISA POOLE
WOLDRING
**DESIGNER**
LISA POOLE
WOLDRING
**CLIENT**
THE WOLDRING
COMPANY

**❷**

**DESIGN FIRM**
GLENN MARTINEZ &
ASSOCIATES
**ART DIRECTOR**
KATHLEEN NELSON
**DESIGNER**
GLENN MARTINEZ
**CLIENT**
WOOD PONTIAC
CADILLAC

**❸**

**DESIGN FIRM**
PEDERSEN GESK
**DESIGNER**
MITCHELL LINDGREN
**CLIENT**
29 POINT 5

**❹**

**DESIGN FIRM**
DEAN JOHNSON
DESIGN
**ART DIRECTOR**
LLOYD BROOKS
**DESIGNER**
LLOYD BROOKS
**ILLUSTRATOR**
LLOYD BROOKS
**CLIENT**
MIKE HARLAN

**❺**

**DESIGN FIRM**
SCHOWALTER[2]
DESIGN
**ART DIRECTOR**
TONI SCHOWALTER
**DESIGNER**
TONI SCHOWALTER
**CLIENT**
TONI SCHOWALTER

**❻**

**DESIGN FIRM**
JASON LOSSER
**ART DIRECTOR**
JASON LOSSER
**DESIGNER**
JASON LOSSER
**ILLUSTRATOR**
JASON LOSSER
**CLIENT**
TKJ CONSTRUCTION

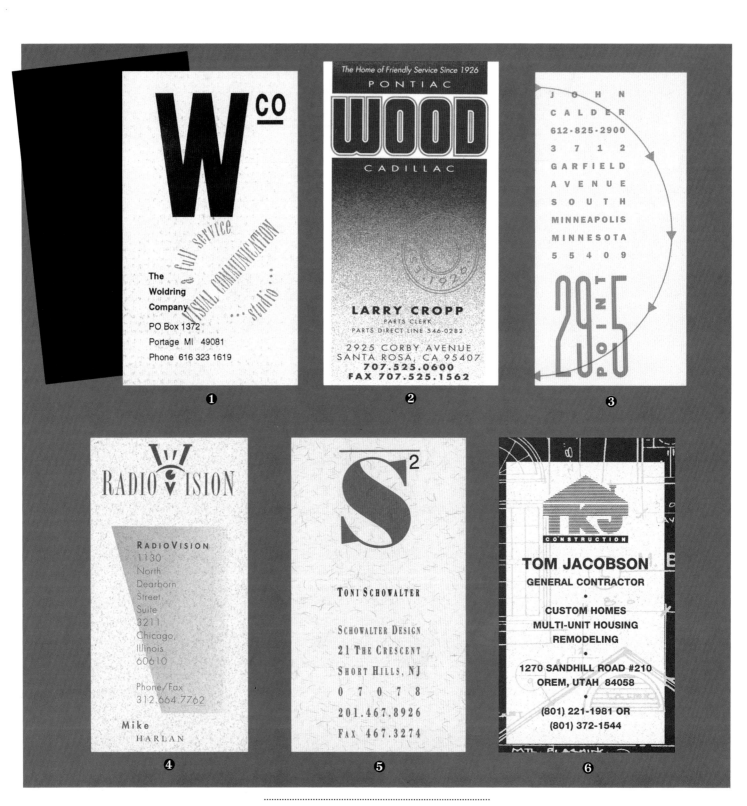

**❶**
**DESIGN FIRM**
RAUL VARELA
**ART DIRECTOR**
RAUL VARELA
**DESIGNER**
RAUL VARELA
**ILLUSTRATOR**
RAUL VARELA
**CLIENT**
RUMOR FILMS

**❷**
**DESIGN FIRM**
ADELE BASS & CO.
DESIGN
**ART DIRECTOR**
ADELE BASS
**DESIGNER**
ADELE BASS
**ILLUSTRATOR**
ADELE BASS
**CLIENT**
LABOY ASSOCIATES

**❸**
**DESIGN FIRM**
RICK EIBER DESIGN
**ART DIRECTOR**
RICK EIBER
**DESIGNER**
RICK EIBER
**PHOTOGRAHER**
RICK EIBER
**CLIENT**
RICK EIBER

**❹**
**DESIGN FIRM**
THE APPELBAUM
COMPANY
**ART DIRECTOR**
HARVEY APPELBAUM
**DESIGNER**
HARVEY APPELBAUM
**CLIENT**
F STOP

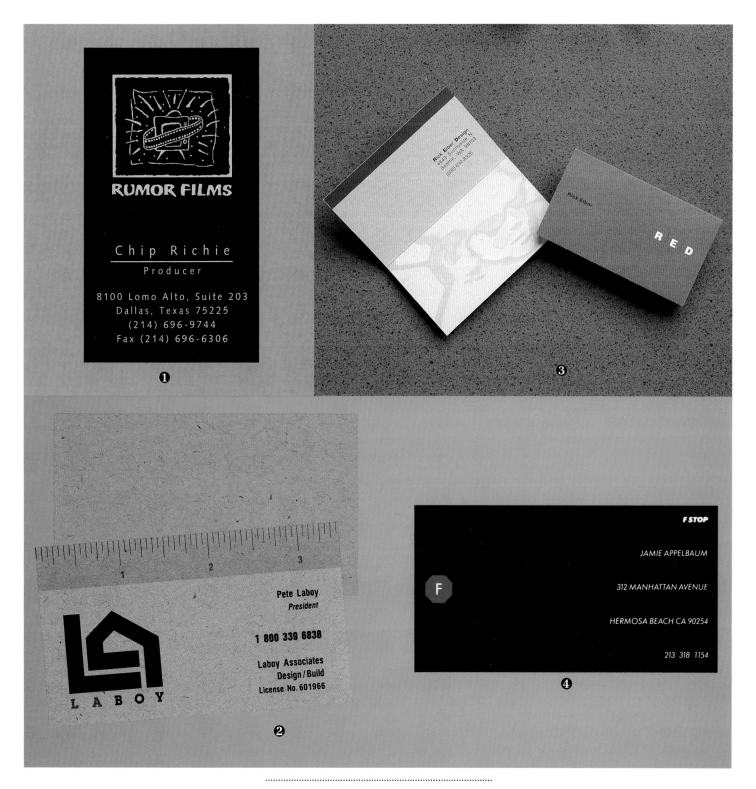

**❶**
**DESIGN FIRM**
TOTO IMAGES INC.
**ART DIRECTOR**
ANDY H. LUN
**DESIGNER**
ANDY H. LUN
**CLIENT**
FACTORY LIMITED

**❷**
**DESIGN FIRM**
MCMONIGLE &
SPOONER
**DESIGNER**
JAMIE MCMONIGLE
**CLIENT**
OCEAN STATES
NETWORK

**❸**
**DESIGN FIRM**
SAYLES GRAPHIC
DESIGN
**ART DIRECTOR**
JOHN SAYLES
**DESIGNER**
JOHN SAYLES
**ILLUSTRATOR**
JOHN SAYLES
**CLIENT**
BECKLEY IMPORTS

**❹**
**DESIGN FIRM**
DANIEL GONZALEZ
**DESIGNER**
DANIEL GONZALEZ
**ILLUSTRATOR**
DANIEL GONZALEZ
**CLIENT**
DANIEL GONZALEZ

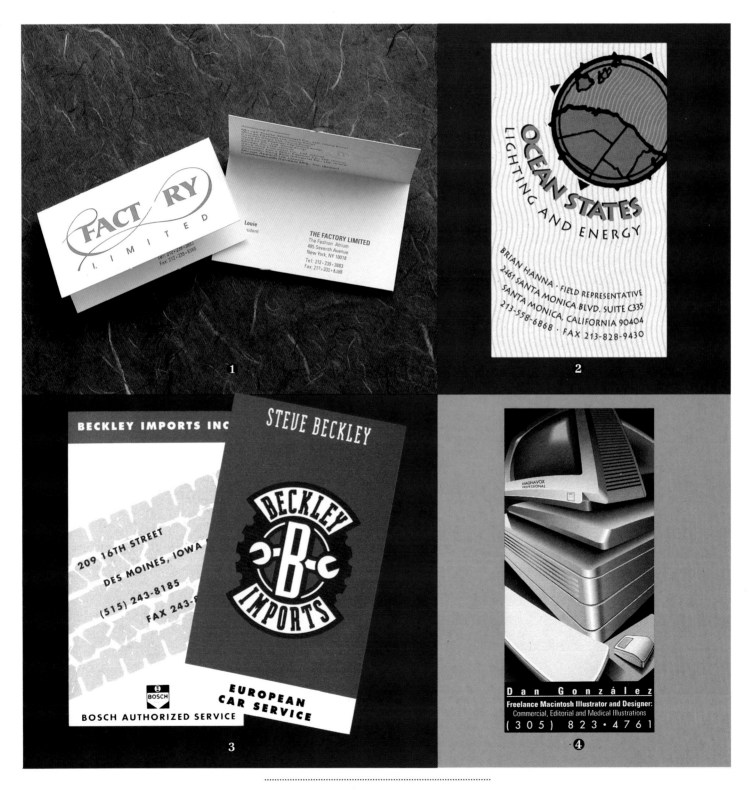

❶
**DESIGN FIRM**
MAEDA DESIGN
ASSOCIATES, INC.
**ART DIRECTOR**
MR. KAZUKI MAEDA
**DESIGNER**
MR. KAZUKI MAEDA
**CLIENT**
MAEDA DESIGN
ASSOCIATES, INC.

❷
**DESIGN FIRM**
MAMMOLITI CHAN
DESIGN
**ART DIRECTOR**
TONY MAMMOLITI
**DESIGNER**
TONY MAMMOLITI
**ILLUSTRATOR**
TONY MAMMOLITI
**CLIENT**
ROGER HACKWORTH
ARCHITECT

❸
**DESIGN FIRM**
LESLIE CHAN WING
KEI
**ART DIRECTOR**
LESLIE CHAN WING
KEI
**DESIGNER**
LESLIE CHAN WING
KEI
**CLIENT**
STEPHEN IP
PHOTOGRAPHER

❹
**DESIGN FIRM**
IMAGE CENTRAL
**ART DIRECTOR**
LIANE WAGNER
**DESIGNER**
LIANE WAGNER
**ILLUSTRATOR**
LIANE WAGNER
**CLIENT**
CALIFORNIA EYES

❺
**DESIGN FIRM**
FRANK D'ASTOLFO
DESIGN
**ART DIRECTOR**
FRANK D'ASTOLFO
**DESIGNER**
FRANK D'ASTOLFO
**CLIENT**
OVATION ANIMATION

❻
**DESIGN FIRM**
THE APPELBAUM
COMPANY
**ART DIRECTOR**
HARVEY APPELBAUM
**DESIGNER**
HARVEY APPELBAUM
**CLIENT**
PERRETTI
PRODUCTIONS

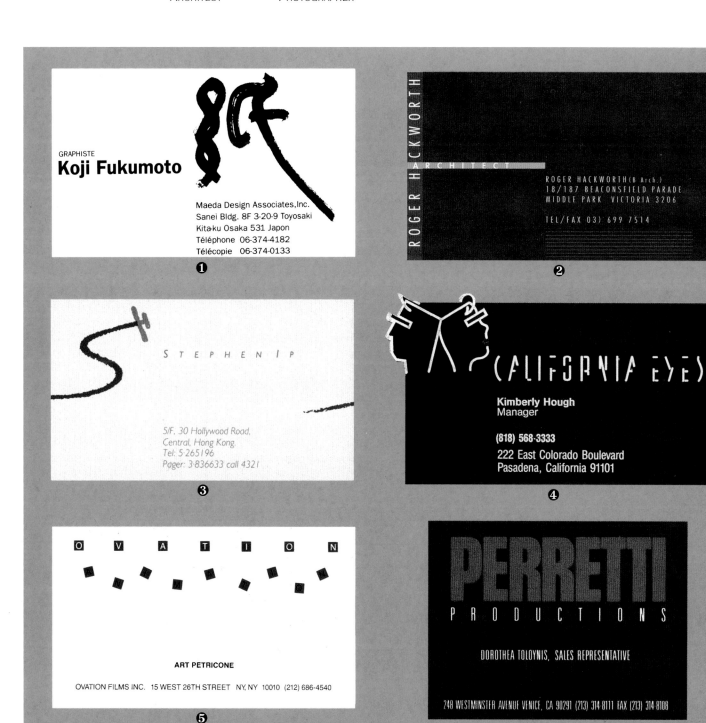

❶

**DESIGN FIRM**
TOTO IMAGES INC.
**ART DIRECTOR**
ANDY H. LUN
**DESIGNER**
ANDY H. LUN
**CLIENT**
EIGES & COHEN,
P.C.

❷

**DESIGN FIRM**
HARTMANN &
MEHLER DESIGNERS
GMBH
**ART DIRECTOR**
ROLAND MEHLER
**DESIGNER**
ROLAND MEHLER
**CLIENT**
OLIVER KAMPF

❸

**DESIGN FIRM**
LIPSON ALPORT
GLASS &
ASSOCIATES
**ART DIRECTOR**
STAN BROD
**DESIGNER**
STAN BROD
**CLIENT**
EDGE GRAPHICS

❹

**DESIGN FIRM**
KYM ABRAMS
DESIGN
**ART DIRECTOR**
KYM ABRAMS
**DESIGNER**
CHARLYNE FABI
**CLIENT**
AARON
BUCHMAN/BUCHMAN
INK, INC.

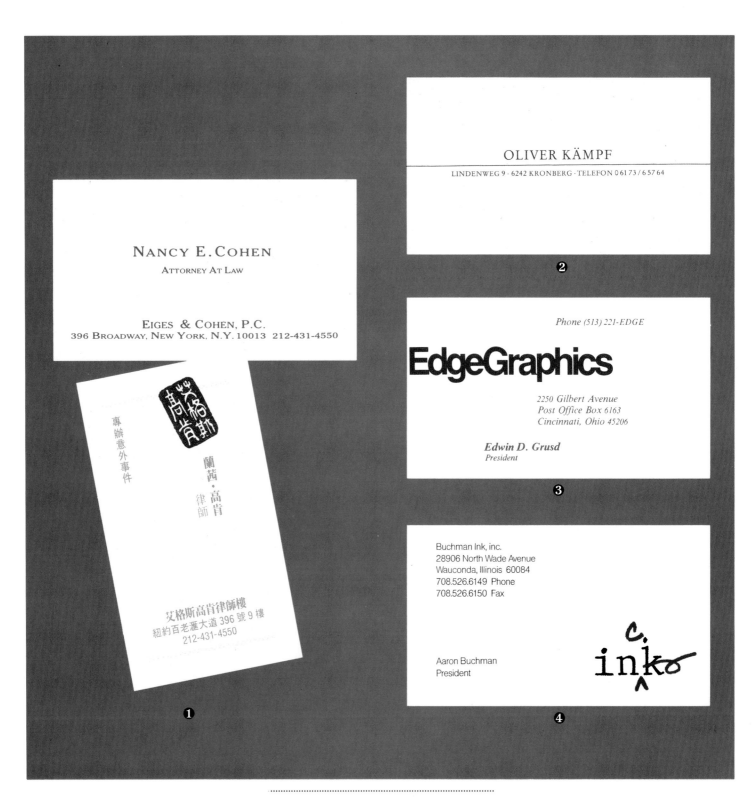

❶
**DESIGN FIRM**
CHEE WANG NG
**ART DIRECTOR**
CHEE WANG NG
**DESIGNER**
CHEE WANG NG
**CLIENT**
CHEE WANG NG

❷
**DESIGN FIRM**
ARETE DESIGN
**ART DIRECTOR**
CHARLES
LETHERWOOD
**DESIGNER**
CHARLES
LETHERWOOD
**CLIENT**
GEORGE DIMITRI

❸
**DESIGN FIRM**
WESTWOOD &
ASSOCIATES
**ART DIRECTOR**
DAVID WESTWOOD
**DESIGNER**
DAVID WESTWOOD
**CLIENT**
AUBERGINE

❹
**DESIGN FIRM**
MERVIL PAYLOR
DESIGN
**DESIGNER**
MERVIL M. PAYLOR
**CLIENT**
RON CHAPPLE
PHOTOGRAPHY

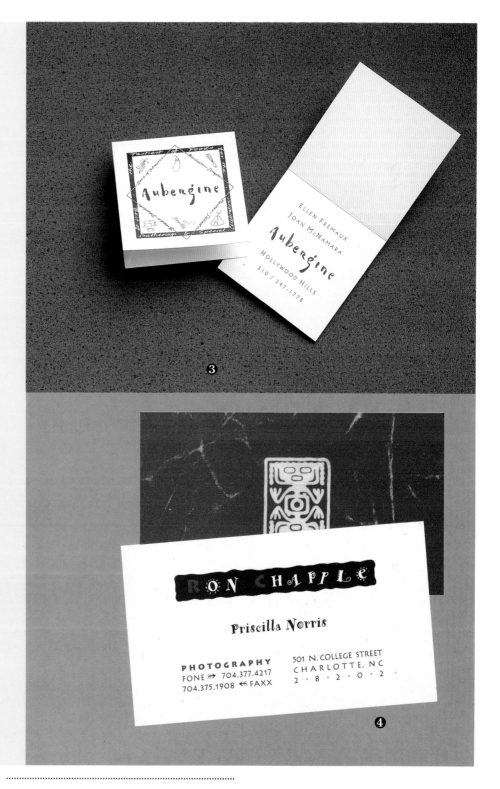

❶

❷

❸

❹

**❶**
**DESIGN FIRM**
LESLIE CHAN DESIGN CO., LTD.
**ART DIRECTOR**
LESLIE CHANG WING KEI
**DESIGNER**
LESLIE CHANG WING KEI, TONG SONG WEI
**CLIENT**
TAIWAN TOHAN CO., LTD.

**❷**
**DESIGN FIRM**
SCHOWALTER²
DESIGN
**ART DIRECTOR**
TONI SCHOWALTER
**DESIGNER**
TONI SCHOWALTER
**CLIENT**
MANESSPACE

**❸**
**DESIGN FIRM**
ROCHELLE SELTZER
DESIGN
**ART DIRECTOR**
ROCHELLE SELTZER
**DESIGNER**
MINNIE CHO
**CLIENT**
ERUDITE PRODUCTS
CORP.

**❹**
**DESIGN FIRM**
LUMA DESIGN
**ART DIRECTOR**
M.J. BLANCHETTE
**DESIGNER**
KRISTINE MCLAVEY
**CLIENT**
PRAGMATECH

**❺**
**DESIGN FIRM**
ABEYTA DESIGN AND
DIRECTION
**ART DIRECTOR**
STEVEN ABEYTA
**DESIGNER**
STEVEN ABEYTA
**CLIENT**
STEVEN ABEYTA

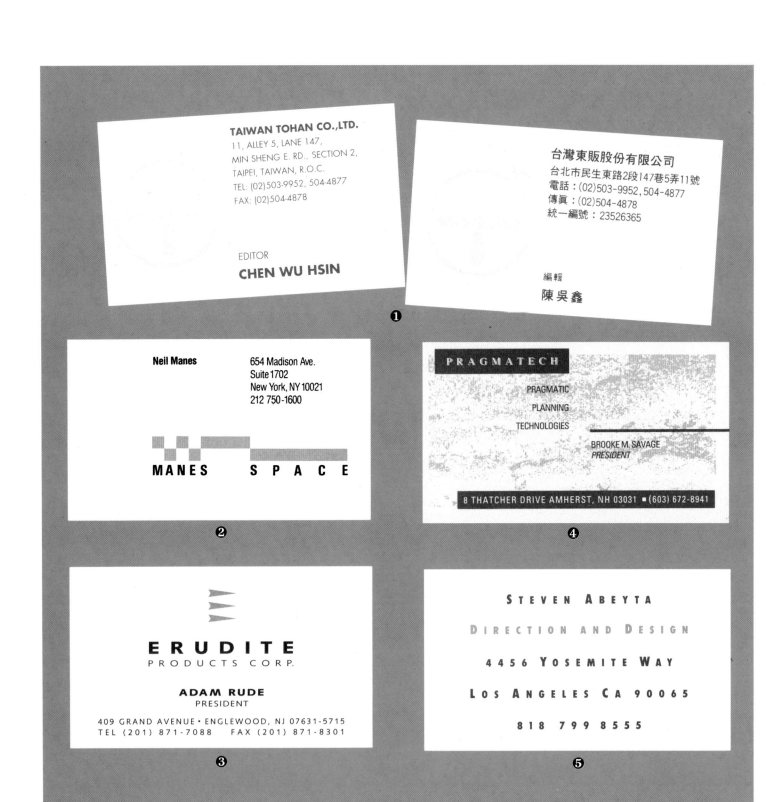

**❶**
**DESIGN FIRM**
PETER HOLLINGSWORTH & ASSOCIATES
**ART DIRECTOR**
PETER HOLLONGSWORTH
**DESIGNER**
STEVEN JOHN WAMMACK
**CLIENT**
FULLER AND KESSLER
ARCHITECTS

**❷**
**DESIGN FIRM**
MAEDA DESIGN
ASSOCIATES, INC.
**ART DIRECTOR**
MR. KAZUKI MAEDA
**DESIGNER**
MR. KOJI FUKUMOTO
**CLIENT**
MAEDA DESIGN
ASSOCIATES, INC.

**❸**
**DESIGN FIRM**
PINKHAUS DESIGN
CORP.
**ART DIRECTOR**
JOEL FULLER
**DESIGNER**
CLAUDIA DECASTRO
**CLIENT**
HARPER, CARRENO,
MATEU

**❹**
**DESIGN FIRM**
BULLET COMMUNICATIONS, INC.
**ART DIRECTOR**
TIM SCOTT
**DESIGNER**
TIM SCOTT
**ILLUSTRATOR**
TIM SCOTT
**CLIENT**
KLEINER DESIGN, INC.

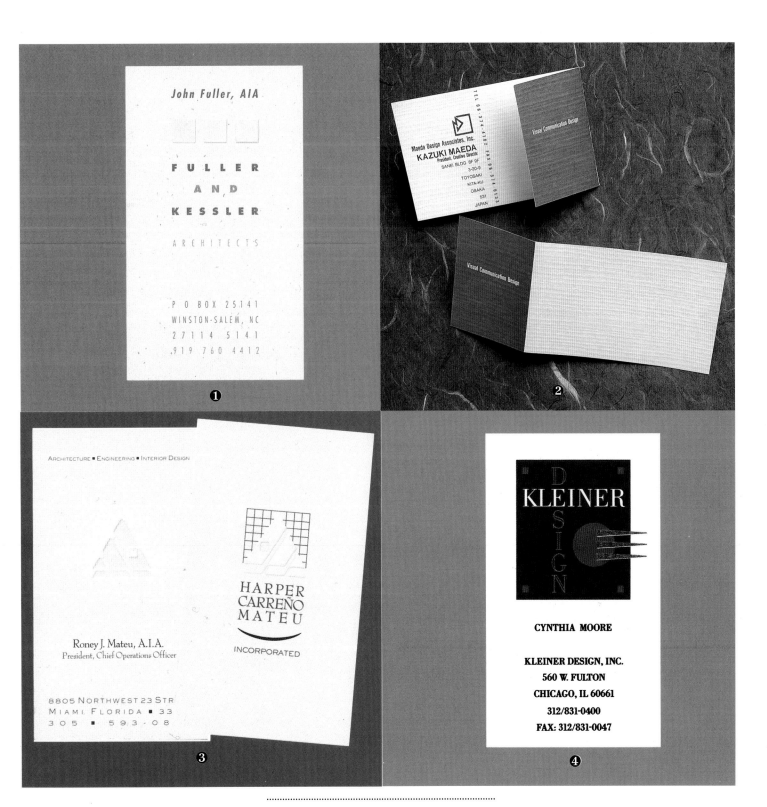

**❶**

**DESIGN FIRM**
RICHARDSON OR
RICHARDSON
**ART DIRECTOR**
FORREST
RICHARDSON
**DESIGNER**
FORREST
RICHARDSON
**CLIENT**
GOLF GROUP LTD.

**❷**

**DESIGN FIRM**
MAMMOLITI CHAN
DESIGN
**ART DIRECTOR**
TONY MAMMOLITI
**DESIGNER**
CHWEE KUAN CHAN
**ILLUSTRATOR**
CHWEE KUAN CHAN
**CLIENT**
PC FORTE PTY. LTD.

**❸**

**DESIGN FIRM**
YAROM VARDIMON
DESIGN
**ART DIRECTOR**
YAROM VARDIMON
**DESIGNER**
YAROM VARDIMON
**CLIENT**
LORDAN & CO.

**❹**

**DESIGN FIRM**
THARP DID IT
**DESIGNER**
KIM TOMLINSON,
RICK THARP
**CLIENT**
FRANKLIN AVERY
FOTOGRAPHER

❶
**DESIGN FIRM**
RICHARDSON OR
RICHARDSON
**ART DIRECTOR**
DEBI YOUNG MEES
**DESIGNER**
DEBI YOUNG MEES
**CLIENT**
A.L. WAKELY
COMFORT
SPECIALISTS

❷
**DESIGN FIRM**
VOLAN DESIGN
ASSOCIATES
**ART DIRECTOR**
JUSTIN DEISTER
**DESIGNER**
JUSTIN DEISTER
**CLIENT**
CROSS
CONDITIONING
SYSTEMS

❸
**DESIGN FIRM**
MARK PALMER
DESIGN
**ART DIRECTOR**
MARK PALMER
**DESIGNER**
MARK PALMER
**PRODUCTION**
CURTIS PALMER
**CLIENT**
CARR
COMMUNICATIONS

❹
**DESIGN FIRM**
SEMAN DESIGN
GROUP
**ART DIRECTOR**
RICHARD M. SEMAN
**DESIGNER**
RICHARD M. SEMAN
**CLIENT**
DENNIS KEYES,
D.M.D.

**❶**

DESIGN FIRM
DEAN JOHNSON
DESIGN
ART DIRECTOR
BRUCE DEAN
DESIGNER
BRUCE DEAN
ILLUSTRATOR
BRUCE DEAN
CLIENT
OJAI NATIVE
AMERICAN ART
GALLERY

**❷**

DESIGN FIRM
THE WOLDRING
COMPANY
ART DIRECTOR
ROBERT WOLDRING
DESIGNER
ROBERT WOLDRING
CLIENT
SOUTHMOST ROCK &
MINERAL CLUB

**❸**

DESIGN FIRM
BUCK BOARD
DESIGN
ART DIRECTOR
LIESL BUCK
DESIGNER
LIESL BUCK
CLIENT
RITZI RAGS LTD.

**❹**

DESIGN FIRM
MICHAEL STANARD, INC.
ART DIRECTOR
LISA FINGERHUT
DESIGNER
LISA FINGERHUT
CLIENT
JOE PRUDDEN, COYOTE JOE'S CAFE

**❺**

DESIGN FIRM
SCHOWALTER[2]
DESIGN
ART DIRECTOR
TONI SCHOWALTER
DESIGNER
TONI SCHOWALTER
ILLUSTRATOR
TONI SCHOWALTER
CLIENT
T.J. MEIER

❶
**DESIGN FIRM**
THE LEONHARDT
GROUP
**ART DIRECTOR**
JANET KRUSE
**DESIGNER**
TRACI DABERKO
**ILLUSTRATOR**
JULIE PASCHKIS
**CLIENT**
TURNIPSEED
BROTHERS

❷
**DESIGN FIRM**
ICONS
**ART DIRECTOR**
GLENN SCOTT
JOHNSON
**DESIGNER**
GLENN SCOTT
JOHNSON
**ILLUSTRATOR**
GLENN SCOTT
JOHNSON
**CLIENT**
VICKI LEE BOYAJIAN

❸
**DESIGN FIRM**
FRANK D'ASTOLFO
DESIGN
**ART DIRECTOR**
FRANK D'ASTOLFO
**DESIGNER**
FRANK D'ASTOLFO
**CLIENT**
ANGELICA KITCHEN

❹
**DESIGN FIRM**
ASCENT
COMMUNICATIONS
**ART DIRECTOR**
ALLEN HAEGER
**DESIGNER**
ALLEN HAEGER
**CLIENT**
HOPE SPRINGS, INC.

❶
**DESIGN FIRM**
EILTS ANDERSON
TRACY
**ART DIRECTOR**
PATRICE EILTS
**DESIGNER**
PATRICE EILTS
**ILLUSTRATOR**
PATRICE EILTS, RICH
KOBS
**CLIENT**
PB&J RESTAURANTS
GRAND ST. CAFE

❷
**DESIGN FIRM**
WATCH! GRAPHIC
DESIGN
**DESIGNER**
BRUNO WATEL
**ILLUSTRATOR**
BRUNO WATEL
**CLIENT**
STYLES UNLIMITED

❸
**DESIGN FIRM**
MALLEN AND FRIENDS ADVERTISING ARTS &
DESIGN
**ART DIRECTOR**
GARY MALLEN
**DESIGNER**
GARY MALLEN
**CLIENT**
MALLEN AND FRIENDS ADVERTISING ARTS &
DESIGN

❹
**DESIGN FIRM**
MARK PALMER
DESIGN
**ART DIRECTOR**
MARK PALMER
**DESIGNER**
MARK PALMER
**ILLUSTRATOR**
CURTIS PALMER
**CLIENT**
SOUTHWEST
LANDSCAPE

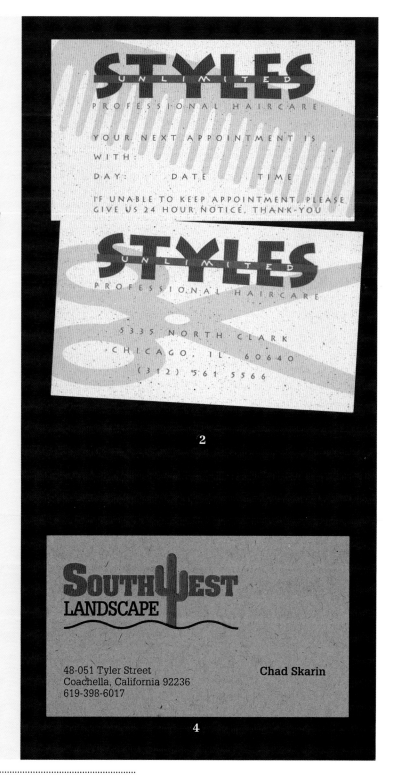

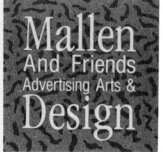

**❶**

**DESIGN FIRM**
QUALLY & COMPANY
INC.
**ART DIRECTOR**
ROBERT QUALLY
**DESIGNER**
ROBERT QUALLY
**CLIENT**
BUSINESS
VOLUNTEERS FOR
THE ARTS

**❷**

**DESIGN FIRM**
B.E.P. DESIGN
GROUP
**ART DIRECTOR**
CAROLE PURNELLE
**CLIENT**
CAROLE PURNELLE

**❸**

**DESIGN FIRM**
THARP DID IT
**ART DIRECTOR**
RICK THARP, CHUCK DRUMMOND
**DESIGNER**
RICK THARP, JANA HEER
**CLIENT**
THARP (AND DRUMMOND) DID IT

❶

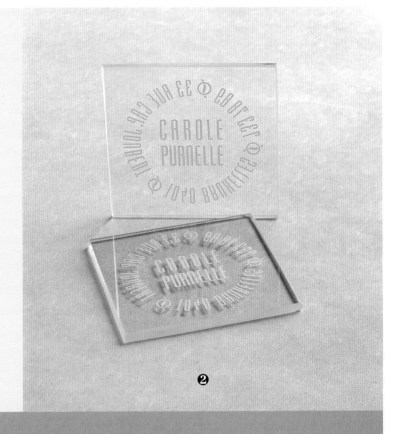

❷

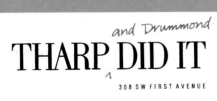

❸

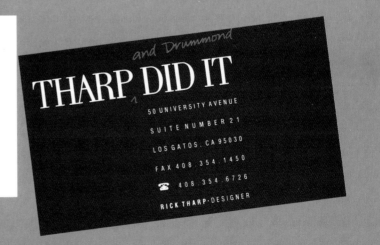

**❶**
**DESIGN FIRM**
THE SALVAGE CREW
**ART DIRECTOR**
KELLY O'CONNOR
**DESIGNER**
RICK THARP
**CLIENT**
THE SALVAGE CREW

**❷**
**DESIGN FIRM**
EILTS ANDERSON TRACY
**ART DIRECTOR**
PATRICE EILTS
**DESIGNER**
PATRICE EILTS
**ILLUSTRATOR**
PATRICE EILTS
**CLIENT**
SPONTANEOUS COMBUSTION

**❸**
**DESIGN FIRM**
TYPO GRAPHIC
**ART DIRECTOR**
ULRICH LANDSHERR
**DESIGNER**
ULRICH LANDSHERR
**CLIENT**
KARE

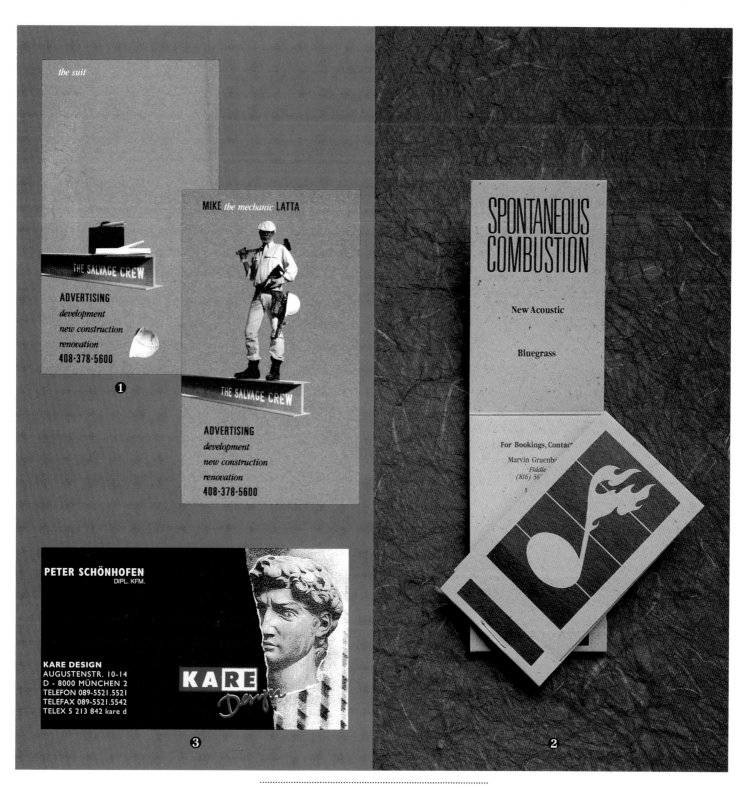

**❶**

**DESIGN FIRM**
ELLIE DICKSON
ILLUSTRATION
**ART DIRECTOR**
ELLIE DICKSON
**DESIGNER**
ELLIE DICKSON
**ILLUSTRATOR**
ELLIE DICKSON
**CLIENT**
ELLIE DICKSON

**❷**

**DESIGN FIRM**
DUNCAN/DAY
ADVERTISING
**ART DIRECTOR**
STACEY DAY
**DESIGNER**
STACEY DAY
**CLIENT**
DUNCAN/DAY
ADVERTISING

**❸**

**DESIGN FIRM**
ALBERT JUAREZ
DESIGN &
ILLUSTRATION
**ART DIRECTOR**
ALBERT JUAREZ
**DESIGNER**
ALBERT JUAREZ
**ILLUSTRATOR**
ALBERT JUAREZ
**CLIENT**
SAMMY LOPEZ
PHOTOGRAPHY

**❹**

**DESIGN FIRM**
DENNIS IRWIN
ILLUSTRATION
**ART DIRECTOR**
ANDREW DANISH
**DESIGNER**
DENNIS IRWIN
**ILLUSTRATOR**
DENNIS IRWIN
**CLIENT**
DENNIS IRWIN

❶

❷

❸

❹

| ❶ | ❷ | ❸ | ❹ | ❺ | ❻ |
|---|---|---|---|---|---|
| **DESIGN FIRM** | **DESIGN FIRM** | **DESIGN FIRM** | **DESIGN FIRM** | **DESIGN FIRM** | **DESIGN FIRM** |
| POWER DESIGN | SUSAN NORTHROP | HURLEY DESIGN | WALTER JOYCE | EINAT PELED | NANCY STUTMAN |
| **DESIGNER** | DESIGN | **DESIGNER** | DESIGN | **DESIGNER** | **ART DIRECTOR** |
| PAT POWER | **CLIENT** | GREG GRIFFIN | **ART DIRECTOR** | EINAT PELED | WENDY WATSON |
| **ILLUSTRATOR** | RICK RUSACK | **ILLUSTRATOR** | W. JOYCE | **ILLUSTRATOR** | **DESIGNER** |
| PAT POWER | | GREG HURLEY | **DESIGNER** | EINAT PELED | NANCY STUTMAN |
| **CLIENT** | | **CLIENT** | W. JOYCE | **CLIENT** | **CALLIGRAPHER** |
| KENNEDY & POWELL | | HURLEY DESIGN | **PHOTOGRAPHER** | EINAT PELED | NANCY STUTMAN |
| | | | JOE RAYMOND | | **CLIENT** |
| | | | **CLIENT** | | SPS CREATIVE |
| | | | SKIP WESTON | | TRAINING SYSTEMS |

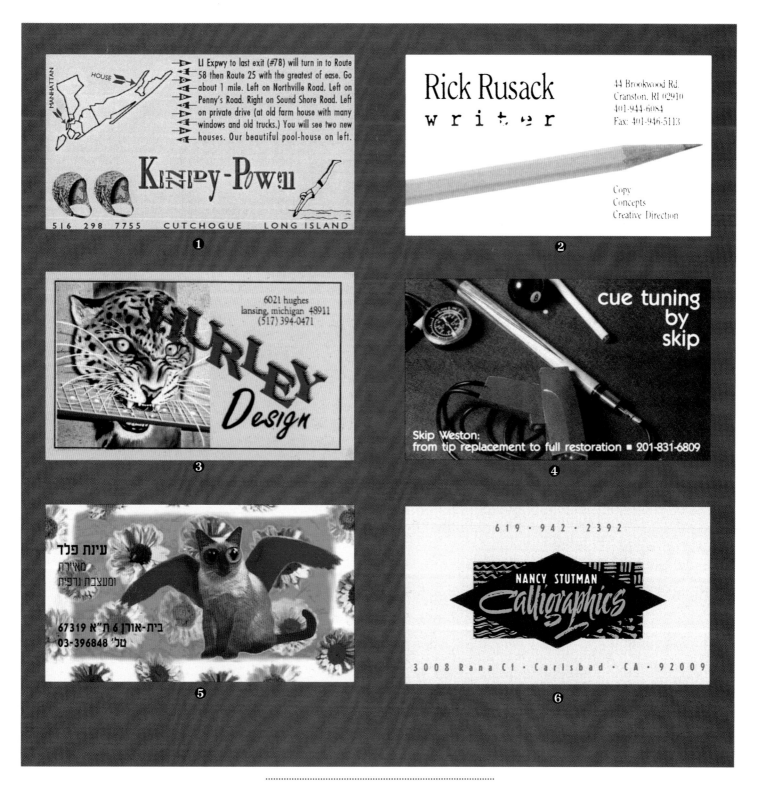

**❶**

**DESIGN FIRM**
OLAUSEN DESIGN
**ART DIRECTOR**
DAVE OLAUSEN
**DESIGNER**
DAVE OLAUSEN
**CLIENT**
OLAUSEN DESIGN

**❷**

**DESIGN FIRM**
ADAM COHEN
ILLUSTRATOR
**ART DIRECTOR**
SUSSAN
GIALLOMBARDO
**DESIGNER**
SUSSAN
GIALLOMBARDO
**ILLUSTRATOR**
ADAM COHEN
**CLIENT**
ADAM COHEN
ILLUSTRATOR

**❸**

**DESIGN FIRM**
TYPO GRAPHIC
**ART DIRECTOR**
ULRICH LANDSHERR
**DESIGNER**
ULRICH LANDSHERR
**ILLUSTRATOR**
ULRICH LANDSHERR
**CLIENT**
KARTEN
VORVERKAUF

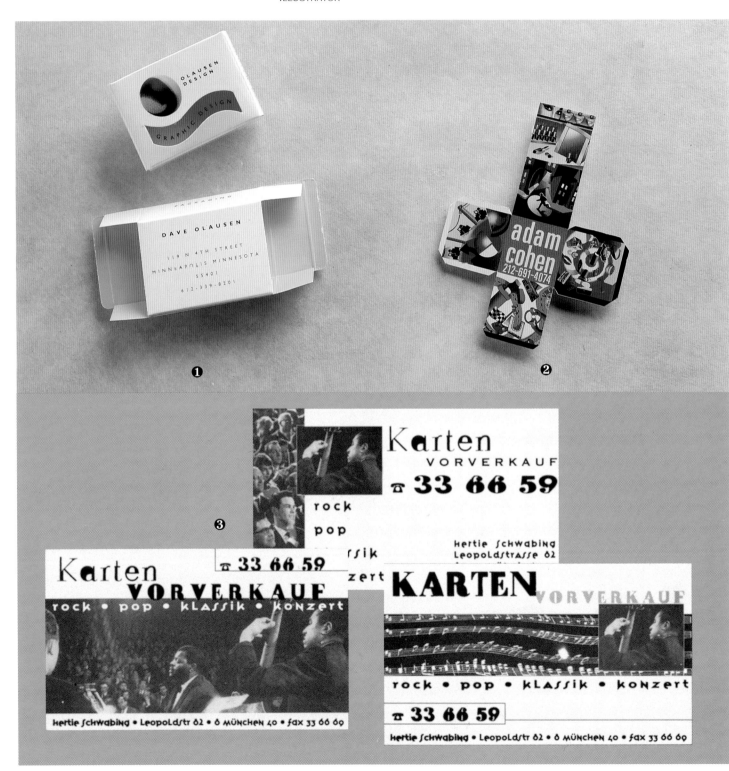

❶

❷

❸

❶

**DESIGN FIRM**
SAYLES GRAPHIC DESIGN
**ART DIRECTOR**
JOHN SAYLES
**DESIGNER**
JOHN SAYLES
**ILLUSTRATOR**
JOHN SAYLES
**CLIENT**
ADVENTURE LIGHTING

❷

**DESIGN FIRM**
ELIZABETH RESNICK
DESIGN
**ART DIRECTOR**
ELIZABETH RESNICK
**DESIGNER** ELIZABETH
RESNICK
**CLIENT**
ELIZABETH RESNICK

❸

**DESIGN FIRM**
FASSINO/DESIGN
**ART DIRECTOR**
DIANE FASSINO
**DESIGNER**
DIANE FASSINO
**CLIENT**
ARCADIA PRESS

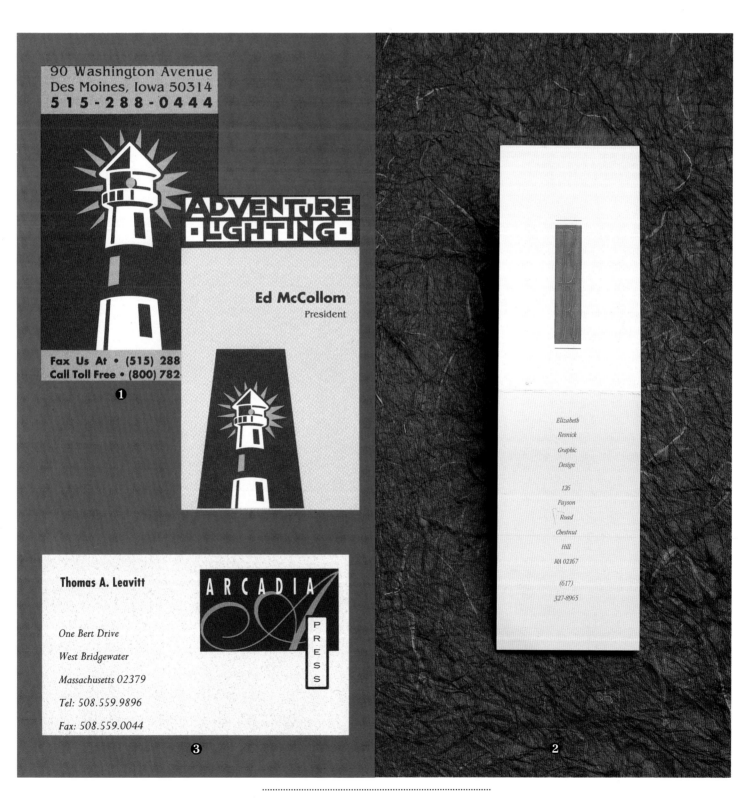

**❶**
**DESIGN FIRM**
DEAN JOHNSON
DESIGN
**ART DIRECTOR**
BRUCE DEAN
**DESIGNER**
BRUCE DEAN
**ILLUSTRATOR**
BRUCE DEAN
**CLIENT**
GREAT WESTERN
BOOT CO.

**❷**
**DESIGN FIRM**
SUPREME DESIGN
**ART DIRECTOR**
ANDREW C. IRVING
**DESIGNER**
ANDREW C. IRVING
**CLIENT**
ON TRACK
INFORMATION

**❸**
**DESIGN FIRM**
FILENI, MENDIOROZ
& BERRO GARCIA
**ART DIRECTOR**
GONZALO BERRO
**DESIGNER**
GONZALO BERRO
**ILLUSTRATOR**
MACARENA UBIOS
**CLIENT**
LA ESQUINITA
RESTAURANT

**❹**
**DESIGN FIRM**
DELONG & ASSOCIATES
**ART DIRECTOR**
KAI SIANG TOH
**DESIGNER**
LESLIE TERGAS
**PHOTOGRAPHER**
DEBORAH BRACKENBURY
**CLIENT**
STRATTAN BROS. COLLECTIBLES INVESTMENT
ASSOCIATION

**❺**
**DESIGN FIRM**
GRAPHIC ART
RESOURCE
ASSOCIATES
**ART DIRECTOR**
ROBERT LASSEN
**DESIGNER**
ROBERT LASSEN
**ILLUSTRATOR**
ROBERT LASSEN
**CLIENT**
ROBERT LASSEN

**❶**

**❷**

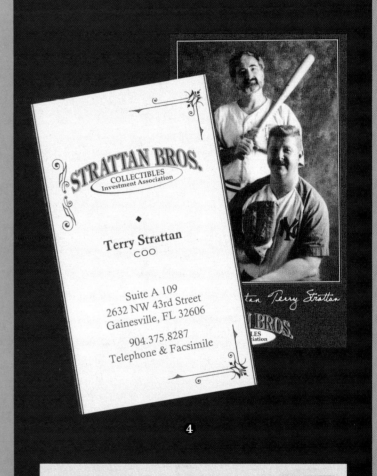

4

**❸**

5

❶
**DESIGN FIRM**
KTM DESIGN
**ART DIRECTOR**
KRISTEN MALAN
**DESIGNER**
KRISTEN MALAN
**ILLUSTRATOR**
KRISTEN MALAN
**CLIENT**
RAYMOND SCHULTZ
BUILDER

❷
**DESIGN FIRM**
FASSINO/DESIGN
**ART DIRECTOR**
DIANE FASSINO
**DESIGNER**
DIANE FASSINO
**ILLUSTRATOR**
LAUREN SCHEVER
**CLIENT**
THE POLLARD HOTEL

❸
**DESIGN FIRM**
THE WELLER
INSTITUTE FOR THE
CURE OF DESIGN,
INC.
**ART DIRECTOR**
DON WELLER
**DESIGNER**
DON WELLER
**ILLUSTRATOR**
DON WELLER
**CLIENT**
TAKOTA TRADERS

❹
**DESIGN FIRM**
DELONG & ASSOCIATES
**ART DIRECTOR**
KAI SIANG TOH
**DESIGNER**
KAI SIANG TOH
**PHOTOGRAPHER**
DEBORAH
BRACKENBURY
**CLIENT**
DELONG & ASSOCIATES

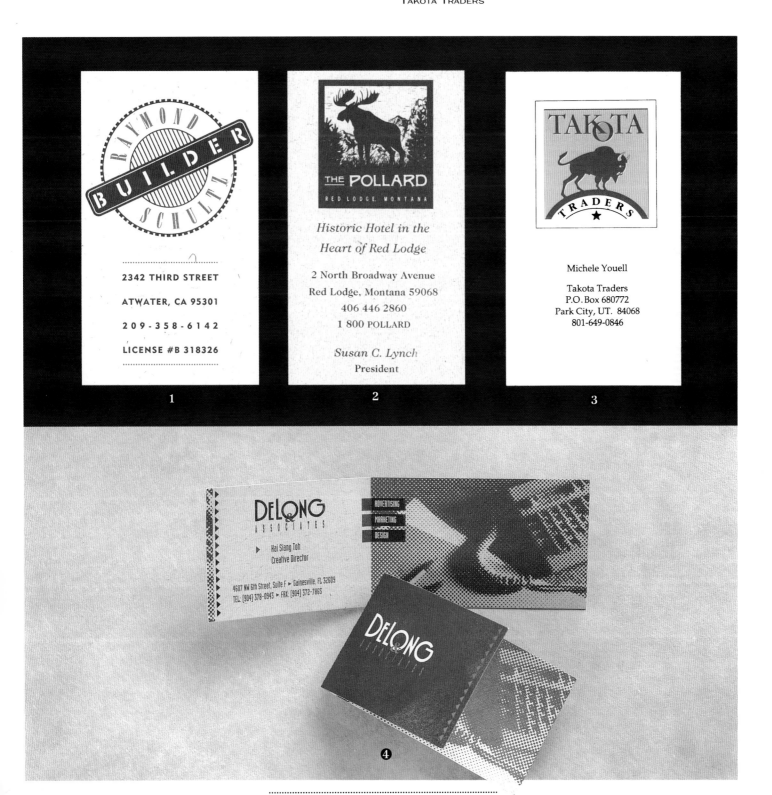





































































































































































































































**❶**

**DESIGN FIRM**
LESLIE HIRST
DESIGN, CO.
**ART DIRECTOR**
LESLIE HIRST
**DESIGNER**
LESLIE HIRST
**ILLUSTRATOR**
LESLIE HIRST
(HAND LETTERING)
**CLIENT**
LESLIE HIRST
DESIGN, CO.

**❷**

**DESIGN FIRM**
STEPHEN SCHUDLICH
ILLUSTRATION &
DESIGN
**ART DIRECTOR**
STEPHEN SCHUDLICH
**DESIGNER**
STEPHEN SCHUDLICH
**ILLUSTRATOR**
STEPHEN SCHUDLICH
**CLIENT**
STEPHEN SCHUDLICH

**❸**

**DESIGN FIRM**
DEAN JOHNSON
DESIGN
**ART DIRECTOR**
BRUCE DEAN
**DESIGNER**
BRUCE DEAN
**ILLUSTRATOR**
BRUCE DEAN
**CLIENT**
CHRIS EASTERDAY

**❹**

**DESIGN FIRM**
DESIGN GROUP
COOK
**ART DIRECTOR**
KEN COOK
**DESIGNER**
KEN COOK
**CLIENT**
CYNTHIA BRAGDON
MARKETING
COMMUNICATIONS

❶

❷

❸

❹

**❶**
**DESIGN FIRM**
SUZY LEUNG
**ART DIRECTOR**
SUZY LEUNG
**DESIGNER**
SUZY LEUNG
**ILLUSTRATOR**
SUZY LEUNG
**CLIENT**
ALBERT Y. YU M.D.

**❷**
**DESIGN FIRM**
VICTOR CHEONG
DESIGN &
ASSOCIATES
**ART DIRECTOR**
VICTOR CHEONG
**DESIGNER**
VICTOR CHEONG
**CLIENT**
WENDY CHEONG

**❸**
**DESIGN FIRM**
RICHARDSON OR RICHARDSON
**ART DIRECTOR**
FORREST RICHARDSON/
VALERIE RICHARDSON
**DESIGNER**
DEBI YOUNG MEES
**ILLUSTRATOR**
PEOPLE UP LATE WITH RUBBER STAMPS
**CLIENT**
ECODEA

❶

❷

❸

**❶**
**DESIGN FIRM**
BUCK BOARD
DESIGN
**ART DIRECTOR**
LIESL BUCK
**DESIGNER**
LIESL BUCK
**CLIENT**
JAVA STAR CAFÉ

**❷**
**DESIGN FIRM**
FANI CHUNG DESIGN
**ART DIRECTOR**
FANI CHUNG
**DESIGNER**
FANI CHUNG
**CLIENT**
FANI CHUNG DESIGN

**❸**
**DESIGN FIRM**
MAMMOLITI CHAN
DESIGN
**ART DIRECTOR**
TONY MAMMOLITI
**DESIGNER**
TONY MAMMOLITI
**ILLUSTRATOR**
CHWEE KUAN CHAN
**CLIENT**
COLIN EDWARDS
DESIGNS

**❹**
**DESIGN FIRM**
DESIGN STUDIO
**ART DIRECTOR**
PALDA
PHOOCHAROON
**DESIGNER**
PALDA
PHOOCHAROON
**ILLUSTRATOR**
PALDA
PHOOCHAROON
**CLIENT**
THE KENOSHA
GROUP

**❶**

**DESIGN FIRM**
THE AD GROUP, INC.
**ART DIRECTOR**
LISA TUCKER
**DESIGNER**
PAULA MASLOWSKI
**ILLUSTRATOR**
PAULA MASLOWSKI
**CLIENT**
THE GATE

**❷**

**DESIGN FIRM**
MIKE SALISBURY
**ART DIRECTOR**
MIKE SALISBURY
**DESIGNER**
JODI FEINHOR
**ILLUSTRATOR**
TERRY LAMB
**CLIENT**
MIKE SALISBURY
COMMUNICATIONS

**❸**

**DESIGN FIRM**
EYMONT KIN-YEE
HULETT PTY. LTD.
**ART DIRECTOR**
ANNA EYMONT
**DESIGNER**
FRANK CHIN
**CLIENT**
MANIDIS ROBERTS
CONSULTANTS

**❹**

**DESIGN FIRM**
ERIC ROINESTAD
DESIGN
**ART DIRECTOR**
ERIC ROINESTAD
**DESIGNER**
ERIC ROINESTAD
**CLIENT**
MICHELE LAURITA
PHOTOGRAPHY

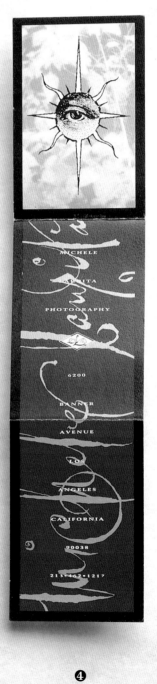

❶
**DESIGN FIRM**
MERVIL PAYLOR
DESIGN
**DESIGNER**
MERVIL M. PAYLOR
**CLIENT**
JOHNSON-POWELL

❷
**DESIGN FIRM**
ATHANASIUS-DESIGN
**ART DIRECTOR**
JEFFREY WALLACE
**DESIGNER**
JEFFREY WALLACE
**ILLUSTRATOR**
JEFFREY WALLACE
**CLIENT**
ATHANASIUS-DESIGN

❸
**DESIGN FIRM**
EVENSON DESIGN
GROUP
**ART DIRECTOR**
STAN EVENSON
**DESIGNER**
STAN EVENSON,
GLENN SAKAMOTO
**CLIENT**
EVENSON DESIGN
GROUP

❹
**DESIGN FIRM**
BURNING BUSH
STUDIO
**ART DIRECTOR**
MIKE STYSKAL
**DESIGNER**
MIKE STYSKAL
**ILLUSTRATOR**
BRUCE MORSER
**PHOTOGRAPHY**
TOM COLLIOOTT
**CLIENT**
SEATTLE VISION CARE

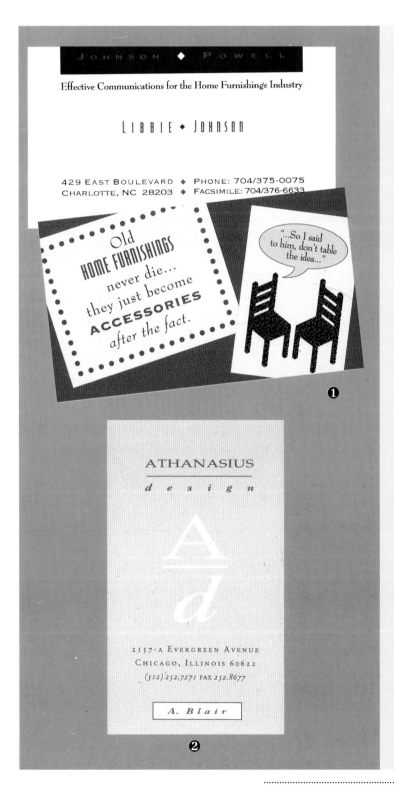

**❶**
**DESIGN FIRM**
THARP DID IT
**DESIGNER**
RICK THARP, KIM TOMLINSON
**CLIENT**
MARRONE BROS., INC.

**❷**
**DESIGN FIRM**
PINKHAUS DESIGN CORP.
**ART DIRECTOR**
JOEL FULLER
**DESIGNER**
LISA ASHWORTH
**ILLUSTRATOR**
LISA ASHWORTH
**CLIENT**
LARRY BLACKMON/ ATLANTA ARTISTS

**❸**
**DESIGN FIRM**
BARRY POWER GRAPHIC DESIGN
**ART DIRECTOR**
BARRY POWER
**DESIGNER**
BARRY POWER
**CLIENT**
JACQUELINE DANCY

**❹**
**DESIGN FIRM**
SIEBERT DESIGN ASSOCIATES
**ART DIRECTOR**
LORI SIEBERT
**DESIGNER**
LISA BALLARD
**ILLUSTRATOR**
LISA BALLARD
**CLIENT**
JEAN CECIL GILLIAM, INC.

**❺**
**DESIGN FIRM**
ROCHELLE SELTZER DESIGN
**ART DIRECTOR**
ROCHELLE SELTZER
**DESIGNER**
ROCHELLE SELTZER
**ILLUSTRATOR**
(CALLIGRAPHY) JEAN EVANS
**CLIENT**
NUSSBAUM/WARE

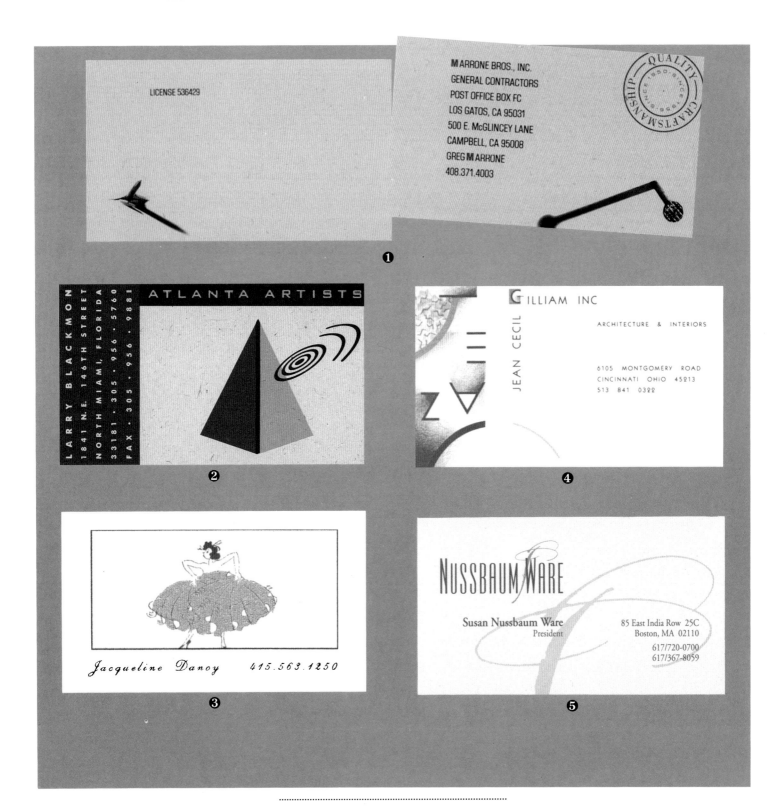

❶
**DESIGN FIRM**
LUMA DESIGN
**ART DIRECTOR**
M. J. BLANCHETTE
**DESIGNER**
M. J. BLANCHETTE
**CLIENT**
LUMA DESIGN, INC.

❷
**DESIGN FIRM**
B.E.P. DESIGN
GROUP
**ART DIRECTOR**
JEAN JACQUES
EVRARD
**DESIGNER**
CAROLE PURNELLE
**CLIENT**
DRAFT

❸
**DESIGN FIRM**
SAYLES GRAPHIC
DESIGN
**ART DIRECTOR**
JOHN SAYLES
**DESIGNER**
JOHN SAYLES
**ILLUSTRATOR**
JOHN SAYLES
**CLIENT**
CASTLE GREEN

❹
**DESIGN FIRM**
LIMA DESIGN
**ART DIRECTOR**
MARY KIENE,
LISA MCKENNA
**DESIGNER**
MARY KIENE,
LISA MCKENNA
**ILLUSTRATOR**
LISA MCKENNA
**CLIENT**
METRO CAT
HOSPITAL

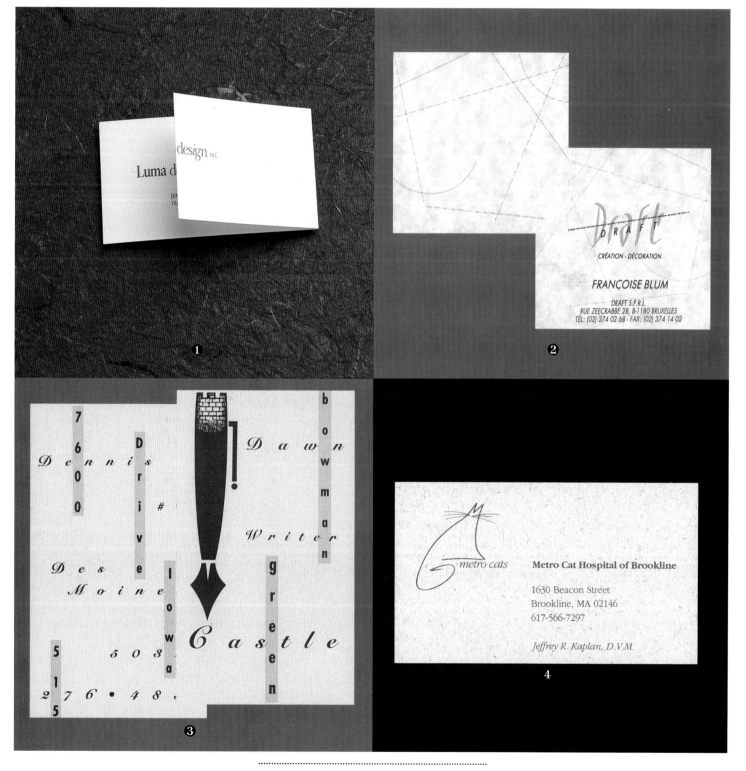

**❶**
**DESIGN FIRM**
RICHARDSON OR
RICHARDSON
**ART DIRECTOR**
FORREST
RICHARDSON
**DESIGNER**
DEBI YOUNG-MEES
**ILLUSTRATOR**
JIM BOLEK
**CLIENT**
GOLF MANAGEMENT
INTERNATIONAL

**❷**
**DESIGN FIRM**
FRANK D'ASTOLFO
DESIGN
**ART DIRECTOR**
FRANK D'ASTOLFO
**DESIGNER**
FRANK D'ASTOLFO
**CLIENT**
BANNING FARM

**❸**
**DESIGN FIRM**
B.E.P. DESIGN
GROUP
**ART DIRECTOR**
JEAN JACQUES
EVRARD
**DESIGNER**
COLIN VALLANCE
**CLIENT**
EXPLOTRA

**❹**
**DESIGN FIRM**
COLONNA FARRELL
DESIGN
**ART DIRECTOR**
TONY AUSTON
**DESIGNER**
CHRIS MATHES
BALDWIN
**CLIENT**
ST. CLEMENT
VINEYARDS

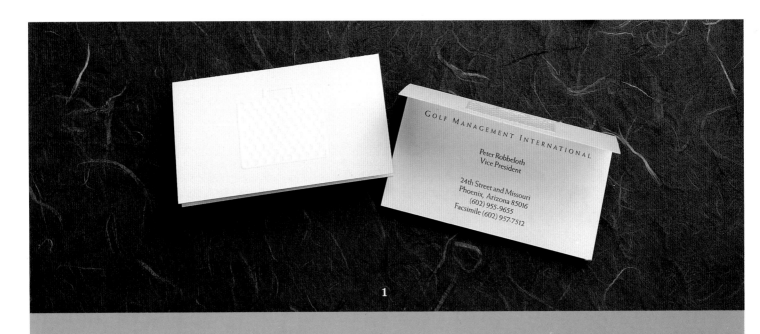

GOLF MANAGEMENT INTERNATIONAL

Peter Robbeloth
Vice President

24th Street and Missouri
Phoenix, Arizona 85016
(602) 955-9655
Facsimile (602) 957-7512

1

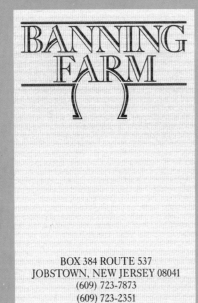

BOX 384 ROUTE 537
JOBSTOWN, NEW JERSEY 08041
(609) 723-7873
(609) 723-2351

DANA B. KATSELAS

❷

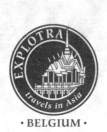

· BELGIUM ·

**Patrick Crépin**
DIRECTEUR

RUE LEOPOLD 10 · B-6000 CHARLEROI
TEL: 32 (0)71 32 15 15 · FAX: 071/33 36 03

❸

ST. CLEMENT

Nicole Busher
Public Relations
Manager

St. Clement Vineyards
2867 St. Helena Hwy. N.
St. Helena, California 94574
707-963-7221
FAX 707-963-9174

❹

❶
**DESIGN FIRM**
HEIDEN STUDIO
**ART DIRECTOR**
STEPHEN HEIDEN
**DESIGNER**
STEPHEN HEIDEN
**ILLUSTRATOR**
STEPHEN HEIDEN
**CLIENT**
ANN AYLWIN/WEPA

❷
**DESIGN FIRM**
ADELE BASS & CO. DESIGN
**ART DIRECTOR**
ADELE BASS
**DESIGNER**
ADELE BASS
**ILLUSTRATOR**
ADELE BASS
**CLIENT**
COASTLINE CONSTRUCTION

❸
**DESIGN FIRM**
PEDERSEN GESK
**DESIGNER**
MITCHELL LINDGREN
**CLIENT**
LOVETT STURGIS
GROUP

❹
**DESIGN FIRM**
ORTEGA DESIGN
**ART DIRECTOR**
JOANN ORTEGA
**DESIGNER**
SUSANN ORTEGA
**ILLUSTRATOR**
SUSANN ORTEGA
**CLIENT**
WHITING NURSERY

❺
**DESIGN FIRM**
JILL TANENBAUM
GRAPHIC DESIGN
**ART DIRECTOR**
JILL TANENBAUM
**DESIGNER**
JILL TANENBAUM
**ILLUSTRATOR**
ELISE MAHAFFIE
**CLIENT**
BEACON HILL
APARTMENTS

❶

❹

❷

❸

❺

❶
**DESIGN FIRM**
S&N DESIGN
**ART DIRECTOR**
STEVEN A. LEE
**DESIGNER**
STEVEN A. LEE
**CLIENT**
FOX APPRAISAL
CONSULTANTS

❷
**DESIGN FIRM**
POWER DESIGN
**DESIGNER**
PAT POWER
**CLIENT**
RALPH COLE, JR.

❸
**DESIGN FIRM**
TED POPOWITZ
DESIGN
**ART DIRECTOR**
TED POPOWITZ
**DESIGNER**
TED POPOWITZ
**CLIENT**
TED POPOWITZ

❹
**DESIGN FIRM**
SH! GRAPHICS
**ART DIRECTOR**
SUSAN HUTTON
**DESIGNER**
SUSAN HUTTON
**ILLUSTRATOR**
SUSAN HUTTON
**CLIENT**
SUSAN HUTTON

**❶**

**DESIGN FIRM**
THEODORE C. ALEXANDER, JR.
**ART DIRECTOR**
THEODORE C. ALEXANDER, JR.
**DESIGNER**
THEODORE C. ALEXANDER, JR.
**ILLUSTRATOR**
THERESE M. ALEXANDER
**CLIENT**
TWO FRIENDS, LTD.

**❷**

**DESIGN FIRM**
BORCHEW DESIGN GROUP INC.
**ART DIRECTOR**
MICHAEL BORCHEW
**DESIGNER**
JACKIE BORCHEW
**ILLUSTRATOR**
JACKIE BORCHEW
**CLIENT**
MICHAEL E. KELLY, M.D.

**❸**

**DESIGN FIRM**
LINNEA GRUBER
DESIGN
**ART DIRECTOR**
LINNEA GRUBER
**DESIGNER**
LINNEA GRUBER
**ILLUSTRATOR**
LINNEA GRUBER
**CLIENT**
MIKE HERNACKI

**❹**

**DESIGN FIRM**
THOM PETERSEN
**ART DIRECTOR**
THOM PETERSEN
**DESIGNER**
THOM PETERSEN
**ILLUSTRATOR**
THOM PETERSEN
**CLIENT**
THOM PETERSEN

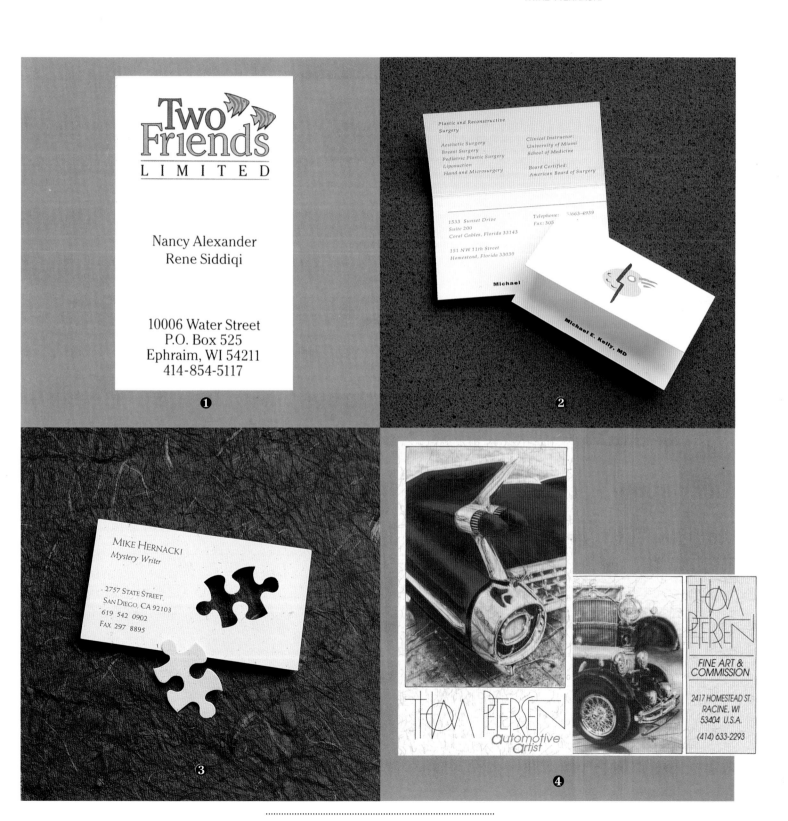

**❶**
**DESIGN FIRM**
SHARP DESIGNS
**DESIGNER**
STEPHANIE SHARP
**CLIENT**
SHARP DESIGNS

**❷**
**DESIGN FIRM**
CHERYL WALIGORY
DESIGN
**DESIGNER**
CHERYL WALIGORY
**CLIENT**
DENNIS MOSNER
PHOTOGRAPHY

**❸**
**DESIGN FIRM**
MICHAEL STANARD, INC.
**ART DIRECTOR**
MICHAEL STANARD
**DESIGNER**
LISA FINGERHUT
**CLIENT**
ANN HASKEL, PROFESSIONAL WEIGHT
TRAINING FOR WOMEN

**❹**
**DESIGN FIRM**
JOHN KNEAPLER
DESIGN
**ART DIRECTOR**
JOHN KNEAPLER
**DESIGNER**
JOHN KNEAPLER
**CLIENT**
JOHN KNEAPLER

**❺**
**DESIGN FIRM**
ALBERT JUAREZ
**ART DIRECTOR**
ALBERT JUAREZ
**DESIGNER**
ALBERT JUAREZ
**CLIENT**
ALBERT JUAREZ

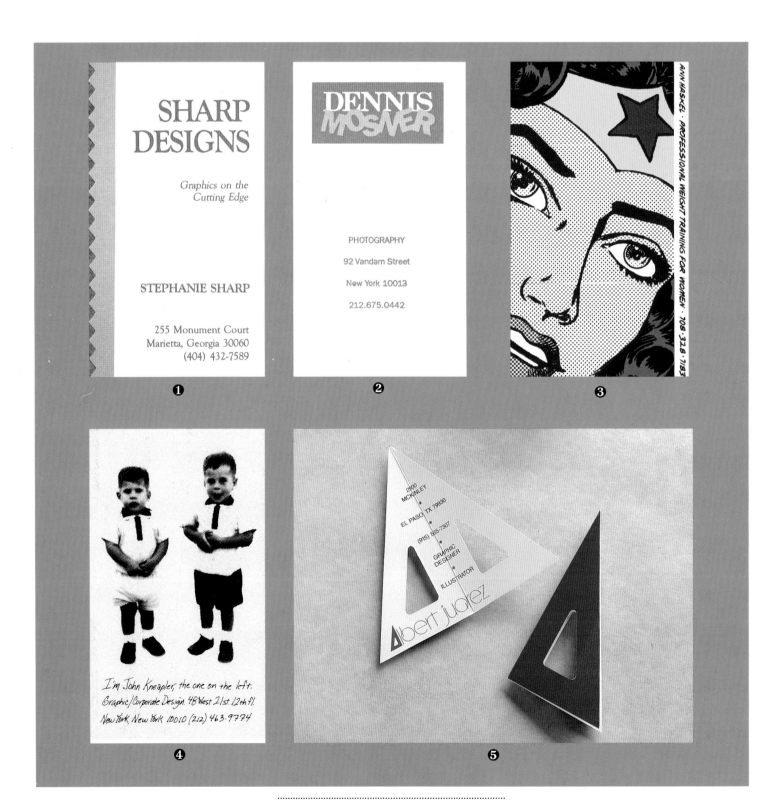

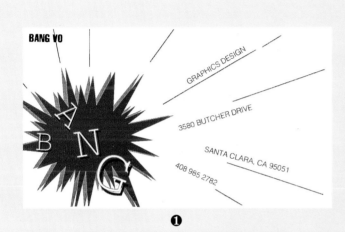

❶

❷

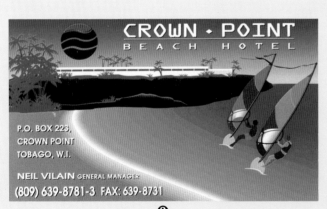

❸

❹

❺

❻

**❶**
**DESIGN FIRM**
HORNALL ANDERSON DESIGN WORKS, INC.
**ART DIRECTOR**
JACK ANDERSON
**DESIGNER**
JACK ANDERSON, HEIDI HATLESTAD,
DENISE WEIR
**CLIENT**
SIX SIGMA

**❷**
**DESIGN FIRM**
EYMONT KIN-YEE
HULETT PTY. LTD.
**ART DIRECTOR**
ANNA EYMONT
**DESIGNER**
ANNA EYMONT
**CLIENT**
DISCWARE
COMPUTERS

**❸**
**DESIGN FIRM**
CHAMP/COTTER
**DESIGNER**
HEATHER CHAMP
**CLIENT**
CLAIRE CHAMP

**❹**
**DESIGN FIRM**
SIEBERT DESIGN
ASSOCIATES
**ART DIRECTOR**
LORI SIEBERT
**DESIGNER**
BARB RAYMOND
**CLIENT**
WYATT DESIGN
ASSOCIATES

**❺**
**DESIGN FIRM**
THARP DID IT
**DESIGNER**
RICK THARP
**ILLUSTRATOR**
KIM TOMLINSON
**CLIENT**
THE DANDY CANDY
MAN

**❶**
**DESIGN FIRM**
ICONS
**ART DIRECTOR**
GLENN SCOTT JOHNSON
**DESIGNER**
GLENN SCOTT JOHNSON
**ILLUSTRATOR**
GLENN SCOTT JOHNSON
**CLIENT**
ICONS

**❷**
**DESIGN FIRM**
DESIGN GROUP
COOK
**ART DIRECTOR**
KEN COOK
**DESIGNER**
KEN COOK
**CLIENT**
PAT EDWARDS
PHOTOGRAPHY

**❸**
**DESIGN FIRM**
MICHAEL STANARD,
INC.
**ART DIRECTOR**
LISA FINGERHUT
**DESIGNER**
MICHAEL STANARD
**CLIENT**
DENISE STANARD,

**1**
**DESIGN FIRM**
DAVID HEALY STUDIO
**ART DIRECTOR**
DAVID HEALY
**DESIGNER**
DAVID HEALY
**CLIENT**
DAVID HEALY

**2**
**DESIGN FIRM**
SOPHISTICATED DOG
**ART DIRECTOR**
KEN MORRIS
**DESIGNER**
KEN MORRIS
**ILLUSTRATOR**
KEN MORRIS
**CLIENT**
SOPHISTICATED DOG
DESIGN GROUP

**3**
**DESIGN FIRM**
MARLENE
MONTGOMERY
DESIGN
**ART DIRECTOR**
MARLENE
MONTGOMERY
**DESIGNER /
ILLUSTRATOR**
MARLENE
MONTGOMERY
**CLIENT**
MARLENE
MONTGOMERY

**4**
**DESIGN FIRM**
THARP DID IT
**CLIENT**
COLLEEN SULLIVAN

**5**
**DESIGN FIRM**
ERIC ROINESTAD
DESIGN
**ART DIRECTOR**
ERIC ROINESTAD
**DESIGNER**
ERIC ROINESTAD
**CLIENT**
THE UNDERGROUND
(PRODUCTION
COMPANY)

**6**
**DESIGN FIRM**
GESCHKE GRAPHICS
**ART DIRECTOR**
RODNEY GESCHKE
**DESIGNER**
RODNEY GESCHKE
**CLIENT**
MICHAEL PETITTI,
SERGEANT
CLEVELAND POLICE
DEPT.

**❶**
**DESIGN FIRM**
LIPSON ALPORT
GLASS &
ASSOCIATES
**ART DIRECTOR**
STAN BROD
**DESIGNER**
STAN BROD
**CLIENT**
MONTAGE
DOCUMENTATION

**❷**
**DESIGN FIRM**
RICKABAUGH
GRAPHICS
**ART DIRECTOR**
ERIC RICKABAUGH
**DESIGNER**
ERIC RICKABAUGH
**ILLUSTRATOR**
ERIC RICKABAUGH
**CLIENT**
RICKABAUGH
GRAPHICS

**❸**
**DESIGN FIRM**
GRAPHIC PARTNERS
**DESIGNER**
KEN CRAIG
**CLIENT**
GRAPHIC PARTNERS

**❹**
**DESIGN FIRM**
ADAM COHEN
ILLUSTRATOR
**ART DIRECTOR**
SUSSAN
GIALLOMBARDO
**DESIGNER**
SUSSAN
GIALLOMBARDO
**ILLUSTRATOR**
ADAM COHEN
**CLIENT**
ADAM COHEN
ILLUSTRATOR

**Montage Documentation**

Case Clements

428 Ada Street
Cincinnati, Ohio
45219

Phone 513-684-9742
CompuServe 72047, 2521
MCI Mail 5417124

❶

❸

384
WEST
JOHNSTOWN
ROAD
GAHANNA
OHIO
43230
FAX
(614)
337-2197
ERIC
RICKABAUGH
PRESIDENT

6
1
4
3
3
7
2
2
2
9

**P H O N E**

❷

adam cohen
illustrator 96 gree

adam cohen
illustrator 96 greenwich ave ny ny 10011 212-691-4074

❹

❶
**DESIGN FIRM**
MERVIL PAYLOR
DESIGN
**DESIGNER**
MERVIL M. PAYLOR
**CLIENT**
ENA SWANSEA
PAINTING

❷
**DESIGN FIRM**
COLONNA FARRELL
DESIGN
**ART DIRECTOR**
TONY AUSTON
**DESIGNER**
TONY AUSTON
**CLIENT**
DAVID BISHOP
PHOTOGRAPHY &
ILLUSTRATION

❸
**DESIGN FIRM**
BARRY POWER
GRAPHIC DESIGN
**ART DIRECTOR**
BARRY POWER
**DESIGNER**
BARRY POWER
**ILLUSTRATOR**
BARRY POWER
**CLIENT**
BARRY POWER

❹
**DESIGN FIRM**
DESIGN FARM INC.
**ART DIRECTOR**
SUSAN SYLVESTER
**DESIGNER**
SUSAN SYLVESTER
**ILLUSTRATOR**
SUSAN SYLVESTER
**CLIENT**
DESIGN FARM

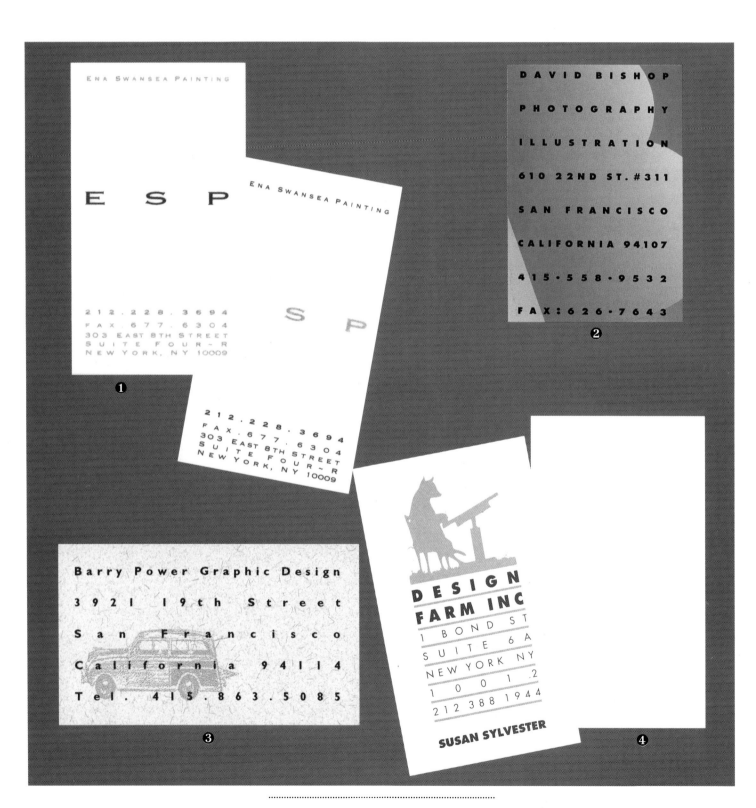

❶
**DESIGN FIRM**
WALLACE CHURCH
ASSOCIATES, INC.
**ART DIRECTOR**
STANLEY CHURCH
**DESIGNER**
STANLEY CHURCH,
JOE CUTICONE
**ILLUSTRATOR**
JOE CUTICONE
**CLIENT**
SHAW NAUTICAL

❷
**DESIGN FIRM**
ROCHELLE SELTZER
DESIGN
**ART DIRECTOR**
ROCHELLE SELTZER
**DESIGNER**
ROCHELLE SELTZER
**CLIENT**
ROCHELLE SELTZER

❸
**DESIGN FIRM**
GLENN MARTINEZ &
ASSOCIATES
**ART DIRECTOR**
KATHLEEN NELSON
**DESIGNER**
GLENN MARTINEZ
**CLIENT**
JUST YOUR TYPE
SERVICE BUREAU

❹
**DESIGN FIRM**
WESTWOOD &
ASSOCIATES
**ART DIRECTOR**
DAVID WESTWOOD
**DESIGNER**
DAVID WESTWOOD
**CLIENT**
WESTWOOD &
ASSOCIATES

❶

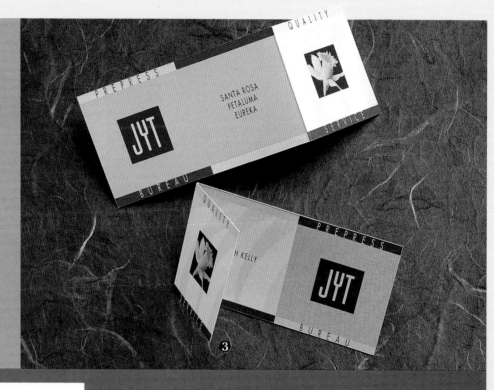

❸

Marketing tools
specifically targeted
to client objectives:

Identity Programs
Packaging
Collateral
Direct Response
Advertising
Posters

❷

❹

**❶**

**DESIGN FIRM**
GRAPHIC PARTNERS
**DESIGNER**
MARK ROSS
**CLIENT**
ORR MACQUEEN
W.S. CORPORATE
& COMMERCIAL
SOLICITORS

**❷**

**DESIGN FIRM**
LORNA STOVALL
DESIGN
**ART DIRECTOR**
LORNA STOVALL
**DESIGNER**
LORNA STOVALL
**CLIENT**
PRINTOLOGY

**❸**

**DESIGN FIRM**
CHAMP/COTTER
**DESIGNER**
HEATHER CHAMP
**CLIENT**
SUZAN PIOVATY
DESIGNER

**❹**

**DESIGN FIRM**
PLANET DESIGN CO.
**ART DIRECTOR**
PLANET DESIGN CO.
**DESIGNER**
PLANET DESIGN CO.
**CLIENT**
LINDSAY, STONE & BRIGGS ADVERTISING INC.

**❺**

**DESIGN FIRM**
JEFF LABBÉ
**ILLUSTRATOR**
JEFF LABBÉ
**DESIGNER**
JEFF LABBÉ
**CLIENT**
JEFF LABBÉ

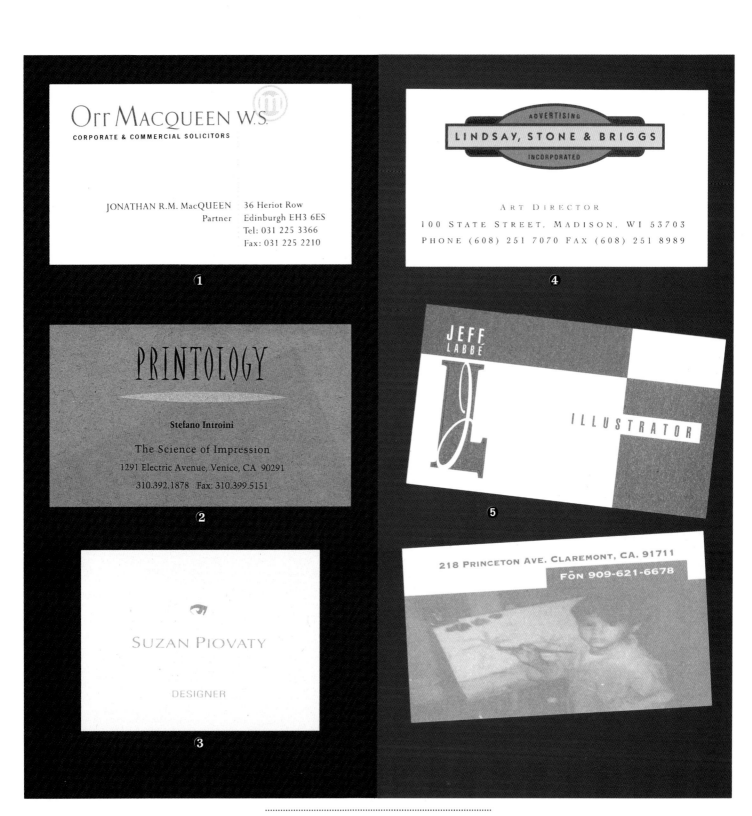

❶

**DESIGN FIRM**
JANN CHURCH
PARTNERS
ADVERTISING &
GRAPHIC DESIGN,
INC.
**ART DIRECTOR**
JANN CHURCH
**DESIGNER**
JANN CHURCH
**CLIENT**
HOLDEN
PHOTOGRAPHY

❷

**DESIGN FIRM**
DZN, THE DESIGN
GROUP
**ART DIRECTOR**
NORM UNG
**DESIGNER**
FELICE MATARÉ
**CLIENT**
DZN, THE DESIGN
GROUP

❸

**DESIGN FIRM**
TYLER BLIK DESIGN
**ART DIRECTOR**
TYLER BLIK
**DESIGNER**
TYLER BLIK
**CLIENT**
OWEN MCGOLDRICK
PHOTOGRAPHY

❹

**DESIGN FIRM**
CLIFFORD SELBERT
DESIGN
**ART DIRECTOR**
CLIFFORD SELBERT,
LIZ ROTTER
**DESIGNER**
LIZ ROTTER
**CLIENT**
DONNA CONRAD

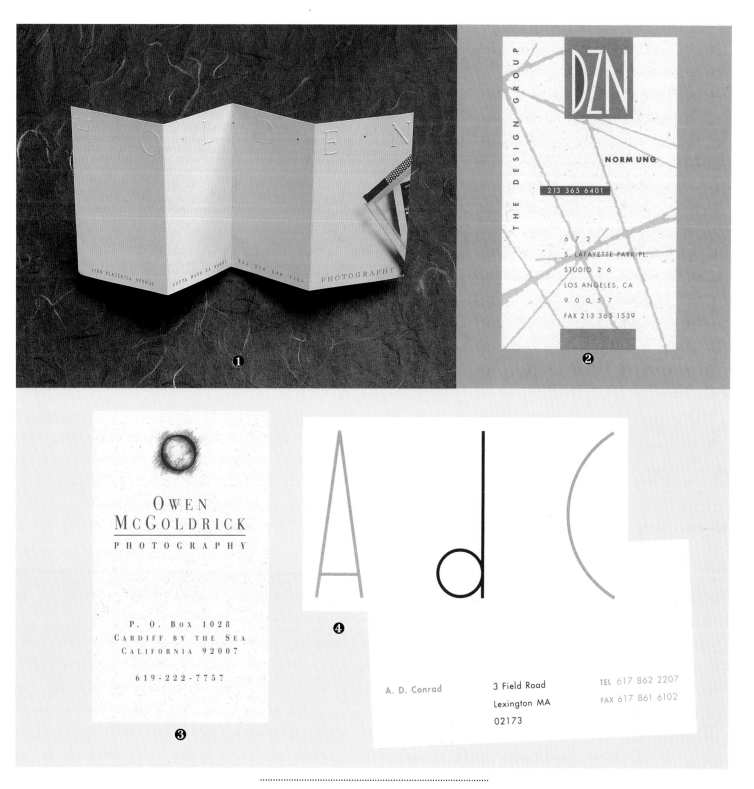

**❶**
**DESIGN FIRM**
BARRY POWER
GRAPHIC DESIGN
**ART DIRECTOR**
BARRY POWER
**DESIGNER**
BARRY POWER
**CLIENT**
JULIAN FAULKNER

**❷**
**DESIGN FIRM**
MICHAEL STANARD,
INC.
**ART DIRECTOR**
LISA FINGERHUT
**DESIGNER**
MARCOS CHAVEZ
**CLIENT**
VICTORIA RENEE
SNYDER,
ARCHITECTURE/INTER
IORS

**❸**
**DESIGN FIRM**
KIRBAN TYPE &
DESIGN, INC.
**ART DIRECTOR**
EILEEN KIRBAN
**DESIGNER**
EILEEN KIRBAN
**CLIENT**
ELIZABETH LANNING
& DIEANNA BALL

**❹**
**DESIGN FIRM**
ADAMS ART
**DESIGNER**
CHERYL O. ADAMS
**ILLUSTRATOR**
CHERYL O. ADAMS
**CLIENT**
CHERYL O. ADAMS

**❶**
**DESIGN FIRM**
FRANK BASEMAN
GRAPHIC DESIGN
**ART DIRECTOR**
FRANK BASEMAN
**DESIGNER**
FRANK BASEMAN
**ILLUSTRATOR**
FRANK BASEMAN
**CLIENT**
CHOUETTE, LTD.

**❷**
**DESIGN FIRM**
JACOBSEN & FREY
DESIGN
**DESIGNER**
CHERYL JACOBSEN
**CALLIGRAPHER**
CHERYL JACOBSEN
**PRINTER**
JANICE FREY
**CLIENT**
JENNIFER BELL

**❸**
**DESIGN FIRM**
JUST YOUR TYPE
**ART DIRECTOR**
RONNIE ARREDONDO
**DESIGNER**
RONNIE ARREDONDO
**CLIENT**
JUST YOUR TYPE

**❹**
**DESIGN FIRM**
TAB GRAPHICS
DESIGN
**ART DIRECTOR**
TANIS BULA
**DESIGNER**
TANIS BULA
**CLIENT**
TAB GRAPHICS
DESIGN

**❶**
**DESIGN FIRM**
GRAPHIC PARTNERS
**DESIGNER**
MARK ROSS
**CLIENT**
JONATHAN CASTLE
COPYWRITER

**❷**
**DESIGN FIRM**
BARRY POWER
GRAPHIC DESIGN
**ART DIRECTOR**
BARRY POWER
**DESIGNER**
BARRY POWER
**CLIENT**
MIKE LUKE C.M.T.

**❸**
**DESIGN FIRM**
BARRY POWER
GRAPHIC DESIGN
**ART DIRECTOR**
BARRY POWER
**DESIGNER**
BARRY POWER
**CLIENT**
MIKE LUKE C.M.T.

**❹**
**DESIGN FIRM**
WHITNEY-EDWARDS
DESIGN
**ART DIRECTOR**
CHARLENE WHITNEY
EDWARDS
**DESIGNER**
BARBI J.
CHRISTOPHER
**CLIENT**
QUEEN ANNE'S
COUNTY VISITORS
SERVICE

❶

❷    ❸    ❹

**❶**

**DESIGN FIRM**
JRDC
**ART DIRECTOR**
JUDI RADICE, KENICHI NISHIWAKI
**DESIGNER**
ANTHONY LUK
**ILLUSTRATOR**
ANTHONY LUK
**CLIENT**
CARNEROS ALAMBIC DISTILLERY

**❷**

**DESIGN FIRM**
HIXSON DESIGN
**DESIGNER**
GARY HIXSON
**CLIENT**
FOXTAIL FLOWERS

**❸**

**DESIGN FIRM**
TANGRAM STRATEGIC
DESIGN
**ART DIRECTOR**
ANTONELLA TREVISAN
**DESIGNER**
ANTONELLA TREVISAN
**CLIENT**
IL BUCCHERO

❶ ❷ ❸

❶
**DESIGN FIRM**
MERVIL PAYLOR
DESIGN
**DESIGNER**
MERVIL M. PAYLOR
**CLIENT**
MELISSA STONE

❷
**DESIGN FIRM**
DESIGN FARM INC.
**ART DIRECTOR**
SUSAN SYLVESTER
**DESIGNER**
SUSAN SYLVESTER
**ILLUSTRATOR**
SUSAN SYLVESTER
**CLIENT**
CAMEO MODELS

❸
**DESIGN FIRM**
FASSINO/DESIGN
**ART DIRECTOR**
DIANE FASSINO
**DESIGNER**
DIANE FASSINO
**CLIENT**
FASSINO/DESIGN

❹
**DESIGN FIRM**
GREGORY SMITH DESIGN
**ART DIRECTOR**
GREGORY L. SMITH
**DESIGNER**
GREGORY L. SMITH
**ILLUSTRATOR**
GREGORY L. SMITH
**CLIENT**
GREGORY SMITH DESIGN

❺
**DESIGN FIRM**
LEEANN BROOK
DESIGN
**ART DIRECTOR**
LEEANN BROOK
**CLIENT**
EMPIRE MEDICAL
MANAGEMENT

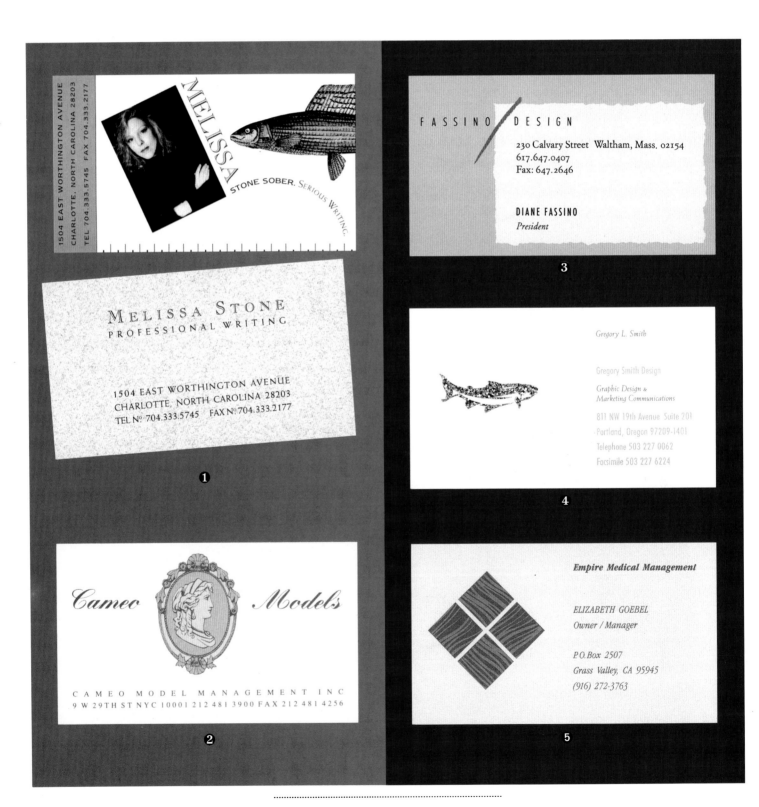

**❶**

**DESIGN FIRM**
ANTERO FERREIRA DESIGN
**ART DIRECTOR**
ANTERO FERREIRA
**DESIGNER**
ANTERO FERREIRA, EDUARDO SOTTO MAYOR
**ILLUSTRATOR**
EDUARDO SOTTO MAYOR
**CLIENT**
PADARIA CRISTAL

**❷**

**DESIGN FIRM**
TANGRAM STRATEGIC
DESIGN
**ART DIRECTOR**
ENRICO SEMPI
**DESIGNER**
ENRICO SEMPI
**CLIENT**
ELIANA LORENA

**❸**

**DESIGN FIRM**
MICHAEL STANARD,
INC.
**ART DIRECTOR**
MICHAEL STANARD
**DESIGNER**
LISA FINGERHUT
**CLIENT**
CALEDONIAN
INCORPORATED

**❹**

**DESIGN FIRM**
PETER HOLLINGSWORTH & ASSOCIATES
**DESIGNER**
STEVEN JOHN WAMMACK
**CLIENT**
RAY TROXELL ASSOCIATES ARCHITECTS

1

2

3

4

**❶**
**DESIGN FIRM**
DORNSIFE &
ASSOCIATES
**ART DIRECTOR**
CAROL ANNE CRAFT
**DESIGNER**
CAROL ANNE CRAFT
**CLIENT**
FINS

**❷**
**DESIGN FIRM**
DEAN JOHNSON
DESIGN
**ART DIRECTOR**
MIKE SCHWAB
**DESIGNER**
MIKE SCHWAB
**ILLUSTRATOR**
MIKE SCHWAB
**CLIENT**
JOHN T.
CUMMINGS, JR.,
M.D.

**❸**
**DESIGN FIRM**
VOLAN DESIGN
ASSOCIATES
**ART DIRECTOR**
JUSTIN DEISTER
**DESIGNER**
JUSTIN DEISTER
**ILLUSTRATOR**
JUSTIN DEISTER
**CLIENT**
ORCHARDS ATHLETIC
CLUB

**❹**
**DESIGN FIRM**
HORNALL ANDERSON
DESIGN WORKS,
INC.
**ART DIRECTOR**
JANI DREWFS
**DESIGNER**
JANI DREWFS,
MICHELLE RIEB
**CLIENT**
AQUA STAR, INC.

**❺**
**DESIGN FIRM**
HIXSON DESIGN
**DESIGNER**
GARY HIXSON
**CLIENT**
HERON, INC.

**❻**
**DESIGN FIRM**
PORTER/MATJASICH
& ASSOCIATES
**ART DIRECTOR**
ALLEN PORTER
**DESIGNER**
ROBERT RAUSCH
**CLIENT**
VICTORIA FRIGO

**1**
Nicholas L. Garbarini

9460-H
Mira Mesa Blvd.
San Diego
California
92126
619.549.3467

FINS
a Mexican eatery

**2**
INDIANA CENTER FOR NEUROSURGERY

John T. Cummings, Jr., M.D.

1400 N. Ritter Avenue, Suite 479
Indianapolis, Indiana 46219
317 355 1020

**3**
ORCHARDS ATHLETIC CLUB

Cal Nickal
GENERAL PARTNER

289 East 29th Street
Loveland, CO 80538
303-667-3800

**4**
536
Fayette Street
Perth Amboy
New Jersey
08861
908-442-8727
FAX 908-442-8805
A BP Nutrition Company

Aquastar

Allen Rolli
General Manager

**5**
HERON

David P. Rizzo
President

Heron, Inc
214 North Church St/Suite 210
Charlotte, NC 28202
704.375.2811
Fax  375.2871

**6**
WRITING & EDITORIAL SERVICES (505) 986-8896 FAX (505) 986-8798

V

VICTORIA FRIGO

625 CAMINO DEL MONTE SOL    SANTA FE, NEW MEXICO 87501

**❶**
**DESIGN FIRM**
HOFFMAN & ANGELIC
DESIGN
**ART DIRECTOR**
ANDREA HOFFMAN
**DESIGNER**
IVAN ANGELIC
**CALLIGRAPHER**
IVAN ANGELIC
**CLIENT**
HOFFMAN &
ANGELIC DESIGN

**❷**
**DESIGN FIRM**
NATALIE NELSON
KEYSER DESIGN
**ART DIRECTOR**
NATALIE NELSON
KEYSER
**DESIGNER**
NATALIE NELSON
KEYSER
**CLIENT**
NATALIE NELSON
KEYER

**❸**
**DESIGN FIRM**
PETER
HOLLINGSWORTH &
ASSOCIATES
**ART DIRECTOR**
PETER
HOLLINGSWORTH
**DESIGNER**
STEVEN JOHN
WAMMACK
**CLIENT**
FIBERWORK
HANDWOVENS

**❹**
**DESIGN FIRM**
BORCHEW DESIGN
GROUP, INC.
**ART DIRECTOR**
MICHAEL BORCHEW
**DESIGNER**
JACKIE BORCHEW
**ILLUSTRATOR**
JACKIE BORCHEW
**CLIENT**
WOMANCARE

**❺**
**DESIGN FIRM**
THE DESIGN
COMPANY
**ART DIRECTOR**
BUSHA HUSAK
**DESIGNER**
BUSHA HUSAK
**CLIENT**
ANNE WORKS

**❻**
**DESIGN FIRM**
POWER DESIGN
**DESIGNER**
PAT POWER
**CLIENT**
PAT POWER

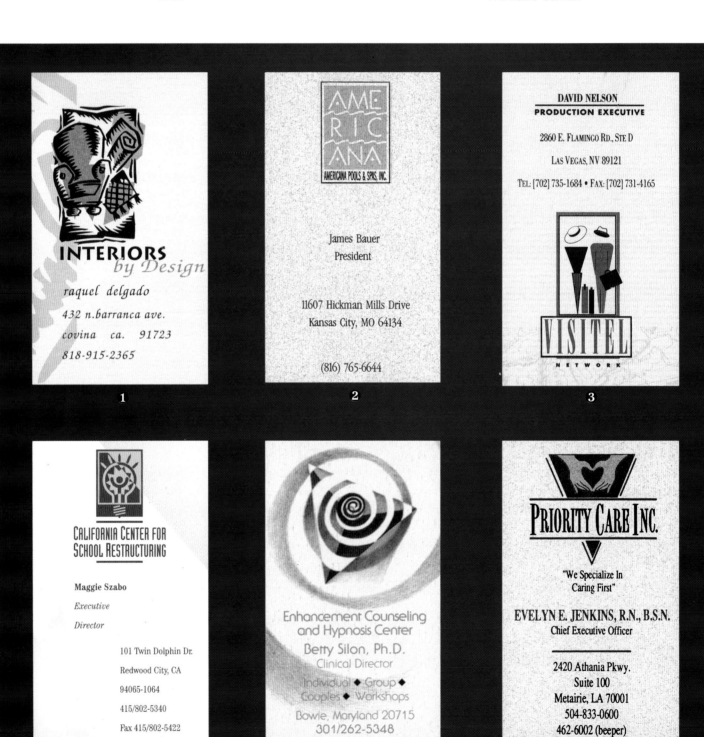

**❶**
**DESIGN FIRM**
CANDY NORTON/GRAPHIC DESIGN
**ART DIRECTOR**
CANDY NORTON
**DESIGNER**
CANDY NORTON
**ILLUSTRATOR**
CANDY NORTON
**CLIENT**
CANDY NORTON/GRAPHIC DESIGN

**❷**
**DESIGN FIRM**
MICHAEL STANARD, INC.
**ART DIRECTOR**
LISA FINGERHUT
**DESIGNER**
MARCOS CHAVEZ
**CLIENT**
LINCX, INC., FINANCIAL MANAGEMENT SERVICES

**❸**
**DESIGN FIRM**
WESTWOOD & ASSOCIATES
**ART DIRECTOR**
DAVID WESTWOOD
**DESIGNER**
DAVID WESTWOOD
**CLIENT**
JOHN MCBRIDE & CO. INC.

**❹**
**DESIGN FIRM**
PETER HOLLINGSWORTH & ASSOCIATES
**DESIGNER**
PETER HOLLINGSWORTH
**CLIENT**
MARTY LENTZ MARKETING COMMUNICATIONS

**❺**
**DESIGN FIRM**
PEDERSEN GESK
**DESIGNER**
MITCHELL LINDGREN
**CLIENT**
HENNEPIN HISTORY MUSEUM

**❻**
**DESIGN FIRM**
DESIGN FARM INC.
**ART DIRECTOR**
SUSAN SYLVESTER
**DESIGNER**
SUSAN SYLVESTER
**ILLUSTRATOR**
SUSAN SYLVESTER
**CLIENT**
CERES

**CN**

Candy Norton
Graphic Design
•
PO Box 151
Essex · MA
01929
•
(508) 768-3430

**❶**

Two North Park Suite 600
8080 Park Lane
Dallas, Texas 75231
214.340.3400

J. Michael Roach

**❷**

**MCB**

John McBride
& Company Inc

John McBride *Director*

1315 S Carmelina Ave
Los Angeles CA 90025
Tel (213) 447 2800
Fax (213) 447 1313

**❸**

Martha W. Lentz

M

**MARTY LENTZ**
MARKETING COMMUNICATIONS

523 Summit Street, Winston-Salem
North Carolina 27101 / 919/724-5311

**❹**

HENNEPIN HISTORY MUSEUM

DOROTHEA
GUINEY
DIRECTOR
2303 THIRD
AVENUE SOUTH
MINNEAPOLIS
MN 55404
612 870 1329

**❺**

CERES
CUSTOM COSMETICS

BROOKE HARGROVE

174 GRAND STREET
SUITE 2B
NEW YORK, NY 10013
212 966 6208

**❻**

**❶**
**DESIGN FIRM**
DEAN JOHNSON
DESIGN
**ART DIRECTOR**
R. LLOYD BROOKS
**DESIGNER**
R. LLOYD BROOKS
**ILLUSTRATOR**
R. LLOYD BROOKS
**CLIENT**
FALLCREEK FAMILY
MEDICINE

**❷**
**DESIGN FIRM**
DUNCAN/DAY
ADVERTISING
**ART DIRECTOR**
STACEY DAY
**ILLUSTRATOR**
STACEY DAY
**CLIENT**
NURSEFINDERS, INC.

**❸**
**DESIGN FIRM**
MARKETING BY
DESIGN
**ART DIRECTOR**
DELLA GILLERAN
**DESIGNER**
JOEL STINGHEN
**ILLUSTRATOR**
JOEL STINGHEN
**CLIENT**
THE PLASTIC
SURGERY CENTER

**❹**
**DESIGN FIRM**
PUCCINELLI DESIGN
**ART DIRECTOR**
KEITH PUCCINELLI /
JOHN DAVIES
**DESIGNER**
KEITH PUCCINELLI
**CLIENT**
JOHN DAVIES

**❺**
**DESIGN FIRM**
MICHAEL STANARD,
INC.
**ART DIRECTOR**
MICHAEL STANARD
**DESIGNER**
LYLE ZIMMERMAN
**CLIENT**
VISION CARE
MANAGEMENT
SYSTEMS

**❻**
**DESIGN FIRM**
WELSH DESIGN
**ART DIRECTOR**
ANNE MARIE WELSH
**DESIGNER**
JENNIFER DELANO
**CLIENT**
LEADING ATTITUDES,
INC.

**Brenda K. Woods**, M.D.

4954 East 56th Street, Suite 15

Indianapolis, Indiana 46220

Telephone (317) 257-2241

❶

**Davies**Communications

*209 East De La Guerra Street*
*Santa Barbara, California 93101*
*telephone: (805) 963-5929*
*telefax: (805) 962-4550*

❹

**Candace J. Alcorn**
*Vice President of Marketing*

**Nursefinders**
*The Professional Choice.*

1200 Copeland Road • Suite 200 • Arlington, TX 76011 • 817/460-1181

❷

**Vision Care Management Systems**

15 Spinning Wheel Road, Suite 10
Hinsdale, Illinois 60521
312.920.1414

**Dr. David M. Sobkowiak, O.D.**

❺

*The*
**PLASTIC**
**SURGERY**
*Center*

**Robert M. Faggella, M.D., F.A.C.S.**
*Certified by the American Board of Plastic Surgery*
*Cosmetic & Reconstructive Surgery*

95 Scripps Drive
Sacramento, CA 95825
916/929-1833
FAX 916/929-6730

❸

**LEADING**
**ATTITUDES**
*INCORPORATED*

2317 Michael Road
Myersville, Maryland 21773

**Barbara Boden**

BUS. 301 696 8818
RES. 301 293 1522

❻

**❶**

**DESIGN FIRM**
TOTO IMAGES INC.
**ART DIRECTOR**
ANDY H. LUN
**DESIGNER**
ANDY H. LUN
**CLIENT**
SO'S (U.S.A.)
COMPANY, INC.

**❷**

**DESIGN FIRM**
SAMENWERKENDE
ONTWERPERS
**ART DIRECTOR**
ANDRE TOET
**DESIGNER**
ANDRÉ TOET
**CLIENT**
PUBLIPARTNERS

**❸**

**DESIGN FIRM**
GREGORY GROUP,
INC.
**ART DIRECTOR**
JON GREGORY
**DESIGNER**
JON GREGORY
**CLIENT**
PARK CITIES
LANDSCAPING
SERVICES

**❹**

**DESIGN FIRM**
SCHOWALTER[2]
DESIGN
**ART DIRECTOR**
TONI SCHOWALTER
**DESIGNER**
TONI SCHOWALTER
**CLIENT**
DECISION
STRATEGIES
INTERNATIONAL

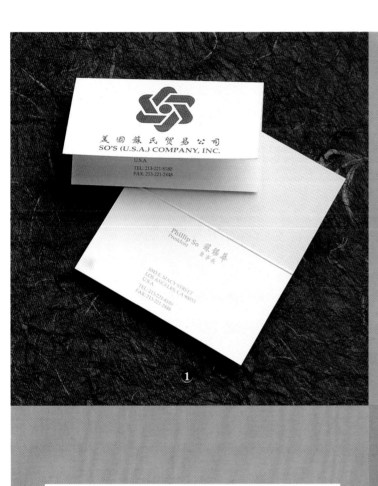

**❶**
**DESIGN FIRM**
EVENSON DESIGN
GROUP
**ART DIRECTOR**
STAN EVENSON
**DESIGNER**
KEN LOH
**CLIENT**
ERAS CENTER

**❷**
**DESIGN FIRM**
MOONINK
COMMUNICATIONS
**ART DIRECTOR**
JOHN DOWNS
**DESIGNER**
JOHN DOWNS
**CLIENT**
MOONINK
COMMUNICATIONS

**❸**
**DESIGN FIRM**
THE PUSHPIN GROUP
**ART DIRECTOR**
SEYMOUR CHWAST
**DESIGNER**
GREG SIMPSON
**CLIENT**
STEPHEN WILKES

**❹**
**DESIGN FIRM**
DE PLANO DESIGN,
INC.
**ART DIRECTOR**
MARCO DE PLANO
**DESIGNER**
ALLISON WRAY
**ILLUSTRATOR**
ALLISON WRAY
**CLIENT**
AMREP
SOLUTIONS, INC.

**❺**
**DESIGN FIRM**
DEVCOM, INC.
**ART DIRECTOR**
STEVEN GROSS
**DESIGNER**
TRACY COLLETTO
**CLIENT**
LIFE MEDICAL
SCIENCES, INC.

**❻**
**DESIGN FIRM**
ROBERT BAILEY
INCORPORATED
**ART DIRECTOR**
ROBERT BAILEY
**DESIGNER**
JOHN WILLIAMS
**CLIENT**
CONSUMER
TECHNOLOGY
NORTHWEST

❶
**DESIGN FIRM**
MCMONIGLE &
SPOONER
**DESIGNER**
JAMIE MCMONIGLE,
STAN SPOONER
**CLIENT**
GATEWAY
EDUCATIONAL
PRODUCTS, LTD.

❷
**DESIGN FIRM**
CHAMP/COTTER
**DESIGNER**
HEATHER CHAMP
**CLIENT**
ANGELYN CHANDLER
ARCHITECT

❸
**DESIGN FIRM**
CARL SELTZER
DESIGN OFFICE
**ART DIRECTOR**
CARL SELTZER
**DESIGNER**
CARL SELTZER
**CLIENT**
CARL SELTZER
DESIGN OFFICE

❹
**DESIGN FIRM**
SAMENWERKENDE
ONTWERPERS
**ART DIRECTOR**
ANDRE TOET
**DESIGNER**
JEROEN KOELEWIJN
**CLIENT**
DE FACTOR M

**❶**
**DESIGN FIRM**
BRITTON DESIGN
**ART DIRECTOR**
PATTI BRITTON
**DESIGNER**
PATTI BRITTON
**ILLUSTRATOR**
PATTI BRITTON
**CLIENT**
BRITTON DESIGN

**❷**
**DESIGN FIRM**
ROBERT BAILEY
INCORPORATED
**DESIGNER**
JOHN WILLIAMS
**ILLUSTRATOR**
CAROLYN COGHLAN
**CLIENT**
OREGON COAST
AQUARIUM

**❸**
**DESIGN FIRM**
LEEANN BROOK
DESIGN
**ART DIRECTOR**
LEEANN BROOK
**CLIENT**
KICKERS

**❹**
**DESIGN FIRM**
TYPO GRAPHIC
**ART DIRECTOR**
ULRICH LANDSHERR
**DESIGNER**
ULRICH LANDSHERR
**CLIENT**
GALA REISEN

**❺**
**DESIGN FIRM**
MARK PALMER DESIGN
**ART DIRECTOR**
MARK PALMER
**DESIGNER**
MARK PALMER
**PRODUCTION**
CURTIS PALMER
**CLIENT**
PETER RABBIT FARMS

❶
**DESIGN FIRM**
MINNIE CHO DESIGN
**ART DIRECTOR**
MINNIE CHO
**DESIGNER**
MINNIE CHO
**ILLUSTRATOR**
MINNIE CHO
**CLIENT**
KOWAL & ASSOCIATES, INC.

❷
**DESIGN FIRM**
JIOBU DESIGN
**ART DIRECTOR**
LAURIE JIOBU
**DESIGNER**
LAURIE JIOBU
**CLIENT**
LAURIE JIOBU

❸
**DESIGN FIRM**
MARKETING DESIGN
ASSOCIATES
**ART DIRECTOR**
KATHLEEN FELIX
**DESIGNER**
KATHLEEN FELIX
**CLIENT**
MARKET WARE

❹
**DESIGN FIRM**
NANCY STUTMAN
CALLIGRAPHICS
**ART DIRECTOR**
JULIE HENSON
**DESIGNER**
JULIE HENSON
**CALLIGRAPHER**
NANCY STUTMAN
**CLIENT**
GENTLE YOGA WITH
NAOMI/THE OFFNER
TEAM

❺
**DESIGN FIRM**
VICTOR CHEONG
DESIGN &
ASSOCIATES
**ART DIRECTOR**
VICTOR CHEONG
**DESIGNER**
VICTOR CHEONG
**CLIENT**
TIM & LYNNE
BRIDGE

❶
**DESIGN FIRM**
HORNALL ANDERSON
DESIGN WORKS
**ART DIRECTOR**
JOHN HORNALL
**DESIGNER**
JOHN HORNALL
**CLIENT**
SMALLWOOD DESIGN
& CONSTRUCTION

❷
**DESIGN FIRM**
XY & I
**ART DIRECTOR**
JANE JEFFREY
**DESIGNER**
JANE JEFFREY
**CLIENT**
XY & I

❸
**DESIGN FIRM**
BEAUCHAMP DESIGN
**ART DIRECTOR**
MICHELE BEAUCHAMP
**DESIGNER**
MICHELE BEAUCHAMP
**CLIENT**
WEARLS CORPORATION

❹
**DESIGN FIRM**
LORNA STOVALL
DESIGN
**ART DIRECTOR**
LORNA STOVALL
**DESIGNER**
LORNA STOVALL
**PHOTOGRAPHER**
MIKE CUKURS
**CLIENT**
MIKE CUKURS

❺
**DESIGN FIRM**
DORNSIFE &
ASSOCIATES
**ART DIRECTOR**
CAROL ANNE CRAFT
**DESIGNER**
CAROL ANNE CRAFT
**CLIENT**
ENDOSCOPIC
TECHNOLOGIES

❶

**DESIGN FIRM**
COLONNA FARRELL
DESIGN
**ART DIRECTOR**
CYNTHIA MAGUIRE
**DESIGNER**
CHRIS MATHES
BALDWIN
**CLIENT**
BIALE VINEYARDS

❷

**DESIGN FIRM**
HARRISBERGER
CREATIVE
**ART DIRECTOR**
LYNN HARRISBERGER
**DESIGNER**
LYNN HARRISBERGER
**ILLUSTRATOR**
LYNN HARRISBERGER
**CLIENT**
MARISA STEELE

❸

**DESIGN FIRM**
ERIC ROINESTAD
DESIGN
**ART DIRECTOR**
ERIC ROINESTAD
**DESIGNER**
ERIC ROINESTAD
**CLIENT**
ERIC ROINESTAD
DESIGN

❹

**DESIGN FIRM**
DESIGN FARM INC.
**ART DIRECTOR**
SUSAN SYLVESTER
**DESIGNER**
SUSAN SYLVESTER
**ILLUSTRATOR**
SUSAN SYLVESTER
**CLIENT**
TOKENS & COINS

**❶**
**DESIGN FIRM**
HIXSON DESIGN
**DESIGNER**
GARY HIXSON
**CLIENT**
LUCIA CASSA

**❷**
**DESIGN FIRM**
ORTEGA DESIGN
**ART DIRECTOR**
JOANN ORTEGA
**DESIGNER**
JOANN ORTEGA, SUSANN ORTEGA
**ILLUSTRATOR**
SUSANN ORTEGA
**CLIENT**
STEVEN AND MARY READ

**❸**
**DESIGN FIRM**
NICHOLAS
ASSOCIATES
**ART DIRECTOR**
NICHOLAS SINADINOS
**DESIGNER**
NICHOLAS SINADINOS,
JAMES CHAMERLIK
**CLIENT**
GATEWAY TO
SANTA FE

**❹**
**DESIGN FIRM**
B.E.P. DESIGN
GROUP
**ART DIRECTOR**
COLIN VALLANCE
**CLIENT**
COLIN VALLANCE

**❺**
**DESIGN FIRM**
BRITTON DESIGN
**ART DIRECTOR**
PATTI BRITTON
**DESIGNER**
PATTI BRITTON
**CLIENT**
VIANSA WINERY

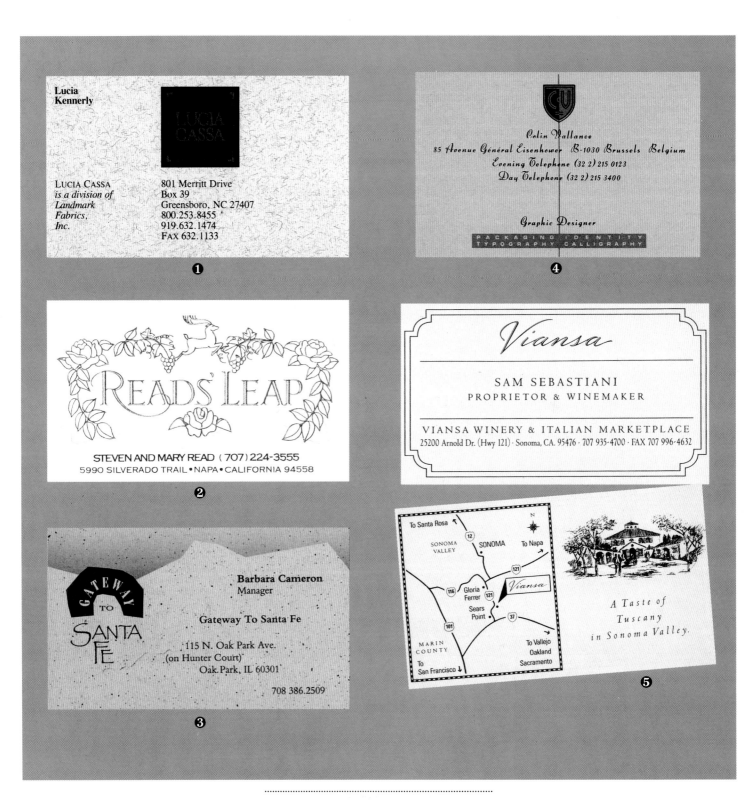

**❶**
**DESIGN FIRM**
HARTMANN &
MEHLER DESIGNERS
GMBH
**ART DIRECTOR**
ROLAND MEHLER
**DESIGNER**
ROLAND MEHLER
**ILLUSTRATOR**
ROLAND MEHLER
**CLIENT**
AMPRO (GERMANY)

**❷**
**DESIGN FIRM**
POWER DESIGN
**DESIGNER**
PAT POWER
**CLIENT**
KATHY KENNEDY

**❸**
**DESIGN FIRM**
LORNA STOVALL
DESIGN
**ART DIRECTOR**
LORNA STOVALL
**DESIGNER**
LORNA STOVALL
**CLIENT**
GOODMAN CHARLTON

**❹**
**DESIGN FIRM**
EILTS ANDERSON
TRACY
**ART DIRECTOR**
PATRICE EILTS, JAN
TRACY
**DESIGNER**
JAN TRACY
**ILLUSTRATOR**
JAN TRACY
**CLIENT**
TRANSITION
MANAGEMENT

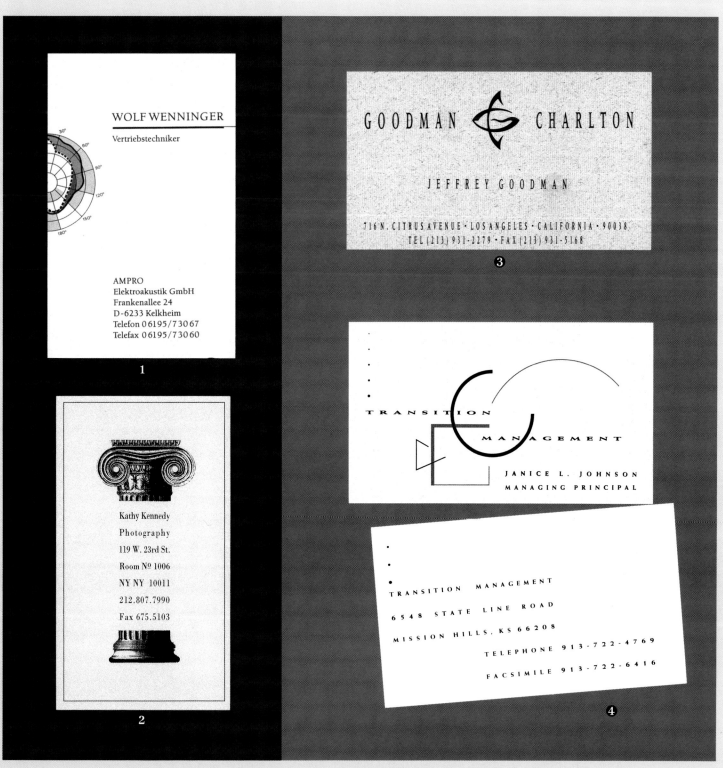

**❶**

**DESIGN FIRM**
DICK JONES
**ART DIRECTOR**
DICK JONES
**DESIGNER**
DICK JONES
**CLIENT**
ILACQUA DIBONA
AND ASSOCIATES

**❷**

**DESIGN FIRM**
EVENSON DESIGN
GROUP
**ART DIRECTOR**
STAN EVENSON
**DESIGNER**
TRICIA RAUEN,
GLENN SAKAMOTO
**CLIENT**
GELFAND, RENNERT
& FELDMAN

**❸**

**DESIGN FIRM**
SCHOWALTER²
DESIGN
**ART DIRECTOR**
TONI SCHOWALTER
**DESIGNER**
TONI SCHOWALTER
**CLIENT**
DAVID SCHOWALTER

**❹**

**DESIGN FIRM**
TANGRAM STRATEGIC
DESIGN
**ART DIRECTOR**
ENRICO SEMPI
**DESIGNER**
ENRICO SEMPI
**CLIENT**
ANTONIO ZUCCONI

**❺**

**DESIGN FIRM**
BB & K DESIGN INC.
**ART DIRECTOR**
DEBORAH BARNETT-
BRANDT
**DESIGNER**
DARLENE VANASCO
**CLIENT**
ICT

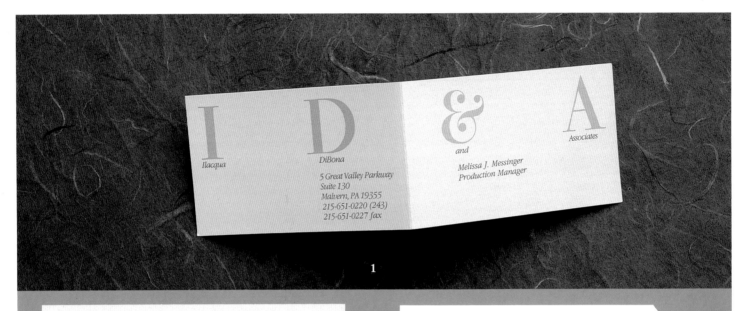

1

❷

❸

❹

❺

❶
**DESIGN FIRM**
QUALLY & COMPANY
INC.
**ART DIRECTOR**
ROBERT QUALLY
**DESIGNER**
ROBERT QUALLY,
HOLLY THOMAS
**ILLUSTRATOR**
HOLLY THOMAS
**CLIENT**
CITYSCAPE
RESTAURANT

❷
**DESIGN FIRM**
AMBROSIA DESIGN
**ART DIRECTOR**
JIM DINVERNO,
BRAD EGNOR
**DESIGNER**
JIM DINVERNO,
BRAD EGNOR
**CLIENT**
AMBROSIA DESIGN

❸
**DESIGN FIRM**
ROCHELLE SELTZER
DESIGN
**ART DIRECTOR**
ROCHELLE SELTZER
**DESIGNER**
ROCHELLE SELTZER
**CLIENT**
LANSDALE
MANUFACTURING,
INC.

❹
**DESIGN FIRM**
BARRY, KNEELAND &
SCHLATTER
**ART DIRECTOR**
RICHARD SCHLATTER
**DESIGNER**
JUDI LYNN
**CLIENT**
BARRY, KNEELAND
& SCHLATTER

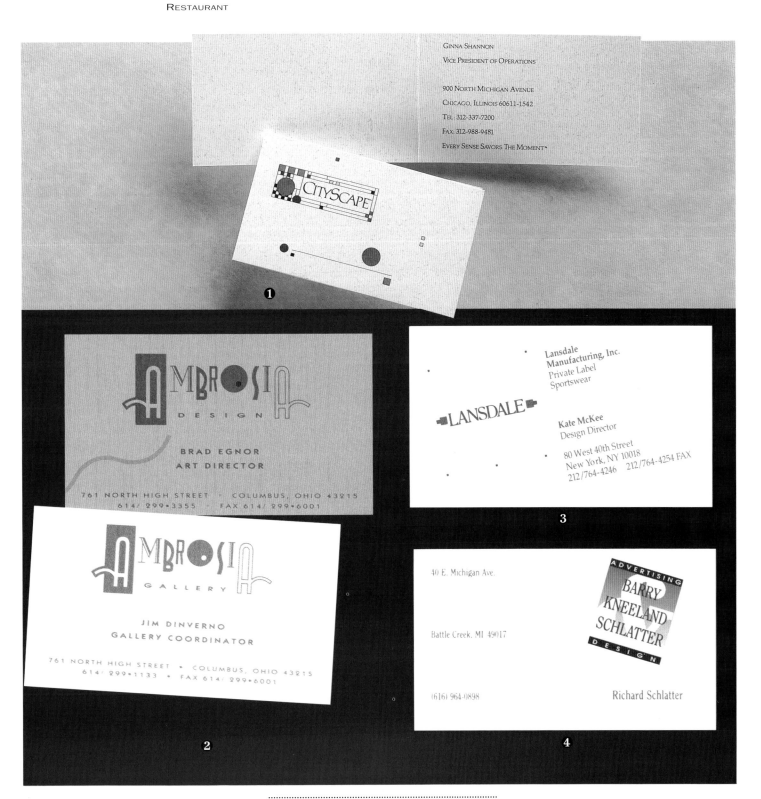

**❶**

**DESIGN FIRM**
CARSTEN-ANDRES
WERNER
**DESIGNER**
CARSTEN-ANDRES
WERNER
**CLIENT**
AUTOMUSEUM STÖRY

**❷**

**DESIGN FIRM**
ANNABEL WIMER
DESIGN
**ART DIRECTOR**
ANNABEL WIMER
**DESIGNER**
ANNABEL WIMER
**CLIENT**
THE DINER

**❸**

**DESIGN FIRM**
HEIDEN STUDIO
**ART DIRECTOR**
STEPHEN HEIDEN
**DESIGNER**
STEPHEN HEIDEN
**ILLUSTRATOR**
STEPHEN HEIDEN
**CLIENT**
SHARKY'S BILLIARD
CLUB

**❹**

**DESIGN FIRM**
WATCH! GRAPHIC
DESIGN
**DESIGNER**
BRUNO WATEL
**ILLUSTRATOR**
BRUNO WATEL
**CLIENT**
ON THE RUN
FOOD CARRY-OUT

**❺**

**DESIGN FIRM**
GABLE DESIGN
GROUP
**ART DIRECTOR**
TONY GABLE
**DESIGNER**
KARIN YAMAGIWA
**ILLUSTRATOR**
KARIN YAMAGIWA
**CLIENT**
DODDIE'S PLACE

Otto Künnecke
St. Adriansplatz 5
3205 Bockenem-Störy
Telefon 0 50 67/7 59

❶

10 East 21st Street, New York City, NY 10010 • (212) 529-8600

❸

Jody Valentine
Manager

**North End Diner**
At the Travelodge
5055 Merle Hay Road
Johnston Iowa 50313

515 276 5151 Telephone
515 276 1709 Fax

Edward F. Tunney
Vice President

8832 W. Dempster
Des Plaines, Illinois
60016
708.296.1111
Fax: 708.299.1035

❹

❷

GENERAL STORE • NEWS & GIFTS
DOLORES' ICE CREAM PARLOR
FREDDIE MAE'S COUNTRY KITCHEN

**WASHINGTON STATE
CONVENTION TRADE CENTER**
800 Convention Place
Suites 401 - 402
Seattle, WA 98101
**tel: 206 623-1253**
fax: 206 447-5388

❺

**❶**
**DESIGN FIRM**
TERRY SWACK
DESIGN ASSOCIATES
**ART DIRECTOR**
TERRY SWACK
**DESIGNER**
JEFFREY GOBIN
**CLIENT**
TERRY SWACK
DESIGN ASSOCIATES

**❷**
**DESIGN FIRM**
SHAHASP HERARDIAN
DESIGN
**DESIGNER**
SHAHASP HERARDIAN
**ILLUSTRATOR**
SHAHASP
HERARDIAN
**CLIENT**
THE ACE CAFE

**❸**
**DESIGN FIRM**
MO VIELE, INC.
**ART DIRECTOR**
MO VIELE
**DESIGNER**
MO VIELE
**CLIENT**
SIGGRAPH 93

**❹**
**ART DIRECTOR**
BANG VO
**DESIGNER**
BANG VO
**ILLUSTRATOR**
BANG VO
**CLIENT**
R. FRIENDS CAFÉ &
PIZZA

**❶**
**DESIGN FIRM**
ARTHUR JOHN L'HOMMEDIEU
**ART DIRECTOR**
ARTHUR JOHN L'HOMMEDIEU
**DESIGNER**
ARTHUR JOHN L'HOMMEDIEU
**ILLUSTRATOR**
ARTHUR JOHN L'HOMMEDIEU
**CLIENT**
ARTHUR JOHN L'HOMMEDIEU

**❷**
**DESIGN FIRM**
JILL TANENBAUM
GRAPHIC DESIGN
INC.
**ART DIRECTOR**
JILL TANENBAUM
**DESIGNER**
JILL TANENBAUM
**ILLUSTRATOR**
JILL TANENBAUM
**CLIENT**
RIMA SCHULKIND

**❸**
**DESIGN FIRM**
SCHOWALTER[2]
DESIGN
**ART DIRECTOR**
TONI SCHOWALTER
**DESIGNER**
TONI SCHOWALTER
**ILLUSTRATOR**
TONI SCHOWALTER
**CLIENT**
JUDY FREEDMAN

**❹**
**DESIGN FIRM**
DESIGN RESOURCES
**ART DIRECTOR**
MICHELLE KIMBALL
**DESIGNER**
MICHELLE KIMBALL
**ILLUSTRATOR**
MICHELLE KIMBALL
**CLIENT**
DESIGN RESOURCES

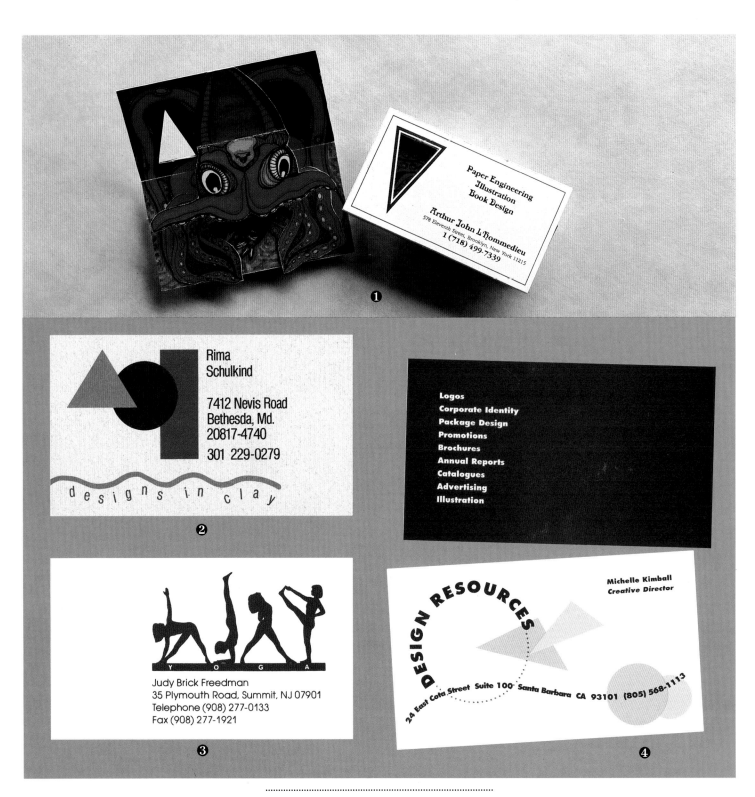

❶
**DESIGN FIRM**
SKYLINE DISPLAYS,
INC.
**ART DIRECTOR**
JEFF JOHNSON
**DESIGNER**
STEVE JAHR
**CLIENT**
SKYLINE DISPLAYS,
INC.

❷
**DESIGN FIRM**
MICHAEL STANARD,
INC.
**ART DIRECTOR**
MARCOS CHAVEZ
**DESIGNER**
MARCOS CHAVEZ
**CLIENT**
DAVID BERK,
POINT ONE MOTORS

❸
**DESIGN FIRM**
BARRY POWER
GRAPHIC DESIGN
**ART DIRECTOR**
BARRY POWER
**DESIGNER**
BARRY POWER
**CLIENT**
KURT BENDIT

❹
**DESIGN FIRM**
MARSH, INC.
**ART DIRECTOR**
GREG CONYERS
**DESIGNER**
GREG CONYERS
**ILLUSTRATOR**
MARK FOX
**CLIENT**
W. BUCKLAND
DOLLS

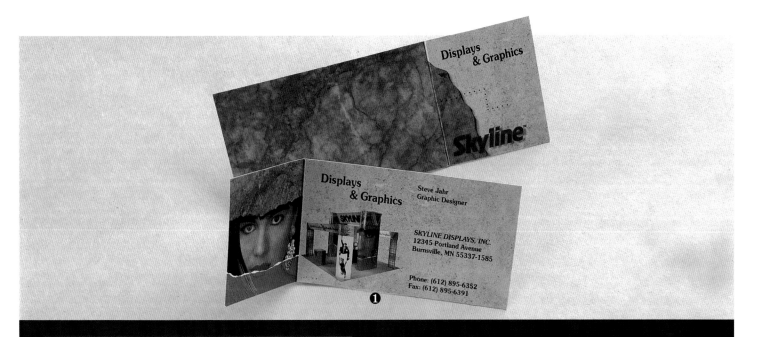

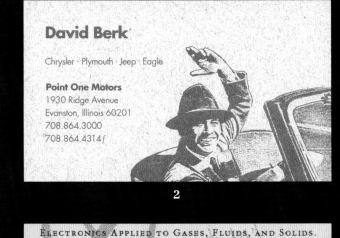

**❶**
**DESIGN FIRM**
MICHAEL STANDARD,
INC.
**ART DIRECTOR**
MARCOS CHAVEZ
**DESIGNER**
MARCOS CHAVEZ
**CLIENT**
WESLEY BENDER
PHOTOGRAPHY

**❷**
**DESIGN FIRM**
DESIGN FARM INC.
**ART DIRECTOR**
SUSAN SYLVESTER
**DESIGNER**
SUSAN SYLVESTER
**ILLUSTRATOR**
SUSAN SYLVESTER
**CLIENT**
JEFF GREENBERG

**❸**
**DESIGN FIRM**
CHAMP/COTTER
**DESIGNER**
HEATHER CHAMP
**CLIENT**
PELSINSKI/
TSURUMAKI

**❹**
**DESIGN FIRM**
DESIGN ASSOCIATES
**ART DIRECTOR**
ALBERT BARRY
**ILLUSTRATOR**
NIGEL HENDRICKSON
**CLIENT**
DENNIS LONGO
ELECTRICIAN

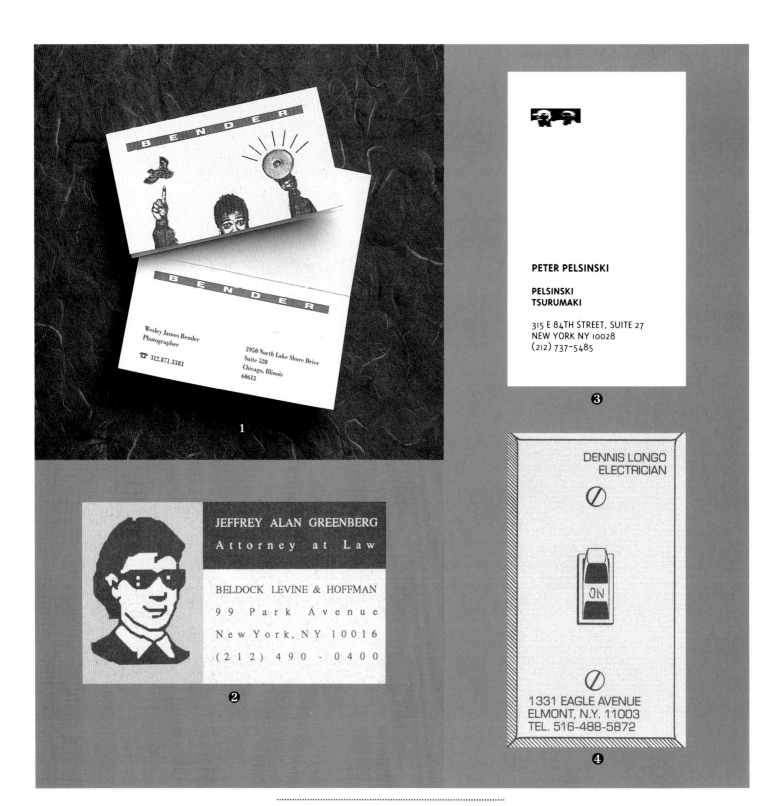

**❶**

**DESIGN FIRM**
BARRY POWER
GRAPHIC DESIGN
**ART DIRECTOR**
BARRY POWER
**DESIGNER**
BARRY POWER
**CLIENT**
BARRY POWER

**❷**

**DESIGN FIRM**
TYPO GRAPHIC
**ART DIRECTOR**
ULRICH LANDSHERR
**DESIGNER**
ULRICH LANDSHERR
**CLIENT**
PETER LUDWIG

**❸**

**DESIGN FIRM**
POWER DESIGN
**DESIGNER**
PAT POWER
**ILLUSTRATOR**
PAT POWER
**CLIENT**
CARRIE LAMSON

**❹**

**DESIGN FIRM**
THARP DID IT
**DESIGNER**
RICK THARP
**CLIENT**
JANA HEER

**❺**

**DESIGN FIRM**
THARP DID IT
**DESIGNER**
RICK THARP
**CLIENT**
RICK THARP

❶

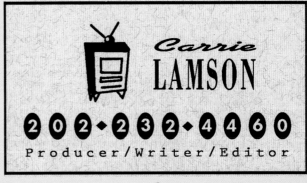

❸

❷

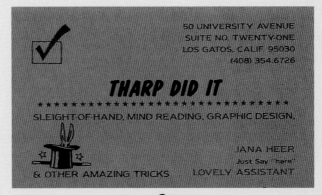

❹

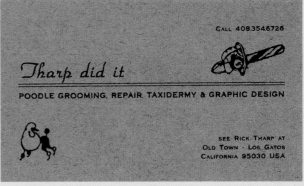

❺

❶
**DESIGN FIRM**
WATCH! GRAPHIC
DESIGN
**DESIGNER**
BRUNO WATEL
**ILLUSTRATOR**
BRUNO WATEL
**CLIENT**
MEANWHILE...

❷
**DESIGN FIRM**
ASCENT
COMMUNICATIONS
**ART DIRECTOR**
ALLEN HAEGER
**DESIGNER**
ALLEN HAEGER
**CLIENT**
LARRY STANLEY

❸
**DESIGN FIRM**
JIM LANGE DESIGN
**ART DIRECTOR**
JIM LANGE
**DESIGNER**
JIM LANGE
**ILLUSTRATOR**
JIM LANGE
**CLIENT**
JIM LANGE DESIGN

❹
**DESIGN FIRM**
DESIGN FARM INC.
**ART DIRECTOR**
SUSAN SYLVESTER
**DESIGNER**
SUSAN SYLVESTER
**ILLUSTRATOR**
SUSAN SYLVESTER
**CLIENT**
VERN CALHOUN

**❶**
**DESIGN FIRM**
ALEX SHEAR &
ASSOCIATES
**ART DIRECTOR**
ANDREW SHEAR
**DESIGNER**
ANDREW SHEAR
**ILLUSTRATOR**
ANDREW SHEAR
**CLIENT**
ANDREW SHEAR

**❷**
**DESIGN FIRM**
SEMAN DESIGN
GROUP
**ART DIRECTOR**
RICHARD M. SEMAN
**DESIGNER**
RICHARD M. SEMAN
**ILLUSTRATOR**
DOUG FREEMAN
**CLIENT**
CYNTHIA THOMASSEY

**❸**
**DESIGN FIRM**
CHRISTINE
HABERSTOCK
**ILLUSTRATOR**
**ART DIRECTOR**
CHRISTINE
HABERSTOCK
**DESIGNER /**
**ILLUSTRATOR**
CHRISTINE
HABERSTOCK
**CLIENT**
SHOOTING STAR

**❹**
**DESIGN FIRM**
JOSEPH DIETER
VISUAL
COMMUNICATIONS
**ART DIRECTOR**
JOSEPH M. DIETER,
JR.
**DESIGNER /**
**ILLUSTRATOR**
JOSEPH M. DIETER,
JR.
**CLIENT**
JOEL KATZ

1

Cynthia Thomassey

**Child Care, Day Care,
Babysitting**

286 Brighton Street
East Pittsburgh, PA 15112

412 824-2992

❷

SHOOTING STAR®
GALLERY

**DIANA LYN**
CURATOR

1441 North McCadden Place
Hollywood, California 90028
Phone (213) 469 2020
Fax (213) 464 0880

❸

Medical Illustration
1124 E. 36th St., Baltimore, MD 21218
301-235-1513

JOEL
KATZ

❹

**❶**

**DESIGN FIRM**
RENNES DESIGN
**ART DIRECTOR**
M. RENNES
**DESIGNER**
M. RENNES
**ILLUSTRATOR**
M. RENNES
**CLIENT**
PREPRESS -
CONSULTING

**❷**

**DESIGN FIRM**
COMMUNICATION
ARTS INCORPORATED
**ART DIRECTOR**
RICHARD FOY
**DESIGNER**
HUGH ENOCKSON
**CLIENT**
ANDY KATZ

**❸**

**DESIGN FIRM**
MCMONIGLE &
SPOONER
**DESIGNER**
STAN SPOONER
**CLIENT**
YOUTH ENTERPRISES

**❹**

**DESIGN FIRM**
PITTARD SULLIVAN
FITZGERALD
**ART DIRECTOR**
ED SULLIVAN
**DESIGNER**
BILL DAWSON
**CLIENT**
NU PICTURES

**❶**
**DESIGN FIRM**
MARK PALMER
DESIGN
**ART DIRECTOR**
MARK PALMER
**DESIGNER**
MARK PALMER
**PRODUCTION**
CURTIS PALMER
**CLIENT**
VASST

**❷**
**DESIGNER**
JODIE STOWE
**CLIENT**
MILLENNIUM
SOFTWARE LABS,
INC.

**❸**
**DESIGN FIRM**
PLANET DESIGN CO.
**ART DIRECTOR**
PLANET DESIGN CO.
**DESIGNER**
PLANET DESIGN CO.
**CLIENT**
DIGISONIX, INC.

**❹**
**DESIGN FIRM**
ORTEGA DESIGN
**ART DIRECTOR**
JOANN ORTEGA,
SUSANN ORTEGA
**DESIGNER**
JOANN ORTEGA,
SUSANN ORTEGA
**ILLUSTRATOR**
SUSANN ORTEGA
**CLIENT**
QUINDECA
CORPORATION

**❺**
**DESIGN FIRM**
MICHAEL STANDARD, INC.
**ART DIRECTOR**
MICHAEL STANDARD
**DESIGNER**
ANN WERNER, MARCOS CHAVEZ
**CLIENT**
SAWTOOTH SOFTWARE

**Vasst Corporation**
68 955 Adelina Road
Cathedral City, CA 92234
**619 325 5234**
FAX 619 322 4179

**Mark Williams**
field coordinator

❶

STUART A. AUSTIN

SALES ENGINEER

COMMERCIAL AND INDUSTRIAL SYSTEMS GROUP

DIGISONIX ∞ ®

8401 MURPHY DR. MIDDLETON, WI 53562-2543

PHONE: 608 828 4204   FAX: 608 836 5999

A DIVISION OF NELSON INDUSTRIES, INC.

❸

JERRY L. SHORT

QUINDECA

117 ATLANTIC AVENUE, SUITE 208, ASPEN, COLORADO 81612 · 303 920-1221
1001 SECOND STREET, SUITE 165, NAPA, CALIFORNIA 94559 · 707 258-2582

❹

1010 El Camino Real, Suite 300
Menlo Park, CA 94025   USA
(415) 321 3720
(415) 321 3650 Fax
jayson@millennium.com

❷

Suzanne Weiss
Director of Marketing
& Sales

Sawtooth Software          1007 Church Street
Suite 302
Evanston, Illinois
60201
312/866-0870

❺

**❶**
**DESIGN FIRM**
WATCH! GRAPHIC
DESIGN
**DESIGNER**
BRUNO WATEL
**ILLUSTRATOR**
BRUNO WATEL
**CLIENT**
BÉTISE - BISTRO ON
THE LAKE

**❷**
**DESIGN FIRM**
GABLE DESIGN
GROUP
**ART DIRECTOR**
TONY GABLE
**DESIGNER**
KARIN YAMAGIWA
**ILLUSTRATOR**
KARIN YAMAGIWA
**CLIENT**
JUSTIN'S SEATTLE
ESPRESSO

**❸**
**DESIGN FIRM**
GABLE DESIGN
GROUP
**ART DIRECTOR**
TONY GABLE
**DESIGNER**
TONY GABLE,
KARIN YAMAGIWA
**ILLUSTRATOR**
KARIN YAMAGIWA
**CLIENT**
ESPRESSO STOP

**❹**
**DESIGN FIRM**
TERRY SWACK
DESIGN ASSOCIATES
**ART DIRECTOR**
TERRY SWACK
**DESIGNER**
KARA NARATH
**ILLUSTRATOR**
TERRY SWACK
**CLIENT**
MARAIS AND ESMÉ

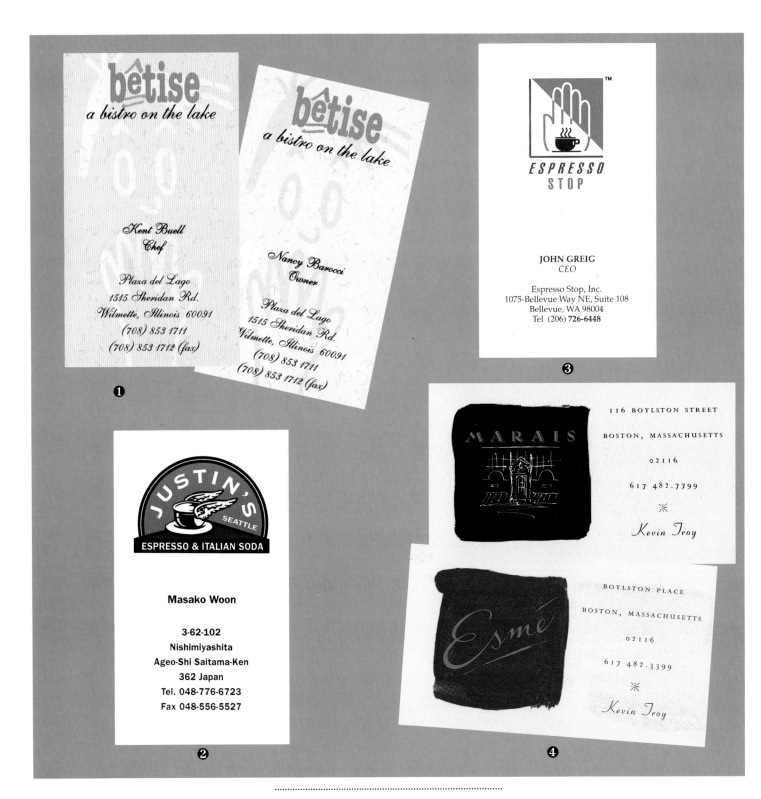

❶
**DESIGN FIRM**
MAMMOLITI CHAN
DESIGN
**ART DIRECTOR**
TONY MAMMOLITI
**DESIGNER**
TONY MAMMOLITI
**ILLUSTRATOR**
TONY MAMMOLITI
**CLIENT**
AMBIENT CONTRACT
INTERIORS

❷
**DESIGN FIRM**
PETER
HOLLINGSWORTH &
ASSOCIATES
**DESIGNER**
PETER
HOLLINGSWORTH
**CLIENT**
WINSTON PRINTING

❸
**DESIGN FIRM**
BINA DESIGNS
**ART DIRECTOR**
BARBARA NEWTON
**DESIGNER**
BARBARA NEWTON
**ILLUSTRATOR**
BARBARA NEWTON
**CLIENT**
BARBARA NEWTON

❹
**DESIGN FIRM**
JOSEPH DIETER VISUAL COMMUNICATIONS
**ART DIRECTOR**
TIM PHELPS & JOSEPH M. DIETER, JR.
**DESIGNER**
JOSEPH M. DIETER, JR.
**CLIENT**
TIM PHELPS / MEDICAL ILLUSTRATOR

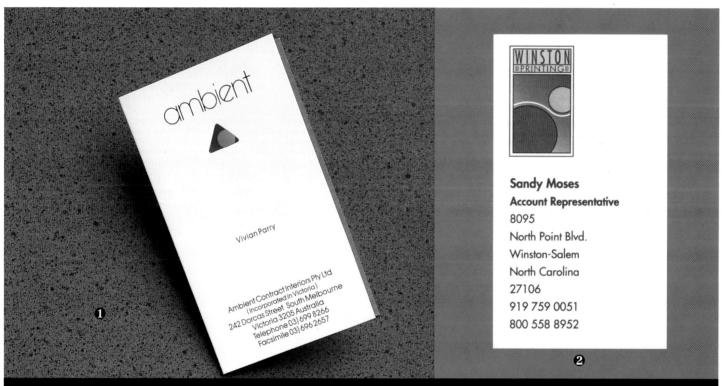

❶
**DESIGN FIRM**
POLLMAN MARKETING
ARTS, INC.
**ART DIRECTOR**
JENNIFER POLLMAN
**DESIGNER**
ANNE WALKER
**CLIENT**
JAITIRE INDUSTRIES

❷
**DESIGN FIRM**
STEPHANIE
McCLINTICK
**DESIGNER**
STEPHANIE
McCLINTICK
**CLIENT**
GREG OWENS
TREE CARE

❸
**DESIGN FIRM**
EPIC (ELITE
PUBLISHING &
IMAGING CENTER)
**ART DIRECTOR**
RODNEY GESCHKE
**DESIGNER**
RODNEY GESCHKE
**CLIENT**
PINEHAVEN
GREENHOUSES

❹
**DESIGN FIRM**
NU VOX
**DESIGNER**
MICHAEL TIEDEMANN
**CLIENT**
C.P.S. HVAC
SERVICES

❺
**DESIGN FIRM**
MARC ENGLISH:
DESIGN
**DESIGNER**
MARC ENGLISH
**CLIENT**
BOSTON FILM/VIDEO
FOUNDATION

❻
**DESIGN FIRM**
MOSCATO
COMMUNICATIONS/
TOUCH MARKETING
**ART DIRECTOR**
GERALD MOSCATO
**DESIGNER**
GERALD MOSCATO
**CLIENT**
NEW CITY YMCA

❶

❹

❷

❺

❸

❻

❶
**DESIGN FIRM**
ADELE BASS & CO.
DESIGN
**ART DIRECTOR**
ADELE BASS
**DESIGNER**
ADELE BASS
**ILLUSTRATOR**
ADELE BASS
**CLIENT**
CAMILO AREVALO

❷
**DESIGN FIRM**
SCHOWALTER²
DESIGN
**ART DIRECTOR**
TONI SCHOWALTER
**DESIGNER**
TONI SCHOWALTER
**CLIENT**
COMMERCIAL DESIGN
GROUP

❸
**DESIGN FIRM**
PEDERSEN GESK
**DESIGNER**
MITCHELL LINDGREN
**CLIENT**
TREND MARKETING

❹
**DESIGN FIRM**
MICHAEL STANARD,
INC.
**ART DIRECTOR**
MICHAEL STANARD
**DESIGNER**
MICHAEL STANARD
**CLIENT**
HAL STANARD
REALTOR

❺
**DESIGN FIRM**
CÓRDOVA DESIGN
**ART DIRECTOR**
CARLOS CÓRDOVA
**DESIGNER**
CARLOS CÓRDOVA
**CLIENT**
CAREY CONTRACTS

**❶**

**DESIGN FIRM**
MARC ENGLISH:
DESIGN
**DESIGNER**
MARC ENGLISH
**CLIENT**
NEWBURY
FILMWORKS, INC.

**❷**

**DESIGN FIRM**
MURRIE LIENHART
RYSNER &
ASSOCIATES
**ART DIRECTOR**
JIM LIENHART
**DESIGNER**
JIM LIENHART
**CLIENT**
MURRIE LIENHART
RYSNER &
ASSOCIATES

**❸**

**DESIGN FIRM**
ANTERO FERREIRA
DESIGN
**ART DIRECTOR**
ANTERO FERREIRA
**DESIGNER**
ANTERO FERREIRA
**CLIENT**
ARTYPRENTA

**❹**

**DESIGN FIRM**
BULLET
COMMUNICATIONS,
INC.
**ART DIRECTOR**
TIM SCOTT
**DESIGNER**
TIM SCOTT
**ILLUSTRATOR**
TIM SCOTT
**CLIENT**
GREG'S BODY SHOP

**❺**

**DESIGN FIRM**
CREATIVE ARTS CO.
**ART DIRECTOR**
GAYLORD BENNETT
**DESIGNER**
GAYLORD BENNETT
**ILLUSTRATOR**
GAYLORD BENNETT
**CLIENT**
MIKE PINTO

**❶**

**❹**

JAMES L. LIENHART
PARTNER, CREATIVE

MURRIE LIENHART RYSNER & ASSOCIATES

■ 58 WEST HURON STREET ▲ CHICAGO, ILLINOIS 60610
● TELEPHONE 312 943 5995  FAX 312 943 6922

**❷**

°artyprenta

Carlos Costa, *Administrador*

RUA DO PRÍNCIPE, 2 1°, 3600 VIGO
TELEFONO 228043, TELEFAX 226599

**❸**

6963 DOUGLAS BOULEVARD. • SUITE 200 • GRANITE BAY, CA 95661
PHONE: 916-791-2531
**MIKE PINTO**

**❺**

❶
**DESIGN FIRM**
BULLET
COMMUNICATIONS,
INC.
**ART DIRECTOR**
TIM SCOTT
**DESIGNER**
TIM SCOTT
**ILLUSTRATOR**
TIM SCOTT
**CLIENT**
BULLET
COMMUNICATIONS,
INC.

❷
**DESIGN FIRM**
NICHOLAS
ASSOCIATES
**ART DIRECTOR**
NICHOLAS SINADINOS
**DESIGNER**
NICHOLAS SINADINOS
**CLIENT**
QUALITY DIRECTIONS,
INC.

❸
**DESIGN FIRM**
HORNALL ANDERSON
DESIGN WORKS,
INC.
**ART DIRECTOR**
JACK ANDERSON
**DESIGNER**
JACK ANDERSON,
DENISE WEIR, LIAN
NG, DAVID BATES
**CLIENT**
STARWAVE
CORPORTAION

❹
**DESIGN FIRM**
ABEYTA DESIGN AND
DIRECTION
**ART DIRECTOR**
STEVEN ABEYTA
**DESIGNER**
STEVEN ABEYTA
**CLIENT**
LAURA SHAEFFER
STYLIST

❺
**DESIGN FIRM**
MORLA DESIGN
**ART DIRECTOR**
JENNIFER MORLA
**DESIGNER**
JENNIFER MORLA,
SHARRIE BROOKS
**CLIENT**
CAPP STREET
PROJECT

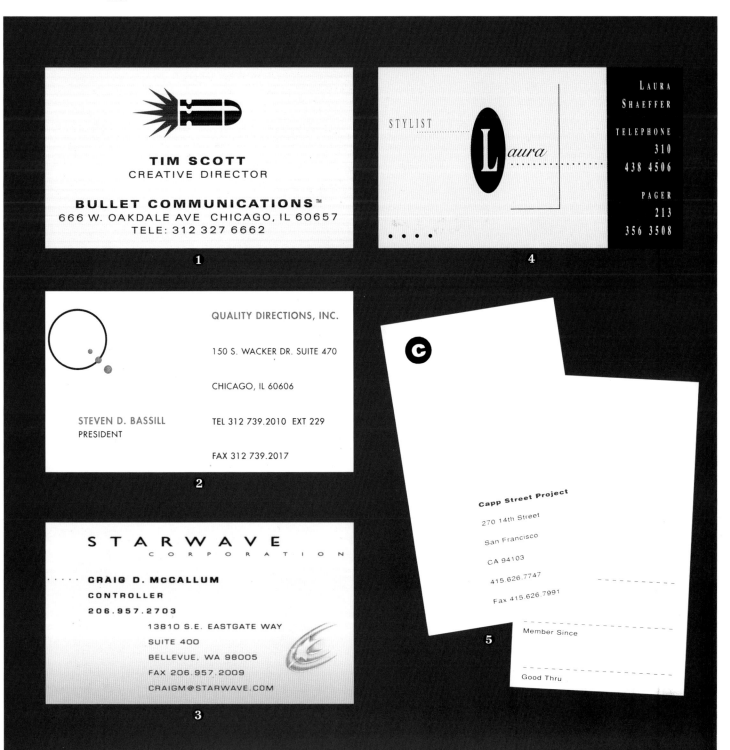

❶
**DESIGN FIRM**
DEAN JOHNSON
DESIGN
**ART DIRECTOR**
MIKE SCHWAB
**DESIGNER**
MIKE SCHWAB
**ILLUSTRATOR**
MIKE SCHWAB
**CLIENT**
THE HOMEWORK
CONNECTION

❷
**DESIGN FIRM**
HIGH
TECHSPLANATIONS,
INC.
**ART DIRECTOR**
MICHAEL J. JAMES
**DESIGNER**
MICHAEL J. JAMES
**ILLUSTRATOR**
MICHAEL J. JAMES
**CLIENT**
HUMANITAS, INC.

❸
**DESIGN FIRM**
EVENSON DESIGN
GROUP
**ART DIRECTOR**
STAN EVENSON
**DESIGNER**
KEN LOH
**CLIENT**
PRIVATE EXERCISE

❹
**DESIGN FIRM**
DEAN JOHNSON
DESIGN
**ART DIRECTOR**
BRUCE DEAN
**DESIGNER**
BRUCE DEAN
**ILLUSTRATOR**
BRUCE DEAN
**CLIENT**
SOME GUYS PIZZA
PASTA GRILL

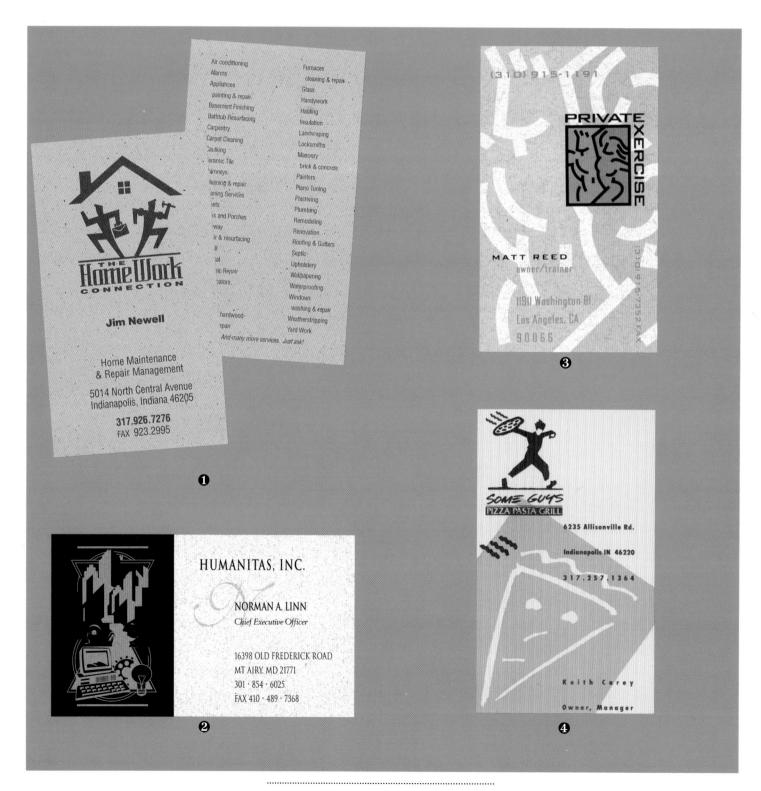

**❶**
**DESIGN FIRM**
MOSCATO
COMMUNICATIONS
**ART DIRECTOR**
GERALD MOSCATO
**DESIGNER**
GERALD MOSCATO
**CLIENT**
GERALD MOSCATO

**❷**
**DESIGN FIRM**
SAMENWERKENDE
ONTWERPERS
**CLIENT**
DA VINCI GROEP

**❸**
**DESIGN FIRM**
JIM LANGE DESIGN
**ART DIRECTOR**
JIM LANGE
**DESIGNER**
JIM LANGE
**ILLUSTRATOR**
JIM LANGE
**CLIENT**
DAVID DEVERICK JR.

**❹**
**DESIGN FIRM**
MURPHY DESIGN,
INC.
**ART DIRECTOR**
MARK MURPHY
**DESIGNER**
MARK MURPHY
**ILLUSTRATOR**
MARK MURPHY
**CLIENT**
BUNDINI SOFTWARE

**❺**
**DESIGN FIRM**
MARKETING BY
DESIGN
**ART DIRECTOR**
DELLA GILLERAN
**DESIGNER**
JOEL STINGHEN
**CLIENT**
SACRAMENTO STOCK
AGENCY

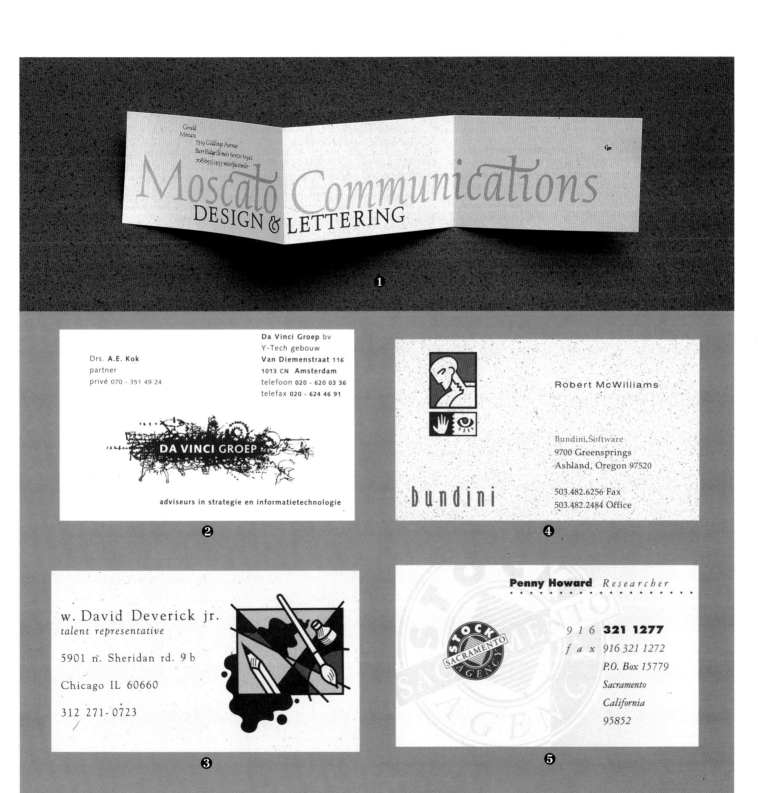

# *Index*